AUTONOMY

AUTONOMY

The Social Ontology of Art under Capitalism

NICHOLAS BROWN

DUKE UNIVERSITY PRESS *Durham and London* 2019

Designed by Matthew Tauch
Typeset in Sabon by Westchester Publishing Services

Library of Congress Cataloging-in-Publication Data
Names: Brown, Nicholas, [date] author.
Title: Autonomy : the social ontology of art under
capitalism / Nicholas Brown.
Description: Durham : Duke University Press, 2019. |
Includes bibliographical references and index.
Identifiers: LCCN 2018037347 (print)
LCCN 2018047133 (ebook)
ISBN 9781478002673 (ebook)
ISBN 9781478001249 (hardcover : alk. paper)
ISBN 9781478001591 (pbk. : alk. paper)
Subjects: LCSH: Art, Modern—21st century—
Economic aspects. | Art and business—History—
21st century. | Art and society—History—21st century. |
Arts—Political aspects—History—21st century.
Classification: LCC N8600 (ebook) | LCC N8600 .B76
2019 (print) | DDC 709.05—dc23
LC record available at https://lccn.loc.gov/2018037347

Cover art: Viktoria Binschtok, *Chanel*, 2016. Framed
c-print. 109 × 85 cm. Courtesy of the artist and
Klemm's Berlin.

For Kevin Floyd.

Contents

Acknowledgments

This book would never have come to be without conversations in person and in my head with Elise Archias, Jennifer Ashton, Sarah Brouillette, Joshua Clover, Iná Camargo Costa, Todd Cronan, Chico d'Alambert, Fabio Durão, Bo Ekelund, Michael Fried, Fredric Jameson, Oren Izenberg, Walter Benn Michaels, Mathias Nilges, Charles Palermo, Roberto Schwarz, Emilio Sauri, Lisa Siraganian, Blake Stimson, Imre Szeman, and others I have surely forgotten to mention. I am particularly grateful to Walter for dropping by my office, then eight floors and two elevators down, to tell me this was my next book, and to Fred, for his encouragement throughout. Also to Mathias for helping me when I got in over my head in German; the mistakes that remain are mine. Also to Anna, for everything. Special thanks must also go to Davis Brecheisen and Bob Ryan for their help in preparing the manuscript. The synthesis attempted here would not have been thinkable for me without two institutions, the Marxist Literary Group and nonsite.org. This book was written with the generous support of the Alexander von Humboldt Foundation. I must also express my gratitude to the University of Illinois at Chicago (UIC), for remaining committed in inhospitable times to its

mission as an urban, public research university; and even more to UIC United Faculty Local 6456, without whom the path of least resistance would be to trample that mission underfoot.

Fragments and early drafts of some of the arguments presented here have been published in my work for *nonsite* as well as in the following: parts of the introduction have appeared in "Close Reading and the Market," in *Literary Materialisms*, ed. Mathias Nilges and Emilio Sauri, as well as in "A obra de arte na era da sua subsunção real ao capital," in *Marxismo: Cultura e Educação*, ed. Fabio Akcelrud Durão, Daniela Mussi, and Andréia Maranhão; parts of chapter 3 have appeared in "Musical Affect, Musical Citation, Music-Immanence: Kurt Weill and the White Stripes," in *Postmodern Culture*, as well as in "Brecht eu misturo com Caetano: citação, mercado e forma musical," in *Revista do Instituto de Estudos Brasileiros*; parts of chapter 4 have appeared in "The Plain Viewer Be Damned," in *The Contemporaneity of Modernism*, ed. Michael D'Arcy and Mathias Nilges.

On Art and the Commodity Form

This book seeks to answer a question first asked more than a century ago by György Lukács: "Works of art exist—how are they possible?"[1] Lukács's version of the problem, still relevant to current debates concerning affect, identity, and form, did not have to confront the "wholesale reduction of culture to a commodity."[2] This phenomenon, lamented on the left while the right celebrates "a more favorable attitude towards the commercialization of culture," is nonetheless confidently affirmed by all sides, which "assert in the most ardent terms that art is, always has been, or has recently become, nothing but a commodity."[3] In a society such as ours, claims to exist outside the circulation of commodities are rightly ruled out as hopelessly naïve. We are wise enough to know that the work of art is a commodity like any other. What is less clear is whether we know what we mean when we say it.

A pair of shoes being a capitalist commodity—or a precapitalist, "simple" commodity, or a noncommodity—has, unless we are talking about Heidegger's pair of peasant shoes, no bearing at all on its being as a pair of shoes. The same goes for hammers, road salt, wallpaper. If there is a problem with the commodification of shoes (of the hammer,

the salt, the wallpaper), it has nothing to do with questions about its status as a pair of shoes and everything to do with what goes on in the labor process, "the hidden zone of production, on whose threshold it is posted: 'No admittance except on business.'"[4] While there is no lack of exploitation in the production of culture commodities, such exploitation concerns us in precisely the same way it does in any other industry. Granting the Heideggerian exception, it would be peculiar indeed to lament the "wholesale reduction of shoes to a commodity." Why should the commodification of the work of art be a problem—why would it seem to matter to its very status as a work of art—while the commodity character of a hammer or a shoe does not matter to its being as a hammer or a shoe?

We can find the answer in Marx's detour into the phenomenology of the market. Since "commodities cannot go to market and exchange themselves . . . we must look behind them, to their owners" (*K* 99/*C* 178):

> What chiefly distinguishes the commodity owner from the commodity is the circumstance that the latter treats every other commodity as nothing more than the form of appearance of its own value. Born leveler and cynic, it is therefore always on the jump to exchange not only soul but body with any other commodity, be it plagued by more deformities than Maritornes herself. With his five and more senses, the owner of the commodity makes up for the latter's lack of a feel for the concrete in other commodities. His commodity has for him no unmediated use value. Otherwise he would not bring it to market. It has use value for others. For him its only unmediated use value is to be the bearer of exchange value, and so to be a medium of exchange. That is why he wants to dispose of it in exchange for commodities whose use values appeal to him. All commodities are non-use values for their owners, use values for their nonowners. Consequently, they must all change hands. But this change of hands constitutes their exchange, and their exchange relates them to one another as values and realizes them as values. Commodities must be realized as values before they can be realized as use values. (*K* 100/*C* 179)

This is a knotty passage (and one whose gender politics are mercifully not entirely legible in translation). Its difficulty and, indeed, "literariness" seem all out of proportion to the matter in hand. Should it not be

among the easiest things in the world to distinguish commodity owner from commodity? Is it not rather an odd flourish to stack the deck by personifying the commodity, then to feign perplexity in distinguishing the personification from the person? But the operation is the opposite of this: we were told in the paragraph preceding this one that "the characters who appear on the economic stage are merely personifications of economic relations" (K 100/C 179). So it is not only that the commodity is personified but, it proving easier to talk of the commodity as a "she" than the owner as an "it," that the owner is. The distinction is therefore between two logical standpoints—something the fact that one of them is occupied by a consciousness tends to obscure—and the distinction is simply this: from the standpoint of the commodity, all commodities are qualitatively indifferent. If you imagine a market without buyers and sellers, you are left with a mass of commodities that are exchangeable in various ratios, but none of which is not exchangeable—that is, none of which possesses any qualities that cannot be expressed as quantity. (The basis of this qualitative indifference, established in Marx's previous chapter, does not concern us here). But from the standpoint of the commodity owner—who, because he owns a commodity and not some other kind of thing, is both buyer and seller—his commodity is qualitatively different from all the others in that his alone has no qualities. To be more precise, his has only one quality that matters, namely its lack of qualities—that is, its qualitative equality with other commodities: its exchangeability.[5]

All other commodities—that is, the commodities he encounters as a buyer rather than a seller—are, for his "five and more senses" full of qualities. Quality, use value, counts for him as a buyer. Otherwise, he would not want to buy. Quality, use value, counts nothing for him as a seller. Otherwise, he would not be willing to sell. Of course, as a seller he knows that the commodities he brings to market must "stand the test as use-values before they can be realized as values" (K 100/C 179). "But"—and this is a Hegelian "but," the conjunction that changes everything that came before—"only the act of exchange can prove whether or not [the human labor expended in them] is useful for others, whether the product of such labor can therefore satisfy alien needs" (K 100–1/C 180). We thus find ourselves in a chicken-and-egg loop—exchange value precedes use value precedes exchange value precedes use value—that Marx's imaginary commodity owner wants no

part of: "He wants to realize his commodity as value . . . whether or not his own commodity has any use value for the owner of the other commodity" (*K* 101/*C* 180).

In societies such as ours, which appear as an "enormous collection of commodities" (*K* 49/*C* 125), any use value is immediately exchangeable. Conversely, only through exchange is use value socially ratified. Therefore, it is only exchangeability that matters to the commodity's owner, as frustrated as he might be by the fact that its use value is from one standpoint prior. If he sells you a salad bowl and you use it for a chamber pot, that is strictly your business. As far as the seller is concerned, the use value of "his" commodity makes its appearance only as exchange value: "only the act of exchange can prove whether or not [such labor] is useful for others." The commodity owner wants to realize the exchange value of his commodity by producing something that is a use value for others. But he is not in the business of legislating or even knowing what that use value should be; he does not even know it has a use value until it sells. Indeed, the more potential uses it has—it slices, it dices; it's a typewriter and a shoe store and a status symbol and a peepshow—the less he legislates what its actual use value should be, and the happier he is.

If this were the only possible state of affairs, there would be no reason to demonstrate its peculiarity. So what is the other of "a society of commodity producers" (*K* 93/*C* 172)? We are given several options in Marx's previous chapter: Robinson Crusoe, the medieval corvée, the peasant family, hints of various historical noncapitalist societies, and finally the famous "association of free people, working with the means of production held in common, and, in full self-awareness, expending their many individual labor powers as one social labor power" (*K* 92/*C* 171). These are all others of capitalist commodity production, but its determinate other, the other that the capitalist market produces as its own internal frame, is Hegel's image of collective labor, which Marx's explicitly recalls. This image appears most explicitly in Hegel's idealized evocation of Greek ethical life, an evocation that refers not to the Greek polis as it actually was or as Hegel imagined it actually was, but rather to its own immanent horizon, an ideal that Greek customary life must presuppose but can only realize in an unsatisfactory, contradictory, and unstable way:

The individual's labor to satisfy his own needs is as much a satisfaction of the needs of others as his own, and the satisfaction of his own needs is achieved only through the labor of others. As the individual in his individual labor already unconsciously accomplishes a common labor, so again he also produces the common as his conscious object; the whole becomes, as whole, his work, for which he sacrifices himself, and precisely thus is himself restored by it.[6]

The problem—the satisfaction of "universal" or social needs through individual labor, through irreducibly particular talents and drives—is the same in Marx and Hegel, though Marx's "full self-awareness" will mark the crucial difference. Marx, however, considers this problem by means of a different social formation—capitalism—in which there is nothing customary about what is produced and nothing individual in who produces it; in which, as we have seen, exchange precedes use. In Marx's version—"only the act of exchange can prove whether or not [such labor] is useful for others, whether the product of such labor can therefore satisfy alien needs"—the two subordinate clauses appear to say the same thing. The function of the second clause is to emphasize the shift from the neutral "other" to "alien" (*fremde*)—that is, to point out the peculiarity of commodity exchange in which "the needs of others," taken for granted in the Hegelian version of customary life, are reduced to a cipher whose index is exchangeability. As Lukács reminded us, the logic of alienation (*Entfremdung*) in Marx is intimately related to that of Hegelian externalization (*Entäußerung*).[7] The other or negative horizon of commodity exchange is what Hegel calls *die Kraft der Entäußerung*, "the power of externalization, the power to make oneself into a thing" (483/§658).[8]

Plenty has been written about the lordship and bondage theme in the *Phenomenology of Spirit*, and we have no interest in revisiting it here, even if the relation of buyer to seller—logically encompassing the two moments of indifference and petulance—does, in its utter failure to produce anything like subjectivity (it produces instead a market where the parties can safely face each other in the aggregate rather than as antagonists) ironically recall it. What is important here is how we get out of this dialectic. As is well known, this occurs through the labor of the bondsman, who, in forming and shaping the thing, in external-

izing himself in the production of the lifeworld of both himself and his master, comes to find in that world not the master's power but his own: "Thus the form [of the product of labor], set outside himself, is not an other to him, for this form is precisely his own pure being-for-self, which to him becomes the truth. What he rediscovers, precisely through labor that appears to harbor only an alien purpose, is nothing other than his own purpose, arrived at through his own means" (154/§196). This is Hegel's materialism—the exact opposite, it might be said in passing, of causal or vulgar or "object-oriented" materialism—and indeed it represents a kind of ideological core to the *Phenomenology*. But the point to be made here is that the object the bondsman shapes is not just made—Marx's commodity will also be the product of labor—but intended: a purpose arrived at by his own means. "Externalization" is not, then, a psychological projection but a matter of social inscription. The thing is not a cipher whose use is indexed by its exchange but a use whose purpose is legible—that is, normative. The master can, and presumably does, find another purpose in it, but that will now be an occasion for conflict. The owner of commodities, however, does not care what purpose a buyer finds in his commodity, as long as someone will buy it.

What we have arrived at is the distinction between the exchange formula C-M-C (commodity-money-commodity, or Hegelian *Sittlichkeit*, the satisfaction of individual needs as the universal satisfaction of needs through the social metabolism, as use values are exchanged through the medium of money) and M-C-M (money-commodity-money), the same relation but now understood as the kernel of capitalism itself, where use value is only a vanishing moment in the valorization of capital. What we have arrived at is the distinction between an object whose use (or purpose or meaning) is normatively inscribed in the object itself—a meaning that is universal, in Hegel's terms simply *allgemeine*, available for everyone and not therefore a private matter—and an object whose use is a matter of indifference from one standpoint and a matter of possibly intense but necessarily private concern from another. What we have arrived at is the distinction between an entity that embodies, and must seek to compel, conviction and an entity that seeks to provoke interest in its beholder—or, perhaps, all kinds of different interest from different beholders. What we have arrived at, no doubt by an unusual route, is the distinction between art and objecthood.[9]

The distinction is Michael Fried's, but it has become central to the debate over the dominant strand in contemporary cultural production, or, more likely, the dominant strand in the cultural production of the very recent past, a period for which the term "postmodernism" will do as well as any other. While aspects of Fried's critique are broadly applicable, the distinction was originally developed to critique the minimalist or "literal" artwork's claim to be nothing more than the specific object that it is—a claim that ultimately produces a kind of theater in which the finally salient aspect is not the form of the object but the experience of the spectator. The claim made by a minimalist work to be literally the object that it is—in brief, to produce an object that provokes an experience rather than a form that calls for an interpretation—manifests the structure of the commodity, which calls for private attachments rather than public judgments. Indeed, everything Fried finds objectionable in the pseudo-art "object"—its pandering appeal to the spectator, its refusal of the category of internal coherence, its infinite iterability subject to drift rather than development—is, however, perfectly legitimate for a certain class of objects with which we are already familiar, namely commodities. Or, to put this more strongly, Fried's "formalist" account of the distinction between art and recent nonart is also a historicist one, fully derivable from the Marxian problematic of the "real subsumption of labor under capital."

Let us return, then, to *Capital*. As we just saw, one way to understand Marx's analysis is to say that in commodity exchange, the mode of purpose or intention shifts. If I make a bowl for myself, it is a bowl because I wanted to make a bowl, and I will be concerned about all kinds of concrete attributes the bowl might have. Intention will be inscribed in the thing itself: if it is shallow rather than deep, wood rather than metal, these attributes—its purposiveness—are as they are because I intend them to be that way, and we are in the world of Hegelian externalization. If I make a bowl for the market, I am primarily concerned only with one attribute, its exchangeability—that is, the demand for bowls. That demand, and therefore all of the concrete attributes that factor into that demand, are decided elsewhere—namely, on the market. Intention is realized in exchange but not registered in the object. While I still make decisions about my bowls, those decisions no longer matter as intentions even for me, because they are entirely subordinated to more or less informed guesses about other people's desires.

Our free-market theorists celebrate this phenomenon as "consumer sovereignty."[10]

The Kantian formula for aesthetic judgment, which opens the way to a concept of art that lends coherence to over two centuries of artistic practice, is the perception of "purposiveness without purpose."[11] Aesthetic judgments in Kant are made without reference to external uses, either idiopathic ones (preferences, market-like judgments) or practical ones (ends, state-like judgments). In an aesthetic judgment, we find something "beautiful"—a term of art in Kant, the coordinates of which are not established with reference to ugliness or difficulty but in opposition to idiopathic and conceptual judgments along one axis and the sublime along the other—but we are indifferent as to its existence. The work of art is, in its being as an artwork, exempted from use value. But as an undeniably unmagical thing, it also has a use value, which means it also necessarily bears an exchange value—and in a society whose metabolism is the market, exchange value is logically prior as *Zweck* or purpose. For hammers, this is not a problem. Estwing's purpose (making money by means of making hammers) is accomplished by fulfilling mine (hammering). The problems arise out of sight of the market, in the production process.

But for the artwork, its commodity character does pose a problem. If a work of art is not only a commodity—if a moment of autonomy with regard to the commodity form is analytically available, if there is something in the work that can be said to suspend its commodity character—then it makes entirely good sense to approach it with interpretive tools. Since its form is a matter of intention, it responds to—indeed, demands—interpretation. (In the passage from Hegel cited earlier—"his own purpose, arrived at through his own means"—the multivalent word "Sinn," translated here as "purpose," could also be translated as "meaning." Indeed, the conflict immanent in the normativity of the formed object will, in the *Phenomenology of Spirit*, devolve in skepticism and stoicism into a mere conflict of interpretation. But that is another story.) But if a work of art is only a commodity, interpretive tools suddenly make no sense at all. Since the only intention embodied in its form is the intention to exchange, the form the object takes is determined elsewhere from where it is made: that is, by (more or less informed guesses about) the market. The point here is not that artistic production, any more than Hegelian externalization, is somehow

precapitalist. This nostalgic-tragic temptation is one of Marxism's less useful inheritances from early romanticism. As we shall see, precisely the opposite is the case: the artwork is not an archaic holdover but the internal, unemphatic other to capitalist society. The aim is, rather, to outline the peculiar character of the commodity and what it would mean if works of art were commodities like any other. If works of art were commodities like any other, desires represented by the market would be subject to analysis and elucidation, but interpretation of the work itself would be a pointless endeavor.

It might seem absurd to say the art commodity is uninterpretable, but think for a moment of James Cameron's science-fiction film *Avatar*, still a kind of high-water mark of culture-industrial spectacle. The memory of critics producing a welter of completely incompatible (but also vaguely plausible) interpretations is an amusing one, and the phenomenon did not go unnoticed by the critics themselves. This empirical profusion is insignificant in itself: all of these interpretations (or all but one) could have been wrong. But it is also possible that since the film is concerned only with producing a set of marketable effects, it cannot at the same time be concerned with producing the minimal internal consistency required to produce a meaning. In fact, Cameron himself is pretty clear that this is the case. When asked why female Na'vi have breasts, he replies: "Right from the beginning I said, 'She's got to have tits,' even though that makes no sense because her race, the Na'vi, aren't placental mammals."[12] Cameron is more precise than he probably means to be when he says that "makes no sense." Pressed in a different interview, Cameron responds that the female Na'vi have breasts "because this is a movie for human people."[13] In other words, people—enough of them anyway—will pay to see breasts, so the breasts go in. But this "makes no sense": there is no point in interpreting it, because the salient fact is not that Cameron wanted them there but that he thought a lot of other people would want them there, and the wildly inconsistent ideology of the film is likewise composed of saleable ideologemes that together make no sense. This is not to say that all art commodities are similarly inconsistent. Some audiences will pay for ideological or narrative or aesthetic consistency, so we have politically engaged documentaries, middlebrow cinema, and independent film. But this consistency does not add up to a meaning, since what looks like meaning is only an appeal to a market niche. It is not that one cannot

consume these with pleasure or understand the messages, consistent or not, that they transmit; it is, rather, that once the determining pressure of market outcomes is recognized—and without the work itself plausibly invoking that pressure as overcome—it is hard to make the ascription of meaning stick.

But this is nothing new. Rather, it is a very old line, essentially Theodor Adorno's critique of the culture industry.[14] The lineaments of that critique are well known; it will be enough for the present to remind ourselves that, in that essay, Adorno has no interest in explicating works, because in commercial culture there are no works to critique and no meanings to be found. The culture industry as it appears in Adorno is simpler than ours, seemingly differentiated only vertically rather than splintered into potentially infinite socio-aesthetico-cultural niches. But the problem is that of the art commodity. "The varying production values in the culture industry have nothing to do with content, nothing to do with the meaning of the product" (*DA* 132/*DE* 124) because the varying production values are aimed at different markets rather than different purposes, and this principle is "the meaningful content of all film, whatever plot the production team may have selected" (*DA* 132/ *DE* 124). While one can ask interesting sociological questions about art commodities (Why do some young men like slasher films?), interpretive questions (Why is there a love scene in the middle of *Three Days of the Condor*?) do not have interesting answers.[15]

Under conditions of Hegelian externalization, meaning is equated with intention—as we shall see, a more complicated proposition than that initially appears—while under market conditions, "meaning" is simply what can be said about the appropriation of commodities. Sociological questions have answers without necessarily involving intentions; interpretive questions, if they have answers, require intentions. One does, of course, "interpret" sociological and other data. The word is the same, but the concept is different, since natural signs and intentional signs call forth entirely different interpretive procedures: the pursuit of causes, on one hand, and of meanings, on the other. One may wish to erase the distinction—though in everyday practice this would be a form of madness—but to do so would simply be to erase the first meaning of interpretation in favor of the second. This is not an unthinkable operation. In fact, it is what we have been saying is entailed, in the realm of art, by the claim that the work of art is a commodity like any other.

Meanwhile, there is nothing threatening to Marxist interpretation in the equation of meaning with intention.[16] The strong claim for the identity of intention and meaning already implies the social. The medium of meaning is a universal, which is, in the Hegelian sense, a social machine, a particular signifying network like literature itself or like the late eighteenth-century culture of wit. There is no meaning outside of a signifying network or social machine: to mean something is immediately to involve oneself in a social machine. (Meaning is a socially symbolic act.) While meanings exist sub specie aeternitatis, the media or social machines in which they mean, it should be too obvious to point out, are historical. If one insists on understanding meaning proper as externalization, one must begin with an account of the social machine. (Always historicize.) Since every intentional act can be described in terms that are nowhere to be found in the moment of intention—think of the endless descriptions of jumping over a railing, turning a tap, or boiling water in the "Ithaca" episode of James Joyce's *Ulysses*—nothing in the analysis of meaning to intention prevents us from chasing down what a meaning might entail as a logically necessary consequence (as opposed to an effect) or condition of possibility (as opposed to a cause), even if these are not intended. Indeed, this is Marx's procedure in the chapter we have been discussing. The future capitalist, for now simply an owner of commodities, wants to sell his goods. That is all. "In their confusion, the commodity owners think like Faust: In the beginning was the deed. They have already acted before thinking" (*K* 101/*C* 180). The logical contortions embodied in the act of exchange (the confusion or embarrassment, *Verlegenheit*, of the commodity owners—indeed, their ideology) are nowhere in the mind of the capitalist. Rather, they are the logical preconditions of the act of exchange itself. In this Hegelian-Marxian sense, the unconscious is simply everything entailed or presupposed by an action that is not present to consciousness in that action. Such entailment is often, in the *Phenomenology of Spirit*, an action's necessary interaction with the universal in which it subsists. Such interactions yield a properly Hegelian mode of irony: think, for example, of the fate of Diderot's sensible man in Hegel's retelling of *Rameau's Nephew* (or think, in our time, of the "outsider" artist) confronting a culture of wit that necessarily turns every attempt at plain truth telling into its opposite. An intention necessarily calls such necessary presuppositions or entailments into

play. (The identity of intention and meaning insists upon a political unconscious.)[17]

Finally, the identity of meaning and intention does not entail any position on the desirability of something like cultural studies, if cultural studies is taken to mean the sociological study of cultural production, distribution, and consumption. What it does entail is the distinction between such study—which will be crucial in what follows, in the form of a sociological understanding of the universal in which contemporary artworks make their way—and interpretation. In the section of the *Phenomenology* on "the matter in hand," the relation between socio-logical motivation (ambition) and scientific purpose (*die Sache selbst*, the matter in hand) is, as it is in the work of Pierre Bourdieu, undecidable: it is always possible that the private motive that drives a given interven-tion is its essential content, its ostensible meaning the inessential. But this very undecidability means that nothing definite can be said about the relation of ambition to work. Intention as an event in the mind is in-accessible even to the mind in which it ostensibly occurs. Intention in the current sense, as we shall see in a moment, can be ascribed only by means of close attention to the matter in hand. As regards what is in the work (as opposed to its entailments and its conditions of possibility, which must be conceived both positively as productive and negatively as a limit)—that is, as regards its meaning in the strict sense—nothing can be divined from sociological research.

Kant's "purposiveness without purpose" is shorthand for a longer formulation: "Beauty is the form of purposiveness of an object insofar as it is perceived therein without the idea of a purpose."[18] It is this longer formulation that Hegel quotes, more or less, in his account of the Kantian aesthetic break.[19] But where Kant's formulation is con-cerned primarily with a mode of perception (a footnote points us in the direction of tulips and stone tools, which we judge beautiful or not beautiful based not on whether they have a purpose, but whether we ascribe a purpose to them as we judge them), Hegel's gloss turns us toward the peculiar character of the work of art itself: "The beautiful should not bear purposiveness as an external form; rather, the purpo-sive correspondence of the inner and outer should be the immanent nature of the beautiful object." This is not a mere change of emphasis; rather, it shifts the meaning of Kant's formulation decisively, for we are talking no longer about a certain kind of perception, but about a

certain kind of purposiveness in the object: "In finite [i.e., plain vanilla, everyday] purposiveness, purpose and means remain external to one another. . . . In this case, the idea of the purpose is clearly distinguished from the object in which it is realized." The purpose of an object is, commonsensically, something other than the object: satisfying my hunger is a purpose external to the quesadilla. "The beautiful, on the other hand, exists as purposive in itself, without means and purpose showing themselves as different, severed sides." The Kantian formulation of "purposiveness without purpose" is then essentially revised to "purposiveness without external purpose." A certain kind of purpose distinguishes Hegel's gloss from Kant's original account—a tulip is not a still life—but it is a purpose that cannot be distinguished from the means of achieving it. In other words, the purpose of a work of art cannot be distinguished from the work itself. Indeed, any separation between ends and means, purpose and work, can only reveal itself as a contradiction within the work itself. The way to the meaning of a work lies not away from the work to its intention understood as an event in the mind of the artist, but into the immanent purposiveness of the work. Meaning, then, is never a settled matter; it is a public ascription of intention. This ensemble of immanent, intended form—purposiveness without external purpose—is, as Stanley Cavell might say, a fact about works of art, not itself an interpretation. It has been a fact about artworks as long as there have been artworks, which is not as long as one might think. If it is not true of artworks, then artworks, as a special class of things deserving a name, do not exist.

As we have seen, however, the commodity form poses a problem for the work of art, which, if it is a commodity like any other, cannot have the structure that Hegel thinks it has. Its purposiveness is subordinated to exchangeability, an external end, which is just another way to say that we make a mistake if we ascribe a meaning to it. Let us return, then, to the art commodity and its other. For Adorno, the art commodity had a plausible other or negative horizon—namely, modernism (even if this is usually referred to collectively in the essay as "bourgeois artworks," and usually in the past tense)—where Hegelian externalization (compensatory, tragic, but an externalization nonetheless) holds. Adorno accounts for this possibility by the residual phenomenon of tributary backwaters within capitalism, spaces left behind by the expansion of capital. The persistence of such spaces "strengthened art in this late phase against

the verdict of supply and demand, and increased its resistance far be-
yond the actual degree of protection" (*DA* 141/*DE* 133). Despite his
lifelong concern with the specificity of the aesthetic, Adorno here takes
an essentially sociological view of the autonomy of the work of art. The
existence of art in its modern sense is indeed intelligible only within
the total logic of capitalist development, but Adorno assumes here that
it is possible only under certain sociological conditions—namely, the
persistence of uncommodified spaces within a relentless logic of com-
modification. As we shall see shortly, Adorno's understanding of those
conditions is definitively superseded by Bourdieu's; more important
still, it would condemn Adorno to an essentially tragic narrative and
to an increasingly desperate search for uncommodified conditions. But
the point for now is that Adorno's culture industry is the precursor to
the self-representation of our own cultural moment, though the con-
temporary attitude of culture critique toward its object is as likely to
be ludic, stoic, cynical, or smugly resigned as tragic. What essentially
differentiates Adorno's culture industry from the self-representation of
our contemporary moment is that the art-commodity is now supposed
to have no other. Fredric Jameson, bringing the problem up to the day
before yesterday, simply says, "What has happened is that aesthetic
production today has become integrated into commodity production
generally."[20] From this, everything follows.

The logic of this transition is already available in Marx, in a draft
chapter for *Capital I* that was not available in the West until the 1960s.
What we have is often fragmentary, but the basic distinction in "Re-
sults of the Immediate Process of Production" between the "formal sub-
sumption" and the "real subsumption of labor under capital" is clear.[21]
Under conditions of formal subsumption, an industry or production
process is drawn into a capitalist economy, but "there is no change as
yet in the mode of production itself" (*R* 106/*C* 1026). Under condi-
tions of "real subsumption," however, the production process itself is
altered so that the producers are no longer selling their surplus prod-
uct to the capitalist but instead are selling their labor to the capitalist,
who eventually will be compelled to reorganize the production process
altogether. (Production, as well as exchange, has both a C-M-C, or "cus-
tomary" in the Hegelian sense, and an M-C-M, or capitalist, form. The
latter haunts the former until the phase change to capitalism proper,
when the former haunts the latter.) The distance between formal and

real subsumption is vanishingly small (just as C-M-C and M-C-M are the same process, considered from different standpoints); but the status of the product of labor, and eventually the work process itself, is fundamentally different under each. Indeed, as will no doubt already be apparent, "formal subsumption" allows for Hegelian externalization to continue under capitalism, since it is, for example, only accidental surplus that is sold: "Milton produced *Paradise Lost* as a silkworm produces silk, as the manifestation of his own nature. He later sold the product for £5 and thus became a dealer in commodities" (*R* 128/*C* 1044). Under conditions of real subsumption, by contrast, we are already in the world of Marxian separation, where the whole production process is oriented toward exchange. But what this logical proximity means is that directly "capitalist production has a tendency to take over all branches of industry . . . where only formal subsumption obtains" (*R* 118/*C* 1036). For formal subsumption in a given corner of industry to obtain with any permanence, it must be afforded some degree of protection: professional guilds, research-based tenure, Adorno's well-funded state cultural institutions, or, as we shall consider shortly, something like Bourdieu's concept of a field of restricted production.

There are sectors of the culture industry where the logic Marx develops in the *Resultate* fragment is directly operative. A character animator for a video-game company performs directly productive labor, and her work is both exploited in the Marxian sense and subject to deskilling, automation, and all the other degradations of work entailed by capitalist production. But for a great deal of artistic production, "capitalist production is practicable to a very limited extent. Unless a sculptor (for example) engages journeymen or the like, most [artists] work (when not independently) for merchant's capital, for example a bookseller, a relationship that constitutes only a transitional form toward merely formally capitalist production" (*R* 133/*C* 1048). In a nearby passage, Marx tells us that "a singer who sings like a bird is an unproductive worker" (*R* 128–29/*C* 1044), an easily misunderstood term that simply means her work does not valorize capital: she produces beauty but does not take part in a process that yields surplus value. "If she sells her singing for money, she is to that extent a wage laborer or a dealer in commodities" (*R* 129/*C* 1044), depending on whether she is employed by a bandleader, say, or works independently. "But this same singer, engaged by an entrepreneur who has her sing for money, is a productive

worker, since she directly produces capital" (R 129/C 1044). Only at the last stage has her labor undergone the "the subsumption by capital of a mode of labor developed before the emergence of capitalist relations, which we call the formal subsumption of labor under capital" (R 101/C 1021). Her employer might extend the working day—make her perform more often for the same pay—but it is hard for Marx to imagine the entrepreneur ploughing a portion of profits back into transforming "the real nature of the labor process and its real conditions" (R 117/C 1034–5)—automation, deskilling, and so on. "Only when this occurs does the real subsumption of labor under capital take place" (R 117/C 1035), and only with real subsumption do we enter the permanent revolution of the capitalist production process.

However, the production process for the music commodity—a CD or a download or a subscription—has followed and continues to follow the trajectory, familiar from the rest of the first volume of *Capital*, of saved labor through increased technical composition of the production process. A staggering amount of musical knowledge has been incorporated into machines, and distribution—on Marx's account, the last stage of production rather than the first stage of circulation—proceeds now with a tiny fraction of the labor input it did even a decade ago. That our singer's job is still recognizable—and the advent of Auto-Tune is an easily audible reminder that even this is far from straightforwardly true—is no more important to the status of the commodity that emerges from the production process as a properly capitalist commodity than is the fact that a machinist's job is still recognizable.

These changes in the production process leave their marks, often very deep ones, on the product of musical labor. However, and possibly frustratingly given the time we have just spent on it, none of this is immediately relevant to the issue at hand. As we saw earlier, the specific problem confronting the work of art under capitalism is not the production process—this a problem but not one specific to art—but the market. Markets preexist capitalism, as does the commodity—indeed, Marx's word is not a specialized one at all, just *Ware*, goods—so the specificity of a Marxist critique of the art commodity might seem to pose a problem. But we remember those passages of the *Grundrisse* and *The Communist Manifesto* that describe the necessary expansion, both intensive and extensive, of the market, the correlate and presupposition of the process of real subsumption: "Every limit appears as a

barrier to be overcome: first, to subjugate every aspect of production itself to exchange. . . . Trade appears here no longer as a function between independent productions for the exchange of their excess, but as an essentially all-encompassing precondition and aspect of production itself."[22] It is the tendential universality of the market as the sole organ of social metabolism that represents the originality of the capitalist market. Neoclassicism's ideology of "consumer sovereignty" agrees with Marx that in commodity production, consumer preference is prior to the intention of the producer, which is entirely subordinated to the goal (*Zweck*) of exchange. "The more production becomes the production of commodities, the more each person has to become a dealer in commodities and wants to make money, be it from a product or a service . . . and this money-making appears as the purpose [*Zweck*] of every kind of activity" (*R* 125/*C* 1041). This is the real tendency of which contemporary aesthetic ideology is the dogmatic representation: that once the means of distribution are fully subsumed, whatever is genuinely unassimilable in artistic labor will cease to make any difference; that the artist, when not directly a cultural worker, must conceive of herself as an entrepreneur of herself; that any remaining pockets of autonomy have effectively ceased to exist by lacking access to distribution and, once granted access, will cease to function as meaningfully autonomous.

Adorno has no trouble imagining a still incomplete real subsumption, which is the culture industry, with modernism as the last holdout of merely formal subsumption.[23] For Jameson, finally, the real subsumption of cultural labor under capital is an established fact. When Jameson describes the "dissolution of an autonomous sphere of culture" that is at the same time "a prodigious expansion of culture throughout the social realm," this end of autonomy directly implies the end of modernism.[24] If canonical modernism conceived of itself as autonomous—as producing the "critical distance" that Jameson sees as having been "abolished," along with any "autonomous sphere of culture . . . in the new space of postmodernism"—then today we tend to understand this critical distance as nothing more than modernism's aesthetic ideology.[25] Modernist artworks are and were, after all, commodities like any other.

Nobody could be more skeptical of modernism's self-representation than Bourdieu. Yet in his two-field theory of aesthetic production,

Bourdieu produced an account of the sociological referent of modernism's self-representation in the development of a "field of restricted production," which lies behind the ability of artists to "affirm, both in their practice and their representation of it, the irreducibility of the work of art to the status of a simple commodity."[26] This dual affirmation is key, for the ideological representation of autonomy has its equivalent in the real autonomization of aesthetic practice in the struggle by artists to institute a "field of restricted production," which forcibly substitutes for the "unpredictable verdicts of an anonymous public"—consumer sovereignty, the problem of the seller of commodities—a "public of equals who are also competitors."[27] In other words, the establishment of a field of restricted production forcibly carves a zone of formal subsumption out of the field of large-scale production that is really and entirely subsumed under capital. (A restricted field is not a market in any meaningful sense. Judgments by peers and struggles over the significance of particular interventions are precisely the opposite of purchases on a market, which cannot provoke disagreement because, as we have seen, no agreement is presupposed.) Adorno's more ad hoc version of the two-field hypothesis conceives of its restricted field as a residual rather than an emergent space, but he and Bourdieu share an understanding of the necessity of such a de-commodified zone to the production of meaning.

Following Bourdieu's logic, the establishment of such a field directly implies the tendency of art produced in it to gravitate toward formal concerns, toward the progressive working out of problems specific to individual media. What a restricted public of (for example) painters, critics of painting, and connoisseurs of painting share is nothing other than expertise in painting. "Painting was thus set on the road towards a conscious and explicit implementation or setting-into-work of the most specifically pictorial principles of painting, which already equals a questioning of these principles, and hence a questioning, within painting itself, of painting itself." [28] In other words, modernism: "Especially since the middle of the nineteenth century, art finds the principle of change within itself, as though history were internal to the system and as though the development of forms of representation and expression were nothing more than the product of the logical development of systems of axioms specific to the various arts."[29] But for the characteristic "as though," which marks this as an imaginary relation whose real

referent is the logic of the restricted field, the words could have been written by Clement Greenberg.[30] Indeed, the Bourdieusian restricted field is, on Bourdieu's account, the condition of possibility of modernism as such, the condition of possibility of a Hegelian concern for "the matter in hand" under full-blown capitalism.

With the collapse of the modernist restricted field, with the real subsumption of aesthetic labor under capital, the possibility of something bearing a family resemblance to modernism abruptly disappears. What had been central was a problem to be addressed—a problem in which the general market, because it is a market, has no interest—and all of the old solutions had been ruled out of bounds not because they were not nice to hang on a wall or to read, but because they had been absorbed into the game of producing new ones. But the leapfrogging, dialectical, modernist game—in which every attempt to solve the central problem represented by a medium becomes, for every other producer, a new version of the problem—becomes more hermetic and difficult to play over time. One can immediately see that, on this account, the isolation of an autonomous field appears not only as the necessary condition of possibility (within market society) for the production of any artwork but also as a condition that leads to the increasing difficulty of producing meaning or, more accurately, the increasing formalization of meaning itself. Meanings are made possible by autonomization, but these meanings themselves are increasingly only formally meanings—that is, they are legible as intentions, but the only meanings they convey are specifically painterly, musical, writerly, and so on. The very dynamic that makes modernism possible tends at the same time to restrict its movement to an increasingly narrow ambit. For this reason, what appears as loss from the standpoint of autonomy is at the same time a tremendous liberation of formal energies, made possible precisely because the old forms are no longer required to respond to interpretive questions.

With the real subsumption of art under capital and the end of the modernist game, then, all of the old "solutions," each one of which had been invalidated by subsequent solutions, suddenly become available again for use. A certain historicism—Jamesonian postmodern pastiche—becomes possible. Such a historicism is null as historicism, since what it does not produce is precisely anything like history. But it is practically bursting with excitement at being allowed to apply its galvanic fluid to the great gallery of dead forms, which are suddenly

candidates for resuscitation. Friedian "objecthood" is also liberated at this moment: the reaction of the spectator, or customer, assumes importance in precise correlation to the recession of the formal problem confronted by the artist.

So far, we have done no more than reconstruct the logic undergirding the common sense with which we began. But, as is probably obvious by now, liberation from the strictures of the old modernist games is at the same time subjection to something else—namely, the "anonymous market" from which the autonomous field had wrested a degree of autonomy. If artworks can now make use of all the old styles (or become objects), it is not clear why one would call them artworks at all, since the honest old art commodity, precisely because it was more interested in the appeal to a market (the effect on an audience) than on formal problems, was able to make use of the old styles (or be an object) all along. In other words, there is nothing new in unabashedly borrowing indiscriminately from the great gallery of dead forms, or in appealing theatrically to consumers' desires. These procedures are in fact the norm. The innovation of postmodern pastiche is—by definition—not formal but derives from the collapse of art into what was already the status quo of the culture at large. Postmodernism's innovation is precisely in evacuating the distinction between industrial spectacle—Cameron's ideological mishmash—and the Jamesonian postmodern art object, assembled from its "grab bag or lumber room of disjointed subsystems and raw materials and impulses of all kinds."[31]

Of course, this is the point. Indeed, there is nothing implausible about a scenario in which artworks as such disappear, to be entirely replaced by art commodities, and in which the study of artworks would have to be replaced with the study of the reception and uses of art, of desires legible in the market, and so on. There is a deeply egalitarian promise in such a scenario, precisely because the formal concerns addressed by artworks are in general the province of a few. In the absence of a strong public education system, they are necessarily the province of a few. But a world where the work of art is a commodity like any other is the world the ideologists of contemporary capitalism claim we already live in and have always lived in, a world where everything is (and if it is not, should be) a market. The old vanguardist horizon of equivalence between art and life—which made sense as a progressive impulse only when "life" was understood as something other than the status quo—

reverses meaning and becomes deeply conformist. Against this market conformism, the assertion of aesthetic autonomy—even as its very plausibility now seems in doubt—assumes a new vitality.

But how do we make the claim to autonomy plausible? If works of art exist, how are they possible? Have we not, in outlining the collapse of modernism's restricted fields, done no more than confirm the wisdom that the work of art is a commodity like any other? In fact, it is the claim to universal heteronomy to the market that is implausible. Markets—and this was recognized in some of the precursors to neoliberal discourse, themselves utopian projects in a way that the institution of art is not—depend on a host of nonmarket actors and institutions, even as these institutions are always at the same time under threat from the market itself.[32] To take a more local example, a consequence of Bourdieu's discovery of the restricted field was the demonstration that the field of large-scale cultural production, characterized as it is by *pasticherie*, is dependent on the persistence of the restricted field.[33] (No *Star Trek* theme without Mahler 1 and 7, but the accomplishments of the past are of only limited use as a finite warehouse of ideas and techniques. When the late pop-funk genius Prince blamed the passing of jazz fusion for what he saw as the stagnation of popular music, he was convinced less of the greatness of Weather Report or the Chick Corea Elektric Band than of the importance of a musically proximate idiom that is not directly submitted to market outcomes—a proximity that can be discerned on some of Prince's most market-successful music, as well as on projects that were never intended to be submitted to the pseudo-judgment of the anonymous market.)[34] Most important, if the old modernist autonomy was revealed to be an aesthetic ideology, there is no reason to believe that the new adherence to heteronomy therefore registers the truth. Like the modernist commitment to autonomy, the insistence on aesthetic heteronomy is a productive ideology: it frees artists to do something other than play the old modernist games (it even, as we shall see, opens the way to new modernist games), and it allows them to work in the culture industry without facing the charge of selling out, which now seems like an anachronistic accusation indeed.

As we have seen, art that is a commodity like any other would not be art in any substantial sense. But the commitment to the heteronomy of art does represent, to use the old Althusserian formulation, an imaginary relationship to real conditions of existence. The subsumption of

art under capital is not a universal quality of the artistic field. But it is, as we earlier saw with the example of popular music, a real tendency in some subfields, and the submission it entails of meaning to the spectator is a quality hegemonically or normatively attributed to art in a way that is historically original to the late 1960s and after. But while sociological conditions may, a posteriori, be discovered to condition the emergence of particular works, they can say nothing about their success or failure as artworks. Successful artworks produced in directly heteronomous fields are rare, but they exist. Works that are indistinguishable from commodities in their foreclosure of meaning, by contrast, litter the restricted fields that do exist. What is dispositive, then, is not the immediate relation to commodity production but, rather, the successful (or failed, canceled, or foreclosed) solicitation of close interpretive attention, which now, whether the threat of real subsumption is itself real or a merely ascribed condition of uninterpretability—under the sign of affect, *écriture*, *punktum*, the emancipation of the spectator, the uses of art, relational aesthetics, or even, in most but not all of its acceptations, political art—must confront that threat as an obstacle to be overcome.

In his discussion of the Laocoön, Lessing was exasperated with commentary that imagined it could leap to interpretive conclusions without passing through the moment of medium specificity. It is not necessarily the case that the Greek was, as Winkelmann had it, "even in extremity a great and steadfast soul" in comparison with modern sufferers; it is necessarily the case that the sculptor of the Laocoön had to deal with the problem of the hole that a scream would require.[35] That the work of art is a commodity like any other is, from the standpoint of the market, not false. The commodity character of the work of art is indeed part of its material support. The moment of truth in contemporary aesthetic ideology has been to make this aspect of the support inescapable. After postmodernism, autonomy cannot be assumed, even by works produced for a restricted field. It must instead be asserted. (How much the postmodern period will appear in retrospect to have been shot through with this assertion—how much the postmodern discontinuity will turn out to have been an illusion—is matter for further research.) Since the structure of the commodity excludes the attribute of interpretability, any plausible claim to meaning—to art as opposed to objecthood—will immediately entail the claim not to be a commodity like any other. The originality of the present moment is that the concept

of medium or material support must be expanded to include the commodity character of the work.

Think, for example, of the BBC television show *The Office* and its American remake, which would most obviously seem to operate in the same medium. The second, however, systematically writes out, from the initial episode on, uncomfortable possibilities in the first. Decisions that confront characters in *The Office* tend to demand—de minimis, naturally—a mutually exclusive choice between advancement and self-respect. In the American remake, the damage inflicted by such choices is domesticated to quirkiness, and ultimately every quirk is a point of relatability. In short, the American *Office* is *Cheers*, where everybody knows your name. The temptation, then, is to make cultural comparisons between the United States and the United Kingdom, or between humor and humour. One's materialist instincts might suggest, on the contrary, that the difference between *The Office* and its remake is not the difference between bitter British office workers and quirky but better-adjusted American office workers, or that between aggressive British humor and a milder American variety, but that between a cultural field supported by a national television license tax, which allows at the margins a certain autonomy from the market, and a cultural field whose one unavoidable function is to sell airtime to advertisers.

Indeed, this distinction is highly relevant a posteriori, but it is not a substitute for interpretation. The former arrangement guarantees nothing—it is not as though every comedy on the BBC was bearable, let alone internally coherent—and is bought at the expense of a relationship both to the state and to a potentially even more stultifying demand for abstract "quality" as an external end in itself. Meanwhile, are we prepared to say a priori that no pop commodity can be art? *The Office* overcomes its commodity character—which is built into the sitcom as a form—not because its conditions of production automatically save its contents from the logic of the commodity, but by means of its formal constitution. *The Office* produces its autonomy from the spectator—without which, whatever its conditions of production, it would turn into a collection of comedic effects—by including her proxy, the camera, in the representation in a way that directly influences what is represented. This is the point of the fiction of the documentary frame, which becomes a formal principle, an internal limit to what can happen and how, thereby introducing an internal criterion. By means of the inclusion

of the camera as a character, *The Office* in effect overcomes the transparency of the televisual eye, introducing a criterion of plausibility and reactivating the "inescapable claim of every work, however negligible, within its limits to reflect the whole" (*DA* 153/*DE* 144).

The American remake, however, immediately turns the roving camera and other techniques into meaningless conventions; the structuring fiction turns into a decorative frame. In both series, for example, characters occasionally reveal their awareness of the apparatus, breaking the fourth wall by looking directly at the camera. In the original series, this tends to happen at moments of high tension, when the camera is invoked by such glances as both a witness and a discomfiting, triggering presence. In the fiction of *The Office*, events are both captured and caused by the camera. In the remake, such moments are subordinated to comic timing, one step shy of the Skipper reacting to whatever kooky thing Gilligan has done this time. By the fourth episode, narrative coherence and even plausible camera placement have been thrown to the wind, and sitcom sentimentality has already begun to take over. It is not that the BBC show is "better" in an abstract sense. The American version was funny, and its identificatory effects were masterfully produced. Nor is it the case that the conditions of production that characterize network television are in principle impossible to overcome by formal means, though in practice they may be nearly so. But the remake makes no attempt to overcome the fact that its end—selling airtime to advertisers—is immediately an external one that is achieved by being more ingratiating than its competitors in that time slot. If it can be said to have a meaning, it has only a sociological one, an ideology by default—that is, the ideology of the sitcom itself: "not, as is maintained, flight from a rotten reality, but from the last remaining thought of resistance" (*DA* 153/*DE* 144). Pointing out the sociological difference does not take the place of interpretation. On the contrary, only close interpretive attention can determine whether and how the otherwise determining instance of the medium has or has not been suspended. Cee-Lo Green and Bruno Mars, both prodigiously talented, occupy the same cultural field and sometimes employ superficially similar procedures. But only one of them, so far, makes music that rewards attention to its immanent purposiveness.

There is a limit to what can be said in advance about the ways in which artworks successfully suspend their commodity character. The only way to demonstrate the autonomy of art from its commodity char-

acter is to catch it in the act—that is, plausibly to ascribe meaning to actual works, an ascription that is itself a claim that the work in question belongs to the institution of art. The only way to make such an ascription compelling is through close interpretive attention. This book is devoted to exploring, by way of close attention to existing works, a few of the ways the commodity character of the artwork is in fact suspended. Two strategies, however, stand out as following directly from the foregoing. The first is what one might call, in search of a better term, "positive historicism," as a necessary logical advance from Jamesonian null historicism or pastiche. As long as an artwork is making a claim to be an artwork—as long as the institution of art persists, even if only as a claim made by or of an artwork that it is interpretable—the very heteronomy proclaimed by historicism can only be the appearance of heteronomy: the disavowal of autonomy and the claim to be art cannot coherently be made of the same object. The "grab bag or lumber room" is then only an apparent grab bag or lumber room; it is, in fact, governed by a principle of selection. If it is an actual grab bag or lumber room, it is the Internet or an archive or a mall or a television channel or simply everyday experience itself, and we do not need artists for those. As a disavowed principle of selection it may be weak or inconsistent or merely personal, but from disavowed principle to conscious principle is but a tiny Hegelian step, and weak or null historicism (Mars) turns into strong or positive historicism (Cee-Lo).[36] In this case the legible element of form, its meaning—the moment of immanent purposiveness—lies not in the formal reduction of an art to the problem of its medium but in a framing procedure, in the selection of a particular formal or thematic problem as central and the rewriting of the history of the medium or genre or even sociocultural aesthetic field as the history of that problem. We return to this possibility in more detail in chapter 3.

A second possibility, which bears a family resemblance to the first but is closer in structure to Fried's version of the problem than Jameson's, is the aestheticization of genre. In a recent discussion, David Simon, the creator of the television show *The Wire*, points to genre fiction as the one place where stories other than the now-standard character-driven family narratives of contemporary high populism can be reliably found.[37] Why should genre fiction be a zone of autonomy? A commercial genre—already marketable or it would not be a genre—is also governed by rules. The very thing that invalidates genre fiction in

relation to modernist autonomy—"formulas," Adorno called them—opens up a zone of autonomy within the heteronomous space of cultural commodities, allowing the commodity character to be addressed as an aspect of the material support. The requirements are rigid enough to pose a problem, which can now be thought of as a formal problem like the problem of the flatness of the canvas or the pull of harmonic resolution. "Subverting the genre" means doing the genre better, just as every modernist painting had to assume the posture of sublating all previous modernisms. Dressing up the genre in fine production values, embellishing it with serious or local content, abandoning it in favor of arty imagery, borrowing its elements for effect, meandering into other genres or into other kinds of narrative—all of these are, on the contrary, mere attractions, excuses for the enjoyment of the genre itself (which needs no excuse), and therefore confirm the product as a commodity like any other. Producing the genre as a problem to which the work represents a solution involves, by contrast, an essentially deductive approach to the given form: the genre appears as a pure given that has to be successfully confronted, such that the support—in this case, the commodity character of the work—can be acknowledged and overcome in the same gesture.

The material support—the canvas as much as the commodity character—cannot, of course, be made to disappear without the work of art itself disappearing. We return to the ways this seeming paradox can be overcome in chapter 4. But Alfredo Volpi's 1958 *Composição* (plate 1) is a different kind of demonstration that the material support can be acknowledged and its determining instance suspended at the same time. The dark tetragonal figure is rigorously deduced from the square shape of the canvas itself, of which it is a torsion. The lower left corner of the tetragonal figure coincides with the lower left corner of the painting. The figure's upper left corner sits directly above its lower right corner; each is placed along an edge of the canvas, and both are placed one-quarter of the width of the canvas from its left edge. The final, as it were unattached, corner of the dark tetragon is placed one quarter of the height of the canvas from its top edge, and centered left to right. This by no means exhausts what one can say about the painting, which bears on color, figure and ground, matter and paint, illusion and abstraction. But the point for now is that while the dark tetragon is deduced from the shape of the canvas, it would make no sense to say

it was caused, produced, or even generated by the shape of the canvas. The shape of the canvas is rather invoked by the tetragonal figure. It is only through the dark tetragon that the square canvas ceases to be the arbitrary, external limit that it in one sense is, and comes rather to make sense, to appear as posited by the shape it contains.

The chapters that follow trace successful attempts to confront the commodity character of the artwork in five media: photography, Hollywood film, the novel, popular music, and television, organized more or less according to the degree to which the medium under discussion appears immediately as a commodity. The ensemble is intended as a rough sketch of what a system of the arts would look like if it were oriented toward the problem that the anonymous market, both as the real and the projected horizon of interpretation, poses for meaning. But since the claim these works make is precisely that medium as a determining instance (including the commodity character as an aspect of medium) is indeed suspended, each chapter begins with a close reading of an artwork whose formal solution bears on the discussion to follow while emerging in another medium altogether. The chapter on photography and movies begins with a novella; the chapter on the novel begins with sculpture; the chapter on music begins with drama; and the chapter on the television police procedural begins with art film. While the whole is thus intended to present a kind of totality, it is meant not to be exhaustive but, rather, to map a space of possibilities. Other possibilities have no doubt already emerged and will continue to emerge. The wager of totality is simply that a new logic could take its place among these, whose constellation it would reconfigure but in relation to which it would not appear alien.

"SOCIAL ONTOLOGY" IS A PARADOXICAL FORMULATION. On one hand, immanent purposiveness is what specifically differentiates the work of art from other kinds of entities. It is a fact about the work of art, a fact in whose light the existence of the artistic and hermeneutic disciplines as we know them makes sense. On the other hand, it is a contingent fact. The claim that artworks in the modern sense are particular kinds of things has nothing to do with the claim that a Greek temple at Paestum obeys the same social logic as a painting by van Gogh. Robustly historicizing the emergence of the work of art as a particular kind of

thing would take us far beyond the scope of this book. Nonetheless, it is worth remembering that Hegel considered the work of deducing the "true concept of the work of art" to have been begun by Kant's *Critique of Judgment* in 1790 and completed by the time of Hegel's lectures on fine art in 1823, and he would have said the same thing in his 1818 lectures on the same topic. Notwithstanding crucial corrections, elaborations, and historical developments, the broad outlines of the concept of the artwork that renders our contemporary practice coherent—the concept of art that explains the fact that we do, even when we imagine ourselves to be arguing for their ordinariness, talk about works of art as things to be interpreted—was developed in a period of less than thirty years, from 1790 to 1818.

The development of actual works of art as self-legislating artifacts is a much more complicated story, progressing in fits and starts, discontinuous across artistic fields and national and cultural histories, sometimes appearing to emerge full-blown in the most diverse circumstances, only to disappear again, apparently without issue. For this reason, the history of art can be pursued all over the globe and to an arbitrarily distant past. Nonetheless, its explicit, self-relating existence, as opposed to its more sporadic, implicit existence in the historical record, dates, almost tautologically, from the same historical moment: Germany in the shadow of the bourgeois revolution. Lukács's writings on Goethe, Schiller, Hölderlin, and the young Hegel are still the most sensitive explorations of the politics of this historical period, characterized above all by the uncomfortable accommodation of revolutionary ideals inspired by the French Revolution to a consolidating bourgeois order.[38] Schiller, with his feverishly ambivalent politics, at once at the vanguard of poetic practice and a crucial though unsystematic theorist of art, is probably the best example.[39] Works of art, born in their unemphatic alterity to the bourgeois order from the ashes of revolutionary desire, are, under capitalism, a peculiar sort of thing: entities that call for judgments that submit neither to inclination nor to adequacy to external concepts. This is as true in Lagos in 1964 as it is in Jena in 1794, but not under any possible circumstances: only in societies where judgments unfold between the state and the market. During genuinely revolutionary moments within modern history—moments when alternatives to the state and to the market were felt to be inchoate in changing social relations and emerging counterinstitutions—culture could flourish without the

conceptual armature of the self-legislating work. We will return to this possibility shortly, but it has little practical significance today.

What does have significance today is the widespread understanding either that the ontological difference of the work of art is at an end or that it was nothing but a mystification in the first place. These are the genus of which the claim that art is or should be a commodity like any other is a species. Such claims, made coherently, are claims about the end of art, and, whether they are coherently made or not, we have seen that they are today thoroughly conformist. The point would not be that such claims have not been made in other periods than our own but that they have become our common sense. But because such claims (made coherently or incoherently, historically or ahistorically) are our common sense, they can be rejected but not ignored.

From the standpoint being elaborated here, Peter Bürger's argument in *Theorie der Avantgarde*, properly historicized, would be largely uncontroversial: "It has been determined that the intention of the historical avant-garde movements was to destroy the institution of art as something withdrawn from practical life. The significance of this intention is not that the institution of art in bourgeois society was indeed shattered, and art thereby made over without mediation into practical life itself. Rather, it is that the weight of the institution of art in determining the real social effect of the individual work was made apparent."[40] Writing "after the events of May 1968 and the failure of the student movement in the early seventies," Bürger analyzes the historical vanguard from the standpoint of its failure, a perspective that produces a powerful framework for understanding both late modernism and the institutional pseudo- or neo-vanguards of the late twentieth century.[41] But we must now consider the vanguardist position from the standpoint of its success.

While the liberatory intention behind the smashing of institutions was not realized, the discrediting of autonomous institutions or universals is a central feature of contemporary social life. The historical relationship between the spirit of 1968 and contemporary market ideology is, like other possible genealogies of the present moment, beyond the scope of this book.[42] But in societies like ours, an anti-institutional impulse without an organized social basis of its own (i.e., without real changing social relations and emerging counterinstitutions) can only tend to clear ground for the existing social basis—namely, capitalist market

relations, a fact that breaches self-consciousness in the affirmations of the commodity character of the artwork with which we began. Only in the soil of an emergent alternative to capitalist society, in other words, does heteronomization hold out any liberatory promise. If that possibility disappears—or was never present in the first place—then the heteronomous intention can result not only in the contradiction-ridden pseudo-heteronomy of the institutionalized vanguard (Bürger), but also in the nonart heteronomy of the art commodity.

Bürger's account of Brecht is illustrative of the difference this new standpoint makes. In Bürger's account, Brecht represents a positive anomaly, since Brecht was intent not on destroying the theater apparatus but, rather, on repurposing it. This much is surely true, but the conclusion Bürger draws from it is not ultimately supportable, for the problem Brecht confronts is not that of an autonomous institution insulated from the practice of life, but of an institution that has become an industry and as such is no longer in any meaningful way insulated from the practice of life. Even escapism, as a commodity, is directly social. While the determining instance of the institution is clearly marked as a concern, the determining instance of the market is, for Brecht confronting the theater as he found it, prior to it. Brecht's contemporary relevance does not derive, then, from the attempt to preserve a zone of institutional autonomy while paradoxically addressing that zone to heteronomous ends (Bürger). Instead, as chapter 3 shows more clearly, it derives from his often successful attempts to produce from within a heteronomous zone of commodity production a universally legible moment of autonomy.

What, after all this, is autonomy? As it is understood in this book, autonomy is not a metaphysical independence from external circumstances, an independence that would be awfully hard to explain. Autonomy—"negativity," in Hegel's idiolect—instead has to do with the fact that precisely those external circumstances are actively taken up by us in ways that are irreducibly normative. A putatively materialist slogan has it that "matter matters." Indeed it does, but mattering is then a matter of relevance—that is, mattering is not itself material but, rather, a question of judgment. As Hegel was fond of pointing out, since "matter" as it is deployed in theoretical disagreements is itself an idea, there is nothing in the name "materialism" that distinguishes it from idealism. Idealism

always seems to sneak back in the end—but, in fact, something was always normatively in play from the beginning.

While interpretation is a spontaneous, everyday activity, the discipline of interpretation is not. To claim that something is a work of art is to claim that it is a self-legislating artifact, that its form is intelligible, but not by reference to any external end. Since it is fundamentally true of artworks that their contingent material substrate is legible as being uncontingently assumed—that is what it means to be self-legislating—works of art are sites at which some of the most controversial claims of the dialectic are thematized as holding sway. The claim that matter is never just matter but is instead always actively taken up in particular ways is not one that will stand without a good deal of discussion; the claim that, in a work of art, matter is never just matter but is instead always taken up in particular ways is uncontroversial. (It would be not the basis of a substantial philosophical disagreement but obviously silly to insist that the cellophane-wrapped candies that constitute Felix Gonzalez-Torres's *Portrait of Ross in L.A.* were nothing more than candies, or that their material qualities—weight, sweetness, consumability—mattered in any other way than the ways in which those qualities are activated by the work itself). Immanent critique does not get you very far in chemistry or Congress. But it is perfectly naïve and perfectly correct to pose the question of a work of art as whether it fulfills the ambitions it sets itself. Trying to figure out whether a work succeeds is inseparable from the process of trying to figure out what it is trying to do. The discipline of interpretation is then the practice of discovering and applying these internal norms. The literary disciplines parochially refer to this practice as "close reading," but "close" is only a metaphor that has more to do with the attempt to approach a work in spirit than necessarily with an attention to fine detail. Since there is no external criterion, the discipline of interpretation is not a search for certainties but, rather, a shared (one might say normative or institutional) commitment to the production of compelling ascriptions of meaning. Such ascriptions are always open to dispute; the evidence is always available to anyone.

But such disagreements can take place only if there is something normatively in play. The existence or legitimacy of such a normative field—of meaning as what is posited, in the act of interpretation, as

what is at stake in interpretation—was the target of the most self-consciously advanced theoretical work of the last third of the twentieth century, and such skepticism remains hegemonic, if more habitual than provocative, at the beginning of the twenty-first. Taken up as a kind of test, such challenges are entirely a good thing. This book is largely conceived as a response to such testing, as an attempt to show that commitments that are, however contingently, nonetheless in place and that artworks constantly invoke—commitments on the basis of which works of art are possible—make sense only if we accept some version of aesthetic autonomy. This recognition necessarily involves disagreements with, among others, literary sociologists and literary neuroscientists, speculative realists and new materialists, distanced readers and surface readers, Althusserians and other Spinozists, affect theorists and liberal champions of the arts.

While the claims being made here primarily have relevance to the hermeneutic disciplines, they have political implications. The charge of elitism, for example—the class stratification of aesthetic response—accrues to the claim to universal heteronomy rather than to autonomous art. If nothing essential distinguishes between art and nonart, the only distinction left—and some distinction is necessary for the word "art" to have any referent, not to mention to populate the institutions that still exist to preserve, transmit, and consecrate it—is between expensive art and cheap art, or art whose means of appropriation are expensive or cheap to acquire. (Rather than affirm emphatically the status of the work of art as nothing more than the luxury good that it undoubtedly also is, it would be prettier to claim heteronomy as a critique of autonomy. But this would mean affirming a meaning, and as we have seen, this would necessarily entail a claim to autonomy from the market even as that claim is disavowed.) The distinction between art and nonart is therefore not a class distinction. A time-travel narrative can have only one of two endings: either history can be changed or it cannot; *Back to the Future* or *La jetée*. The problem of the time-travel film is how to keep these two, incompatible possibilities in play until the end—and, if possible, even beyond the end, so there can be a sequel. Because of this found, generic logic, James Cameron can produce a solution to the problem of the time-travel film that at the same time produces the time-travel film as the problem to which the solution responds. That is, Cameron can produce a film whose formal qualities can be understood to derive their

coherence from possibilities immanent to the logic of the genre rather than by demands attributed to consumers, and *The Terminator* can be a work of art while *Avatar* is only an art commodity.

Further, under contemporary conditions, the assertion of aesthetic autonomy is in itself a political assertion. (A minimal one, to be sure.) This was not always the case. In the modernist period, for example, the convincing assertion of autonomy produced, as it does now, a peculiar nonmarket space within the capitalist social field. But there is no natural political valence to modernism's distance from the market, since modernism does not make its way under anything like the dominance of market ideology that we experience today. Indeed, autonomy from the state and state-like institutions is often the more pressing concern.[43] (It was also easier to confuse personal with aesthetic autonomy. Today their opposition is clear. Autonomy, which can be asserted only on the terms of an existing normative field—an institution, apparatus, or social machine—has nothing to do with freedom or creativity. Outside of a claim immanent to the work itself, the assertion of autonomy is advertising copy.) Modernism tends to be hostile to the culture market, but all kinds of politics (Heidegger as much as Adorno) are hostile to the market. Indeed, Lisa Siraganian has suggested that underlying the panoply of modernist radicalisms is nothing other than a deeper commitment to classical political liberalism, to a zone of deliberative autonomy.[44] Modernist hostility to the market acquires a definite political valence only after modernism, when the claim of the universality of the market is, as it is today, the primary ideological weapon wielded in the class violence that is the redistribution of wealth upward. The upward redistribution of wealth in the current conjuncture would be unthinkable without this weapon. The entire ideology of our contemporary moment hinges on the assertion that this redistribution is what a competitive market both produces and requires as a precondition.

But capitalism is a mode of production, not an ideology, and it is entirely likely that this upward redistribution and its ideological justification are symptoms of a deeper crisis in the value form itself. It may be, in other words, that capitalism is no longer capable of producing a mass of value sufficient to satisfy the social demands normalized during an earlier stage of development, and that no amount of ideological work will render those demands achievable.[45] That would be no reason to stop making such demands, since capitalism's inability to meet them—as

a historical outcome rather than as a theoretical postulate—would itself be instructive. But the ideological force of the autonomy of the work of art is not that it returns us to these sorts of demands, but that it makes a demand of an entirely different nature. As we have seen, the mode of judgment peculiar to commodities is private, particular, and segmented by its very nature. The mode of judgment peculiar to the work of art, however, is subjective but universal. In other words, the mode of judgment appropriate to artworks is public and structured by disagreement rather than stratified by class or particularized in different bodies and identities. If the response to works of art is, in fact, deeply stratified (as it is for science, as well), this owes nothing to the concept of art and everything to a society that accords the luxury of de-instrumentalized knowledge to only a very few. What the concept of the work of art demands, then, is not only universal access to a good education, a demand often enough made but perhaps not realizable in societies such as ours. Rather, it demands the de-instrumentalization of education itself, a demand that is certainly not realizable in societies such as ours, whose educational systems are geared toward producing workers at the increasingly polarized skill levels that the economy requires. That such a demand is unrealistic is not a critique of the demand but, rather, a rebuke to the conditions that make it so. As long as the pursuit of noninstrumental knowledge is reserved for only a few, the directly humanistic noises we make about it are vicious mockeries of themselves. But the degree to which we no longer make them reveals the degree to which we have stopped pretending our societies are fit for human beings.

The claim that the work of art is or is not a commodity is not an analogical or figural claim: everything is like or unlike anything else in some way. The work of art is not like a commodity; it is one. (Nor are the cognate claims for the submission of meaning to the spectator merely similar to the claim that the work of art is a commodity like any other. They are, rather, members of the same genus.) The question is whether the work of art is a commodity like any other or whether it can, within itself, suspend the logic of the commodity, legibly assert a moment of autonomy from the market. If the claim to autonomy is today a minimal political claim, it is not for all that a trivial one. A plausible claim to autonomy—to actions ascribable to intention rather than to causal conditions—is in fact the precondition for any politics at all other than the politics of acquiescence to the status quo.

How, then, does one account for what appears, paradoxically, as the contemporary will to heteronomy? Any act, no matter how intentional, is conditioned by innumerable processes to which it is heteronomous, and has innumerable effects that are not intended. When one begins to tot up and name these processes, from the laws of physics down to evolutionary biology, political economy, and institutional systems, not to mention the aleatory (which is only a way to say untheorized) confluence of all these, the preponderance is, by a vast margin, on the side of heteronomy. And yet. Hegel's absolutization of autonomy in the *Phenomenology of Spirit*—"the enormous power of the negative, the energy of thought, of the pure I" (36/§32)—hardly takes place in ignorance of this fact. On the contrary, the *Phenomenology* repeatedly thematizes the contradiction between intention, on one hand, and its conditions and effects, on the other. Indeed, nothing can be more banal than this contradiction, which no theory of intentional action can be unaware of. The question is one of standpoint: is a particular action to be understood in terms of its heteronomy to external processes or its autonomy from them?

A dialectical account, as this one is intended to be, encompasses both of these standpoints. In Marx's polemics against idealism, largely written when he was in his mid-twenties and the "Young Hegelians" were achieving notoriety, what he criticizes under that banner is the division of intellectual (*geistige*) labor from material labor, such that the former consequently "appears as something separated from common life, something extra-otherworldly."[46] In place of this, Marx offers the proposition that "people are the producers of their conceptions, ideas, and so on, but they are actual, active people, conditioned by a definite development of their productive forces" and relations of production.[47] The target of Marx's criticism is thus the attempt to understand the ways in which the world is taken up without a consideration of the world that is taken up: a Hegelian point, it must be said, even if Hegel, who was concerned to show that consciousness was an active rather than merely receptive capacity, gave some of his posthumous followers on the left in the 1840s reason to understand otherwise.

But non-Marxist "materialism" only makes the same mistake from the other side. Marx's critique of materialism during this period is, therefore, the same as his critique of idealism: "The chief defect of all materialism until now . . . is that things, actuality, sensuousness, are only taken up in the form of objects or representations, but not as

sensuous human activity, as practice; not subjectively."[48] If Marx's criticism of the Young Hegelians is that they are insufficiently materialist, his criticism of materialism is that it is insufficiently Hegelian. In a letter well known in this context, written to Ludwig Kugelmann in 1870—that is, three years after the publication of *Capital* and at a time that the hegemony of Hegelianism had definitely passed—Marx writes, "Lange is so naïve as to say that I 'move with rare freedom' in empirical matter. He has no idea that this 'free movement in matter' is nothing other than a paraphrase for the *method* of dealing with matter—namely, the *dialectical method*."[49]

Hegel's privileging of autonomy within this dialectic is a political claim; it cannot be understood outside of the possibility raised by the French Revolution (viewed with intense interest but from afar and in relatively backward political and economic circumstances) of a human collectivity consciously making its own history. The point about Hegelian autonomy is not that it underestimates heteronomy but, rather, that conditions, without ceasing to be genuinely determining, are understood to be subsumable under the standpoint of autonomy. It is as though one could choose to take a step in such a way that one at the same moment chose the law of gravity, the mass of the Earth, the articulation of one's limbs. If this is dance, it is also politics. The conditions in which one acts are not of one's choosing. But politics means not wishing for or waiting for or imagining other conditions, tendencies that are abundantly celebrated by today's intellectual left—think of the protagonist of Ben Lerner's *10:04* (to which we turn in a later chapter), an avatar of contemporary left stoicism, who spends the entire novel catching glimpses of a world just like ours but also magically "before or after" capitalism. Politics requires choosing to intervene in the conditions that exist; in effect, choosing that about which one has no choice. *Hic Rhodus, hic salta*. In describing Hegel's elevation of autonomy as conditioned by the necessary illusions of German radical democrats at the turn of the nineteenth century, we have already gone beyond it. But we have also identified its moment of truth, which is that no politics can do without an absolutely minimal moment of autonomy: choosing one's heteronomy to the present or, to say precisely the same thing, taking up the present as a field of action. One has never been astonished to find radical critics of autonomy among partisans of the status quo. What is astonishing is to find them—and to find, what is rigorously the same, those "materialists"

who ascribe agency to what is fully determined—imagining themselves to be on the left.

The work of art also chooses its heteronomy. To be a work of art means to intervene in the institution of art, which is in turn the social basis of the artwork: what makes it count. This point bears emphasizing. Autonomy, as has been suggested, has nothing to do with personal freedom; if it were, it would not be worth discussing. The specific autonomy of art from the market and from the state is fundamentally institutional in character; only by invoking the institution of art—a social machine that includes practices experienced as spontaneous, such as interpretation, as much as organized institutions such as museums, learned journals, academic departments—can the work of art assert its autonomy, which, again, holds sway only within its boundaries in the form of immanent purposiveness. The moment a work of art disavows the institution of art—critique is a form of commitment rather than a disavowal—it becomes absolutely heteronomous to those forces that, for the artwork, hold sway only contingently and externally. "Relative autonomy" has meanwhile always been a phrase without a concept. Absolute heteronomy to the institution of art is a condition of the work's absolute autonomy.

The work of art, then, is not itself emancipatory. Unlike unions or political parties, works of art have no political efficacy of their own. The claim to autonomy is neither a politics nor a substitute for politics. But under current conditions, it has a politics. For Schiller, the aesthetic principle was both a utopian social project (art would educate humanity out of the barbarism of contemporary social relations) and, contradictorily, a compensation for the absence of a utopian social project (art would compensate for the barbarism of contemporary social relations).[50] These positions are as untenable now as they were then. The point is not to make extravagant claims for the social impact of art, in either a radical mode or a liberal one. The point is, instead, to establish the specificity of art and to determine whose side it is on.

Apparently paradoxically, art that bears immediate political messages poses a problem—unless these meanings are mediated and relativized by the form of the work as a whole, which is another way to say unless they mean something other than what they immediately say. First, taken immediately, manifest political intentions open up a chasm between form and content. Artistic means and political ends are separate. If we are

judging the political content, the artistic means appear inessential. If we are judging the form, the political ends appear inessential. Of course, one would like to say that both form and content are essential, since they are inseparable in a successful work. But all that means is that the work calls for close interpretive attention, and in that case, immediate political messages are a red herring. Second, a message is an external end. Once again, an external end is a use value; use values, in societies whose metabolism takes place entirely through the exchange of equivalents, are immediately subject to the logic of consumer sovereignty. Immediate political messages do not succeed or fail the way artworks do. Instead, they are popular or unpopular in one market or another, the way shoe logos are. When it means simply what it says it means, political art does not mean anything at all except to the person consuming it.

All this should not be taken to suggest that artworks are restricted to the purely formal politics of the artwork as such that has been outlined in the past few pages. If that were the case, there would be little point in discussing individual works, which would all end up saying the same thing. The point, instead, is that the inseparability of form and content is an internal criterion that saves the politics of individual works from being mere expressions of the opinions of their creators. The moment a meaning, political or otherwise, is seen to emerge from the brain of the artist, it ceases to compel: you find it congenial or you do not, which is a way to say that it might as well have emerged from the invisible hand of the market. While the cynicism of craft sometimes produces something worthwhile, sincerity as an attribute of the artist rather than of the art is indistinguishable from cynicism. As we shall see in the next chapter, the antiracist politics of J. M. Coetzee, the feminist politics of Cindy Sherman, the class politics of Jeff Wall, and the culture-industry critique of Alejandro González Iñárritu are compelling only, and precisely, because they appear to emerge as if unbidden from the material on which these artists work.

In moments of genuine political upheaval, the unemphatic negativity of the work of art will come to seem decadent compared with the project of constructing a world without hunger and without police, and this is how we should understand the impatience of the historical avant-gardes with the institution of art, which they set out to destroy. Think, for example, of Ferreira Gullar, the great theorist of the Rio school of Brazilian Concretism in its high-modernist phase, who in the run-up to

Brazil's failed revolution quite reasonably suggested that the concretists should stage a final exhibition in which they destroyed all their existing works—a position he later, and again quite reasonably, revised.[51] In the light of the political and cultural institutions, alliances, and forces coalescing around him in the early 1960s, Gullar could state, with some historical justification even in hindsight, that the "popular culture" that was to replace the self-overcoming, autonomous field "is, more than anything else, revolutionary consciousness."[52]

To believe the same today is madness. Absent such upheaval, impatience with the unemphatic alterity of the institution of art, as we have already suggested, switches polarity. The neo-avant-gardes of the late 1960s and after, with their period insistence that institutions as such are "ideological state apparatuses," array themselves against the state and the institution of art alike. But in the end, falling prey to a ruse of history, they only expose their contents to (both real and imagined) subsumption under the commodity form. The standpoint of the critique of the commodity form, however, produces an account of the aesthetic that is coherent with its concept. This should come as no surprise, since the aesthetic itself—the institution of art, understood not in a purely sociological sense but also as a set of normative commitments under which artworks are possible—is produced alongside capitalism as its unemphatic other. The point of this book is not that aesthetics has anything to teach Marxism, but that Marxism has something to teach aesthetics.

1 Photography as Film
and Film as Photography

J. M. Coetzee's first published work of fiction, *Dusklands*—published in 1974, the year Jeff Wall would later proclaim was "the last moment of the pre-history of photography as art"—consists of two novellas whose thematic relation to each other, while not immediately obvious, is not that interesting once we do figure it out. We are to understand *Dusklands* as allegories of the West as *Abendland*.[1] What ties them together more interestingly is a formal symmetry. Each novella deliberately and violently breaks the continuity of the narrative surface with a single metatextual gesture. In "The Vietnam Project," the protagonist narrates in the present tense his own loss of consciousness. "A convention," he writes, "allows me to record these details" (44). At the core of the formally more ambitious second novella, "The Narrative of Jacobus Coetzee," is a first-person narrative of an exploratory raid by Jacobus Coetzee into Namaqua territory, translated from the Dutch by J. M. Coetzee. The novella includes an appendix purporting to be the "Deposition of Jacobus Coetzee," who was indeed a historical "pioneer," with all the ambivalence residing in that word. But the "Narrator" (134) of the dictated deposition signs the document with an "X," suggesting that

he is illiterate. Only on the very last page of the novella are we certain that what we have been reading in this first-person narrative are entirely someone else's words. Between Jacobus Coetzee and J. M. Coetzee stands J. M.'s fictional father, S. J. Coetzee, who is said to have given "a course of lectures on the early explorers of South Africa . . . between 1934 and 1948" (59). The dates are carefully chosen to bracket the rise of the National Party, which would begin to implement apartheid in 1948. Thus, there is little question with what kind of salt we are to take S. J. Coetzee's version, whose sources presumably include Jacobus's three-page deposition but are otherwise obscure. S. J. has followed Jacobus's footsteps and undertaken a kind of popular-historical account of the journey but presents it as an "Afterword" and describes himself as an "editor" of a source text that is possibly, within the fiction (and certainly, outside the fiction) "a positive act of the imagination" (116).

As described thus far, "The Narrative of Jacobus Coetzee" is architecturally dense, but its multiple framing is not obviously different in kind from recognizably modernist framing structures. The outermost frame is J. M. Coetzee; the middle frame is S. J. Coetzee; at the heart of the narrative is Jacobus Coetzee. All three, as far as the structure of the novella is concerned, are fictional, even if two share names with real people. One of the classically modernist functions of the frame was to separate out standpoints of enunciation: in Conrad's *Heart of Darkness*, we encounter three distinct versions of imperial ideology, each emerging from a distinct position in social space and a distinct narrative level. Here, too, we encounter three distinct ideologies—the old explorer's, the nationalist ideologue's, and the modern translator's—but in the central narrative it is impossible to separate out distinct narrative levels. Is an unmarked, maladroit citation of Marx (92) the translator's irony at the ideologue's expense, or the ideologue's irony at Marx's expense, or is it, rather, the translator's lucky find, attributable in some form to the explorer himself? A reference to Borges seems most easily attributable to the translator and cannot belong to the explorer as a reference. But is the Borgesian dream that prompts it dreamed by the explorer, invented by the ideologue, or embellished by the translator? And so on. But the point is not that these ideologies are indistinguishable—each possible reading is in fact distinct—but that the texts that they inhabit are indistinguishable, in fact, unitary: a Borgesian point, it must be said, rather than a distinctively Coetzeean or meaningfully postmodern one.

At a certain point, Jacobus Coetzee's faithful servant Klawer is swept away by the current during a difficult river crossing, going "to his death bearing the blanket roll and all the food" (100). In the next sentence, however, Klawer is alive—though not for long, as he survives the river crossing only to be abandoned dying of a fever a page later. There is no way to understand this doubled death diagetically—there is no standpoint or movement between standpoints from which Klawer appears to die twice. Nobody is hallucinating, nobody is mistaken, nothing magical has happened. Rather, Klawer's two deaths have to be seen as taking place at the scene of writing itself—successive drafts, discrepant versions, embellishment by one of the authors, a spiteful "restoration" by the translator. As Coetzee (the real Coetzee, or as real as one can be in an interview) puts it, "All one is left with on the page is a trace of the process of writing itself."[2] Such metafictional games have by now a decidedly period flavor, as Coetzee already foresaw: "Anti-illusionism—displaying the tricks you are using instead of hiding them—is a common ploy of postmodernism. But in the end there is only so much mileage to be got out of the ploy" (27).

However, there are two things to note beyond this first approach. First, what we find in "The Narrative of Jacobus Coetzee" is nothing like the trace of the actual process of writing "The Narrative of Jacobus Coetzee." The metafictional break destroys the illusionism of the Jacobus narrative (already stretched to the limit in other ways) but draws our eyes to the other fiction—namely, the narrative of the three or more authors and the ideological and historical conflicts among them. The result is a peculiar sort of historical novel that imbues its narrative contents with the ineluctably ambivalent ideological valences of settler exploration through formal rather than narrative means. The nationalistic account of the heroic explorer as a law unto himself cannot obscure his genocidal monstrousness, and the critical account of the same figure cannot quite manage to obscure his heroism—a dialectic as familiar to the Schiller of *Die Räuber* as it was to the Brecht of *The Threepenny Opera*.[3] The second thing to note is that Coetzee's procedure in these novellas in no way marks a radical break in the novelistic tradition.[4] If, as Alain Badiou suggested in an early essay, the novel as a form is characterized by the thoroughgoing "inseparability" of all the statements it contains—the immanence of all of its viewpoints to the narrative space of the novel—then the source of its language is going to pose a formal

problem that must be suppressed, evaded, or confronted.[5] In certain novelists with whom Coetzee has engaged extensively—Ford Madox Ford and late Beckett among them—the problem of plausible narration, no longer of secondary concern to the problem of plausible narrative, is experienced as a kind of crisis. The narrator of Ford's *The Good Soldier* anxiously preempts the reader's question, "You may ask me why I write"; Beckett's *Worstward Ho!* virtually abandons the plane of the narrative for that of narration—but not quite, as the anxiety registered at the level of narration concerns the legitimacy of the narrative: "It stands. What? Yes. Say it stands." "It stands" is the axis of the narrative. "Yes. Say it stands" is the axis of the narration.[6]

"The Narrative of Jacobus Coetzee" in effect produces a solution to the problem by rotating it ninety degrees: the novella is committed to plausible narration without being committed to a plausible narrative. The picture plane, as it were, is for most of the novella understood to be the illusionistic narrative of Jacobus Coetzee, framed by its disseminator and its translator, each of whom is progressively nearer to us the readers, both in time and in narrative space. The moment that illusion is broken decisively, the picture plane flips on its side: there is no illusionistic narrative, only an illusionistic narration, which now occupies the picture plane formerly occupied by the narrative. Despite its destruction of the narrative unity of the Jacobus narrative, then, Coetzee's early metafiction is as committed to formal closure as anything in the novelistic tradition: what is to be read is not Jacobus's journey but the struggle over the meaning of Jacobus's journey. It is only when metafictional technique becomes merely decorative rather than structural—something supplemental rather than something necessary—that Coetzee begins to look postmodern. Mrs. Curran in *Age of Iron*, for example, narrates her own death via the conventions of the epistolary novel, but that does not disturb the sentimental surface of its ethical fable. The later novel stubbornly or lazily maintains its narrative axis at the level of the narrative; the impossible narration just makes it arty.

What is at stake in this distinction? The question is whether *Dusklands* is an artifact that demands close reading, the discipline of interpretation as we developed its concept in the introduction. If *Dusklands* merely, in a playful or apocalyptic mode, stages a surface without a stable meaning (postmodernism as Coetzee seems to have understood

it), or if it, in a seemingly contrary mode, presents us with an extract-able ethical fable (postmodern culture in a more common, everyday guise), it operates in a mode that is fundamentally perpendicular to the plane of the narration. In both cases there is something held out for the reader: an object or what we used to call, after Barthes, a "writerly" text whose meaning lies wholly in its playful appropriation, or a lesson laid over narrative material that is otherwise incoherent. In neither case is there a criterion available by which to judge the work. The third possibility proposed here is that *Dusklands* demands close interpre-tive attention—an activity that takes place along the picture plane, into which axis of narration has now been folded—that it proclaims itself as a self-legislating artifact whose individual moments can be understood only through the form of the whole. In this case, the work of art con-tains its own criterion—namely, the plausibility and internal coherence of the narrative conflict among three historical moments.

In sum, what looks like the exposure of plot to the operation of écri-ture, to use the period term, in the name of an open, un-totalizable text turns out instead to organize itself into a thematization of narrative as a site of struggle. This operation—the foreclosure of immediate appro-priation by a reader, an appropriation we will shortly characterize as theatrical, in favor of a legible demand for close interpretive attention—will, of course, look rather different in art photography or Hollywood film, where the reader is replaced by a beholder or by an audience that is immediately a market. The ways theatrical immediacy can be forestalled in favor of a commitment to immanent form are presumably infinite, but that does not prevent us from seeking out family resemblances. In the rest of this chapter, we will be examining successful attempts to fold the appropriative line from artwork to audience into the immanent structure of the work. The readings are loosely oriented along two axes. Along the first, film and photography each borrow aspects of the other medium—avowed stagedness in Cindy Sherman's and Jeff Wall's work and thematized indexicality in Richard Linklater's and Alejandro Iñár-ritu's—to foreground problems posed by its own. Along the second, film and photography differ in their almost diametrically opposed relation-ships to the market.

Not long after Coetzee published *Dusklands*, Cindy Sherman began producing the series "Untitled Film Stills." The individual images are

easy to like, and just as easy to dislike; it may be that our usual reasons for liking them or disliking them have little to do what they have to say about their medium. Sherman's film stills do not lend themselves to close reading at the level of the individual image, an intuition that is confirmed by the fact that none of the images have individual names. The images add up to something substantial in a way that the individual images do not quite embody. In this sense the existence of the work takes place at the level of the series rather than at the level of the individual picture. But the temptation to relate the images narratively is rejected early on. The first six images are originally conceived as implying an inchoate, inaccessible narrative—the central figure has blond hair in each but otherwise the pictures are not obviously related—but this initial series is quickly broken up, and the first six pictures are not exhibited together. The meaning of the series, then, is not to be found in something exterior to the images, as a story that exists between and transcends them, but is something entirely immanent to them. Not only is it a series, moreover; it is understood as a series that is, in a sense yet to be defined, complete. "I knew it was over," Sherman writes, "when I started repeating myself."[7] A concept is external to its examples, which are contingent and disposable; a genus, however, exists only in and through its species. Like Bernd and Hilla Becher's cooling towers or blast furnaces (figure 1.1), the untitled film stills are meant to be seen as a kind of genus, whose essence or meaning can be approached only through its mode of appearance as individual images.

The genus to which the images belong is, obviously, the film still. But equally obviously, what we are looking at is much more specific than that: images of women (a series of men was started and abandoned), staged and photographed in a way that evokes a set of cinematic conventions whose strongest and most easily legible element (specifically yet, as we shall see, paradoxically vaguely) is Italian neorealism (see plate 2). The crucial question here is whether Sherman is primarily interested in the film still as a form or immediately as a kind of content. Both aspects are essential. But if the content of the film stills is to be taken in its immediacy, we are dealing with a concept rather than a genus. What is exposed is a certain fantasy of the female figure and the camera as the embodiment of the male gaze: far from a trivial issue, but one that exhausts itself in the telling and one that, furthermore, does not fit the facts. The primary fact is that of the closure of the series. If the male gaze were

1.1 Bernd and Hilla Becher, *Water Towers, 1963–1980.* Series of 12 black and white photographs. 68.25 × 75.25 in. SONNABEND GALLERY, NEW YORK. © ESTATE BERND AND HILLA BECHER.

the determining instance, one picture would be enough, and a thousand pictures would not be enough. One would be enough because the male gaze is a spurious universality that subtends all its instantiations; a thousand would not be enough because the movie industry has not failed to invent new ways to frame women as objects. The secondary fact is that of the vague specificity of the neorealist-ish aesthetic: if it is the specific that matters, why choose this specificity when there are plenty of other kinds of images of women out there? If it is the generality that matters, why stick to any specific aesthetic?

If, instead, we look first at the form, we begin to notice what makes the series a genus. First, the figure defines the space rather than the other way around. The mise-en-scène, which at a first glance seems like

a defining aspect of the images, in fact plays an entirely passive role. The woman in a head tie and apron in *Untitled Film Still #35* defines the space around her as domestic (see plate 2); the fact that she is standing on industrial diamond-plate flooring does nothing to dispel that sense. In *Untitled Film Still #4*, a massive exposed beam, which usually signifies, and probably is a real trace of, post-industrial live/work rehab, should comport oddly with the elegant figure slumped against a (hotel room?) door, but instead it recedes into insignificance. In other images, the background is generic (e.g., *#58, #8*), illegible (e.g., *#36*), obscure (e.g., *#5* [figure 1.2]), or restricted to a tiny portion of the picture surface (e.g., *#27* [figure 1.3]). In *Untitled Film Still #10*, no attempt is made to obscure the fact that inside a torn grocery bag are late twentieth-century American groceries. When one thinks of the obsessiveness with which contemporary culture tends to treat period detail—think of a television series like *Mad Men*, for example—one realizes how far historical pastiche is from the point (compare plate 4 and plate 6). There are counter-examples, but they are both rare and some of the least compelling in the series. In *Untitled Film Still #50* (plate 5), for example, the central figure becomes a prop among the others, a signifier like the paired African and modernist sculptures in the background—or indeed, like the Erik Buch stools in Megan Draper's apartment in *Mad Men* (plate 7). The meaning of these images, then, resides in the central figure, which is capable of defining the space that surrounds it.

In his essay "Art and Objecthood" (1967), already touched on in the introduction, Michael Fried famously distinguishes pictorial from theatrical logic. Because it produces an experience that exceeds the object and not a meaning that inheres in the work, theatricality, the production of a kind of experience, is not open to close interpretive attention. Pictorial logic, by contrast, requires that we find the work itself compelling or not—in the case of the shaped modernist painting closest to the minimalism Fried is critiquing, that the work itself "hold" as shape—a criterion that can be invoked only by the painting itself. That is, Fried understands pictorial logic, quite in line with the post-Kantian development of early German Romanticism, as invoking a notion of self-legislating form, such that any particular aspect can be understood only as mediated by the whole. The theatrical, however, appeals immediately to appropriation by the spectator, bypassing the mediation of the whole or, in the case of minimalist sculpture, presenting the aspect of a whole

1.2 Cindy Sherman, *Untitled Film Still #5*, 1977. Gelatin silver print. 8 × 10 in.
COURTESY OF THE ARTIST AND METRO PICTURES, NEW YORK.

without parts. What separates these categories, in terms of the present account, is the difference between two forms of value. An experience is immediately a use value, and therefore in a society such as ours immediately entails the logic of the commodity, the dynamic of uninterpretability described in the introduction. Aesthetic judgment, meanwhile, sets aside use value even if it cannot do away with it.

In the essay, Fried has these astonishing words to say about film:

> There is . . . one art that, by its very nature, escapes theater entirely—the movies. This helps explain why movies in general, including frankly appalling ones, are acceptable to modernist sensibility whereas all but the most successful painting, sculpture, music, and poetry is not. Because cinema escapes theater—automatically, as it were—it provides a welcome and absorbing refuge to sensibilities at war with theater and theatricality. At the same time, the automatic, guaranteed character of the refuge—more accurately, the fact that what is provided is a refuge from theater and not a triumph over it, absorption not conviction—means that the cinema, even at its most experimental, is not modernist art.[8]

1.3 Cindy Sherman, *Untitled Film Still #27*, 1979. Gelatin silver print. 10 × 8 in. COURTESY OF THE ARTIST AND METRO PICTURES, NEW YORK.

Astonishing because nothing could be more theatrical than the movies. Extra-diegetic music, expository camera work, editing as a pacing technique, mise-en-scène, the studied attractiveness of the leading actors, seemingly sophisticated touches such as references to the history of film or of the genre, seemingly vulgar ones such as gore or explosions, even plot in the sense of something whose effect can be spoiled by revealing it—all of these are naked attempts to produce directly, theatrically, a certain effect for a spectator. Of course, one also sees the truth of what Fried is saying, and it is a truth that goes back to Walter Benjamin's discussion of film acting. Inasmuch as the film apparatus imposes its own invisibility, film does not need to efface its own stagedness—indeed, it must go to extraordinary lengths to produce it. (Think of the opening scene of *Day for Night*.) Since, further, the apparatus always directly mediates all aspects of the film, filmic meaning can bypass acting altogether: a reaction shot can use footage unrelated to the action, and so on. Film is nontheatrical (but not antitheatrical) when all of its nakedly

theatrical elements are set aside—that is, film is nontheatrical when it is thought of as a sequence of still images.

Sherman's film stills are, of course, a version of film as a sequence of still images. But they are a fictional version: as we shall see, they are no longer nontheatrical, but antitheatrical. Nontheatricality in film is a function of the fact that the conventions of film acting insist on the fiction that the camera does not exist. Paradigmatically, the projection of a character's meaning in film acting is parallel to the picture plane. Characters are behaving for other characters, not acting for us, and the unremitting possibility persists that what the camera captures and makes expressive is in excess of the actor's intentions. In Sherman's untitled film stills, nothing that counts is in excess of the artist's intentions, and there is no one else in the picture plane, which cannot be thought of as other than posed for us. How are we then to read these images?

Let us turn to one of the first ones, *Untitled Film Still #3* (plate 3), somewhat arbitrarily chosen but representative, in detail. A woman stands before the sink in a modest kitchen—the plain wall behind and the shelves made of plywood comport tolerably well with the woman' simple dress and her frilly but inexpensive-looking apron. She has apparently been interrupted, or has interrupted herself, in the middle of doing dishes. All of the straight lines in the picture—shelves, pot handle in the foreground, dish rack—converge on the woman at the sink, whose attitude is defined by the angle between her left arm, which bears some of her weight and cuts almost all the way across the picture from bottom to top, and the tilt of her head as she glances back and to the left. Her right arm is folded across her midriff. The glance itself, awkwardly cropped in a way that emphasizes the picture's rhetoric of instantaneousness, is both the focus of the picture and unreadable. One cannot tell whether the glance is reciprocal or she is observing something; there is something guarded in the glance and in the way she holds her right hand over her midriff, but her pose is not defensive. Her left arm bears her weight in a way that suggests that she is at ease.

We can try to emplot this image, to guess at what happens in the previous frame or the next one, at who or what lies outside the frame. But there is no plot—we can come up with an arbitrarily large number of possible plots, none of which has any necessary relation to the picture— and there is nothing outside the frame. As soon as we try to emplot these images, we have missed the point of their stillness. The woman wears

makeup, and her hair, mostly cropped out of the image, appears to be carefully done. We are dealing with a certain feminine ideal: a woman performing a humble domestic task but, at the same time, wearing a mask of femininity. (Her apron embodies the same contradiction. Why should an apron, an item of workwear, be frilly?) But the rhetoric of the picture—and this is the point of its being a film still and the point of its being set in some not-quite-definite past—is that she is not wearing the mask for us. She is in a film still, which means the mask is put on for someone else, someone outside the frame.

So far, so filmic. But even the fictional film is not staged for us. The picture's actual beholders are not paradigmatically male, and for those who empirically might plausibly embody the male gaze, the figure displayed in the picture is no longer a representation of their projected fantasy figure; it is a palpably dated one. (The point is not that these images could not contingently appeal to a beholder on the basis of his or her fantasy, but that, since this is contingent, the images cannot be taken as a critique of the viewer's gaze in general.) This blunts the force of an otherwise attractive, immediately feminist reading of the pictures even as it brings the way the pictures work into focus. The implied gaze for whom the woman puts on makeup is, as in the movies, contained within the space implied by the picture. But beyond this, the audience— not the empirical beholder, but the audience implied by the picture, the gaze for whom the image is, in the fiction of the film still, set up—is and can only be a function of what we find in the pictorial space. as well. The line between the image and its beholder, a line that should extend directly out to the actual beholder of the image, in effect has been rotated ninety degrees. It is now part of what is exhibited within the image itself.

The dominant motif of these pictures is the unreadability of the depicted female figure, which, though marked through and through by a certain period femininity, is nonetheless "captured" in a moment of illegibility. Even when the figure seems clearly to be exchanging glances and, as in *Untitled Film Still #5* (see figure 1.2), appears even to be on the verge of speech, the dominant impression is one of inwardness. (The airmail letter the figure holds, which is facing toward her and away from us, confirms this impression.) The content of these images lies, that is, in the excess of subjectivity over the masks that it assumes—"the enormous power of the negative, the energy of thought, of the pure

I"—the nonidentity of consciousness with the conditions that otherwise determine it.[9]

In what he intends as a feminist meditation, Theodor Adorno writes, "The feminine character, and the ideal of femininity on which it is modeled, are products of masculine society"—or, as he has it a few sentences later, "The feminine character is a negative imprint of domination [*Herrschaft*]."[10] This is more or less the standpoint that produces the immediately feminist reading of the *Untitled Film Stills* that we rejected a moment ago. The problem with Adorno's feminism is that, in going for a radical critique, he truncates his own dialectic. *Herrschaft* here is meant to recall the master-slave section ("Herrschaft und Knechtschaft") in Hegel's *Phenomenology of Spirit*. But we find, a few sentences farther on, that "feminine natures [*weiblichen Naturen*] are, without exception, conformist."[11] We understand that "feminine natures" is not a synonym for "women"; Adorno is no misogynist. Nonetheless, we are right to be caught up short by it. Consciousness, insofar as it has substance, as it counts as a consciousness, is a consciousness for others; it bears an inescapably social aspect, which means that a certain noncoincidence with itself is constitutive even in its most inward aspects. Reciprocally, the others that are the substance of the social aspect of consciousness have no immediate sway over the inward movement of the "I," which, in turn, exerts a negative power over its own social aspect. Negativity, the immanent dissolution of positive identity, is constitutive of consciousness in its social aspect as much as in its inward aspect. This is very basic to the Hegelian dialectic, and it should be basic for Adorno. But "feminine character" here shows no sign of the dialectic, despite Adorno's clear reference to Hegel. It is reduced to a one-sided effect of capillary power. "The feminine character is a negative imprint of domination. But therefore," Adorno continues, "just as bad."[12] To say that the slave is "just as bad" as the master in the Hegelian dialectic would be not so much wrong as completely missing the point. The bondsman is not the "negative" imprint of the lord's positivity; rather, the bondsman's negativity has a different structure and a different meaning from the negativity of the lord. What *Untitled Film Stills* thematize is precisely the noncoincidence of the "feminine character" with the consciousness that achieves its social substance through it.

This noncoincidence is doubly thematized. First, as we have seen, it is thematized as inwardness, as the excess of subjectivity over femininity in

the latter's aspect as the "negative imprint of domination." But further, we know that the consciousness that in fact achieves its artistic substance in the picture is none other than the artist herself. What we are looking at, but what the picture is not explicitly about, is a moment in the process of making the work of art that we are looking at. Like Sherman, Nan Goldin put the artist in front of the camera. Compare Sherman's *Untitled Still Image #27* (see figure 1.3) with Goldin's *Nan One Month after Being Battered* (1984). While in Goldin's photography the artist and her world take the place of the photographic subject (producing an identity of artist and subject), in Sherman's pictures, the photographic subject appears in the place of the artist. This produces a split within the photographic subject, which, on one hand, is the presentation of a subject exceeding the subject she also is, and on the other, the photographic record of an artist in the process of making a picture, a documentary record of studio practice. In *Untitled Film Stills*, the photographic subject coincides in the picture, grain for grain, with the artist, but thematically, the artist and the subject occupy entirely different levels. The artist in the picture is captured in the act of making an artwork about the subject of the picture. We know this fact from the sequence of pictures, but it is legible in none of the pictures individually, which instead show only the abstract autonomy of consciousness from the power relations that otherwise determine it.

The film stills, then, are not only about the excess of subjectivity over its objective determinations, but also about the excess of art over image, of meaning over content. While these images unavoidably document Sherman's studio practice, it is just as obvious—in fact, much more obvious—that they are not about that practice but are about something else. (The foregoing pages have tried to explicate what that something else might be, but the more immediate reading we considered and rejected would do here just as well.) Even though each successful picture in the series (but not the unsuccessful ones, such as #50 [see plate 5]) presents a meaning other than "Cindy Sherman dressing up," we are unavoidably aware that we are also seeing Cindy Sherman dressing up, which means that the suspension of the literal content—Cindy Sherman dressing up—is also part of the meaning of the pictures. The literal content of the photograph no more exhausts the meaning of the picture than femininity as the "negative imprint of domination" exhausts the subjectivity of "feminine natures." This doubled autonomy is the same

autonomy that art has from its material support, the excess of meaning over the medium and institutions that condition it. This is the same autonomy the art photograph asserts from the photograph as such, which tends to be subordinated to what it immediately depicts. This is the autonomy that a work's meaning has from all of the stories that can be told about it.

Sherman's strategy of folding the appropriative line from picture to beholder into the picture itself is a formal principle that need not be activated by filmic content. While Sherman's film stills thematize the autonomy of art as an overtone of the autonomy of the central figure, the clusters of images in the contemporary photographer Viktoria Binschtok's recent *Cluster* series, which look nothing at all like Sherman's film stills but mobilize the same principle, centrally and insistently concern the excess of art over image. *Cutting Mat Cluster* (plate 8) appears to be a purely formal exposition of the mode of the series. Each cluster consists of two to four images that rhyme visually. Beginning with a picture from her own archive—images that were always intended, one way or another, to be beheld as artworks or as parts of artworks—Binschtok searches the Internet for visually similar images that are not intended as artworks: "promotional advertising . . . documentary war images . . . personal party snapshots . . . travel photography."[13] The found images are then made the basis of new pictures through staging, photography, and manipulation, and then displayed, more or less unhierarchically, alongside "traditional studio work." In *Cutting Mat Cluster*, for example, one of the images appears to be an oblique view of an exit from the Alexanderplatz U-Bahn station in Berlin. The other image seems obviously staged, from the desk pen with its "casually" separated cap to the artfully dispersed chalk dust. The visual register that the picture belongs to is the commercial stock photo, in the same way that Sherman's images belong to the film still, and it conjures up the stereotype—requires the stereotype—in the same way. And as in Sherman's images, the point is that it means something in excess of the stereotype. There is something wrong with this "stock photo": the Legos do not go with the clipboard; the office pen does not go with the cutting mat; the cutting mat does not go with the Legos; the chalk dust does not go with the office pen, and so on. These incongruities are meant to be legible.

In Binschtok's *Chanel* cluster (plate 9), the Chanel No. 5 box is handmade. The original image, which we can still see through its

representation, was meant to evoke a mood. While the original Chanel box may have been artfully angled, and a great deal of care may have gone into its lighting and so on, it is meant not to be read but, rather, simply to be appealing. The fact that the Scotch tape in the foreground of Binschtok's constructed Chanel box is not cropped or airbrushed out, by contrast, means that it is meant to be read: it is part of the handmade artifice of the object represented in the picture. (Also, the horizontal of the edge of the black paper that the tape secures echoes the lightly crumpled bottom edge of the back of the mail truck in the neighboring image.) The presence of the match in the opposite picture ("Perpetual Calendar"), apparently placed there for scale, suggests that the original of that picture was also an advertising image, though of a much less elevated sort: a snapshot of a secondhand item for sale on an auction site. The point of Binschtok's reconstructions is to replace the external purpose of the advertising image (immediately a cultural commodity, but the logic holds equally for the party snapshot or documentary photograph, which exist precisely to evoke the stories that can be told about them [see, e.g., plate 21]) with immanent purposiveness. That the projected meaning of the original image is rotated ninety degrees is literalized in the juxtaposition of the images, which have to be read as belonging together along the picture plane. The pen cap and the chalk dust from *Cutting Mat Cluster* are not there to serve the external purpose of projecting casual disorder, as they would be in the stock image. Instead, they echo the polished sheen of the metal handrail and the glare reflected from ceramic tiles of the neighboring image.

Jeff Wall's "near-documentary" pictures return us to the relationship between photography and film. The kinship of Wall's earliest transparencies to Sherman's film stills (see *A Woman and Her Doctor* [plate 10]) is not difficult to discern. As Wall says about the first picture in his catalogue raisonné, *The Destroyed Room* (1978), "The picture was planned in reference to the patterns of meaning identified with . . . movie and theater sets, and intended to articulate disturbing social imagery in terms of the fascination generated by the beautiful objects or commodities positioned within those carefully regulated modes of representation"—modes that "high art, with its critical outlook," is meant to defamiliarize.[14] It may very well be the case that *The Destroyed Room* exceeds Wall's own youthful vulgar-Adornian description of it (but as we have seen, Adorno has his own vulgar moments). But it

1.4 Jeff Wall, *Volunteer*, 1996. Silver gelatin print. 221.5 × 313.0 cm. COURTESY OF
THE ARTIST.

is just as much the case that this boring description bears a family re-
semblance to the immediately feminist description of Sherman's work:
one would be enough or a thousand would not be enough. While Wall's
pictures in this mode deliberately recall cinema in that they are explic-
itly staged, lit, and acted, their acknowledged stagedness very quickly
becomes something that is meant to be overcome by means of a certain
version of documentary plausibility rather than by the fiction of the film
still. *Volunteer* (figure 1.4), for example, is acted on a set, and, like some
of Wall's other images, may be a reconstruction of something he saw but
did not photograph. But the rhetoric has now become documentary; the
"near-documentary" pictures present themselves not as filmic poses that
are somehow subverted by the "critical outlook" of the artist, but as if
they were chance events captured by the camera.

The importance of this distinction can be seen in *An Eviction* (fig-
ure 1.5) of 2004, Wall's revision of *Eviction Struggle* (1988). The origi-
nal image has been more or less erased from the public record, but we
have accounts of it. The art historian Julian Stallabrass writes, "In line
with the change of title, Wall removes two figures who do not merely
glance at the scene but watch steadily from a distance, and who may

1.5 Jeff Wall, *An Eviction*, 1988/2004. Transparency in lightbox. 229 × 414 cm.
COURTESY OF THE ARTIST.

be read as officials or landlords overseeing the eviction. So we move
from a piece that was a long landscape view of class conflict, to one
that may more easily be read as a meditation on human imperfection,
in which power relations are toned down and 'struggle' is lost."[15] But
what essentially characterizes the difference between the two pictures
is not a more or less substantial class politics. The earlier picture staged
class conflict and judged it from the "critical outlook" of the artist. But
the very staginess of the picture was a problem, which derived from the
fact that the image was wildly implausible in a way that ruined the pic-
ture and its politics at the same time. An eviction is a moment of class
violence, but it does not look like class violence. It just looks like the
law. Owners—bank officials or landlords—petition judges for eviction
orders, but they do not drive across town to watch them being carried
out. The presence of the "officials or landlords" turns the picture into
an allegory, a term that will be used in this chapter to designate a figure
that both telegraphs and betrays the meaning of the picture as an event
in the mind of the artist.[16] In Wall's near-documentary photography, the
conventionally indexical character of the photographic image is mobi-
lized to produce a nonallegorical rhetoric, a rhetoric of just-thereness,
of immanence of the logic of the photograph to the substance of the
real. (Sherman's *Untitled Film Stills* series includes but overrides the
indexicality of the photograph—the steel floor, the exposed beam—

while the staged pictures in Binschtok's *Cluster* series put it in question, since there is a nonindexable gap between the found image and its reconstruction.) So by manifestly staging class struggle as an allegory rather than producing the plausible fiction of having captured its logic, the picture from 1988 loses the rhetorical force of just-thereness that is essential to the power of Wall's near-documentary pictures and turns the picture into a message—a meaning projected perpendicular to the picture plane—that one is free to like or dislike, agree with or not, but that invokes no criterion other than the beholder's own politics.

The version from 2004, by contrast, does not look like a message. The palpable stagedness of the central eviction tableau is contained with transformative results for the picture as a whole, not least because the unheeded theatricality of evictions is not unique to represented ones. The newer version removes the allegorical aspect, relying instead on the picture's ability to convince us that it stages something we might have seen but did not photograph, to convince us that its logic is immanent to the real. Plausibility, a category we return to throughout this book, is closely related to immanence: it is the capacity to produce the conviction that what we are seeing belongs to the logic of the material rather than to some external, contingent compulsion. Where the work of art is concerned, it is a far more stringent criterion than representational fidelity, which is rarely absent even in the least compelling representation. (Every selfie on Instagram conveys something indexically true about its subject. That does not mean that what it says is plausible.) In the revised picture, the ones who "watch steadily from a distance" are not bankers or owners but the picture's viewers: us. The class antagonism in the picture has not ceased to exist, but it is no longer a personal antagonism between figures in a picture, which we were free to deplore without discomfort; rather it is an antagonism between figures in the picture and forces, such as property law, that cannot be personified because they are structural, and in which we are unavoidably implicated. We can think of this antagonism as one of class, or we can think of it as the related but not identical one between the contemplative attitude of the beholder of the picture and the violence depicted in the picture. Either way, the picture is not strictly a critique of these antagonisms. Rather, it reveals them as organizing a relationship that appears immediately as peaceful—namely, that between the evicted and the viewers in the gallery. This organizing antagonism, like the eviction itself, is just there.

One of Wall's most distinctive strategies is to present the viewer with two distinct and uncommunicating worlds in a single picture: marine life and a terrestrial graveyard in *The Flooded Grave* (plate 11); the world of the Afghan living and the Russian dead in *Dead Troops Talk*; industrial agriculture and a Hokusai painting in *A Sudden Gust of Wind (after Hokusai)*. These pictures are in one regard the opposite of Martha Rossler's *Bringing the War Home* series, in which the co-presentness of uncommunicating worlds can be produced only by means of a theatrical violence. Despite expectations, there is nothing fevered or surreal in the mode of presentation. To the contrary, the impact of pictures such as *The Flooded Grave* is completely dependent on its sobriety. The social version of this strategy is often bound up with the ubiquitous theme of caretaking and cleaning. Sometimes the two worlds are straightforwardly class worlds: In *Housekeeping* (figure 1.6), for example, we see the same hotel room as both a place of work and an object of consumption, the same object as an element in two overlapping but noncommunicating worlds that are nonetheless part of a single totality. The two worlds we see need not be classed, however; the figure we see in *Volunteer* (see figure 1.4), because he is a volunteer, is not a worker, but his experience of the fictional space does not communicate with that of its users, represented by the empty chairs pushed against the wall. This strategy may be at work in all of the caretaking images. *Cuttings*, depicting bundles of twigs lined up on a sidewalk, thematizes but does not depict a subject for whom the sidewalk is not just a sidewalk but something to be cared for and maintained.

This brings us to two well-known, ambitious pieces. The first is *A View from an Apartment* (plate 12). Here we are squarely within the two worlds dynamic: the port of Vancouver, metonymic site both of global trade and of class struggle, and a modest domestic interior, sealed off by glass from the port it overlooks. Once again, the force of this juxtaposition—not just a class juxtaposition, which it certainly is, but a juxtaposition between two standpoints, production and consumption, that undeniably form one totality but do not add up to that totality, do not form a continuous, mutually communicating whole—is that it is not presented as allegorical. It is, rather, presented as just there. A rift yawns and is captured by the camera. The rest of us carry on with our business.

The work of the photographic index in these pictures, no matter how saturated with intention the image is, is to allow for the presentation

1.6 Jeff Wall, *Housekeeping*, 1996. Silver gelatin print. 192×258 cm. COURTESY OF THE ARTIST.

of meanings as though they were not meanings at all. Mike Osborne's *Aufzug* (plate 14) would be unbearably allegorical as a painting. Eight strongly marked perspective lines, produced by bright-yellow, fluorescent-lit architectural cladding that is recognizably infrastructural, recognizably German, and recognizably cost-efficient, converge on the lopsided, rumpled, weary-looking figure occupying the cramped, single-occupant elevator at the end of the hallway. The elevator might as well be a coffin, and we might as well be looking down on an open grave. Nothing could be trying more clearly to communicate something, and nothing could, by this very clarity, fail to do more than issue in a cliché. But *Aufzug* is not a painting. It is a photograph. The yellow hallway and tiny elevator in the Stuttgart U-Bahn are just there, doing nothing but being themselves, and the rhetoric of the photograph is that the man in the rumpled suit is just there, being himself. Of course, the photograph may be staged, but there is nothing in the picture to suggest that.[17] As long as the picture manages plausibly to sustain its rhetoric of just-thereness, its meaning can insist without being insisted upon.

In Martinus Rørbye's *View from the Artist's Window* (1825 [figure 1.7]), the receding lines of the open casement window do not seal off two worlds. Rather, they lead the eye to a Danish warship, palpably connecting the interior world of the artist's room to the world of maritime power and trade. The objects in the foreground, however—empty sketchbook, plants in various stages of development, a caged bird—constitute an allegory: they appear not as objects that are just there, but as objects that were placed there to tell a story that bypasses the form of the whole. If we imagine Wall's *A View from an Apartment* as a painting, the television in the foreground would function in the same way as Rørbye's plants. Not only is it an imported consumer good that has passed through this harbor or one like it; not only is it a third reflective glass surface and a third, and equally ignored, window; but the light from the harbor is reflected in its surface.[18] The reflected light from the harbor enters from the back of the picture, crosses the room between the two figures (intersecting but not entering their sight lines), and bounces off the screen, out of the picture plane, toward the viewer.

The painted television, like the plants in Rørbye's window, would telegraph its intendedness, insisting on being read allegorically: the worlds of production and consumption are hermetically sealed off from one another, but they nonetheless form one totality. This is a lesson one may well find congenial, but in a painting it would pose a political problem (if it is a lesson rather than something found in the real, what authority can the lesson have?) and an aesthetic problem (what relation can the immediately allegorical elements have to the form of a whole that does not mediate them?). In Wall's photograph, this same meaning is presented as immanent to the just-thereness of the harbor and the just-thereness of the apartment—not a matter of intention at all—and this presentational immanence is essential to the plausibility of the picture.[19] However, unless there is a third window outside and to the right of the picture frame—which does not seem to fit with the shape of the room—it is hard to make sense of the image in the television screen as the reflection of the two visible windows that it initially appears to be.[20] The television turns out to be an allegorical plant after all, and while the just-thereness of the apartment and its view is not ruined, the allegory of the television diminishes it.

Morning Cleaning (plate 15) may be the highest achievement of Wall's two worlds strategy. The setting is the Barcelona Pavilion, origi-

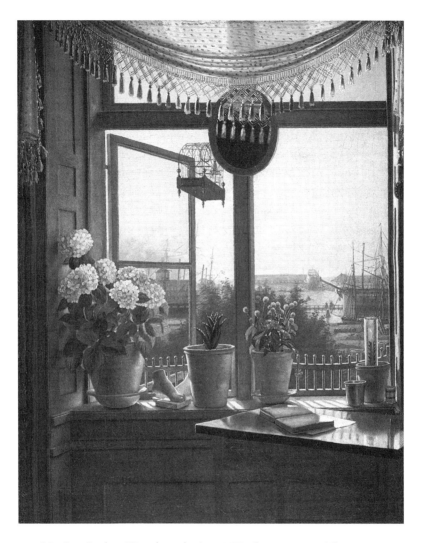

1.7 Martinus Rørbye, *View from the Artist's Window*, ca. 1825. Oil on canvas. 38 × 29.8 cm. NATIONAL GALLERY OF DENMARK.

nally designed by Mies van der Rohe for the 1929 Barcelona International Exposition, disassembled in 1930, and reconstructed in the mid-1980s as a kind of monument to the original. As may be obvious from the extraordinary clarity of almost every part of the picture, *Morning Cleaning* (like *A View from an Apartment*) is not exactly a photograph. Wall spent twelve days shooting the interior of the reconstructed Barcelona Pavilion for digital assembly back in his studio: about thirty-five minutes each morning for the interior itself, and about twenty minutes each morning with Alejandro, the window cleaner. Instead of providing a detailed description of the picture, we will concentrate on a few details that, in light of the painstaking process involved, must be understood to be intentional. First, the car visible obliquely through a window at the extreme right of the photograph activates the rhetoric of the "just-thereness" of the photograph: the extraneous detail that one would edit out if one could is, because one can, in effect, edited in. Unlike the reflection in the television, however, there is nothing in the car—nothing in the whole picture—that declares its intentionality, that forces us to understand it as allegorical. True, given the compositional process, everything must be understood as potentially intentional. However, if we were to go to the Barcelona Pavilion, we would see much of what is in the picture, untouched by Wall's intention. We should say instead that everything in the picture is presented as if it is just there, a principle that is not violated anywhere in the picture.

Second is the fact that, while the window cleaner does not occupy the center of the picture, he is strongly framed by the column that divides the picture into two unequal halves. Georg Kolbe's *Alba*, the competing, opposite figure, similarly placed within its frame but on the other side of the glass wall, ought to dominate the other half; but despite its superior position and apposite title, it is effaced by the soapy film on the window. The window cleaning—which, as the title insists, is a routine part of someone's working day—is the focus of the picture. But it is not as though the picture is "about" window cleaning in some ethnographic sense.

Finally, as in *Volunteer*, the chairs are discomposed. The stools at the sides, like the dark carpet in the center of the space, look as though they are waiting to be straightened up for the day, while the chairs near the center of the composition seem to be moved to make way for the work

of cleaning the windows. Over one of the chairs—almost precisely at the geometric center of the picture—cleaning rags are casually slung. At the geometric center of the picture is a pair of chairs at odd angles to each other and to the relentless grid of the floor plan, with cleaning rags slung over them; at the thematic center of the picture is the window cleaner apparently adjusting his equipment. The rags at the geometric center belong to the window cleaner at its thematic center. So does the discomposition of the chairs, the soapy film on the windows, the casually placed stools, the ruffled carpet, and the haphazardly opened curtain at the right of the composition. In effect, the space belongs to, is defined by, the window cleaner, for whom this is a place of work. The window cleaner's involvement with his equipment reminds us—is no doubt meant to remind us—of the early chapters of Heidegger's *Being and Time*, of the experience of the readiness-to-hand of equipment as primordial. In this sense, not just the cleaner's tool and the rags but the soap and the furniture—indeed, the whole space of the interior of the pavilion—are transformed in the picture into a kind of Heideggerian workshop as *Zuhandenheit,* just as the confrontation with the impossible knot of *Untangling* (figure 1.8) evokes the *Vorhandenheit* of the broken tool.

Michael Fried has taken up and thoroughly explicated this aspect of the picture.[21] But while the picture undoubtedly exploits this dimension of Heidegger's thinking and rhetoric, Heidegger's thinking and rhetoric do not exhaust the picture. This is not the place to make the argument in full, but it can be shown that the Being that corresponds to the concept of the "world" opened up by the reliability of equipment in Heidegger is, despite the forgetting and strife that characterize the latter, unitary and nonuniversal. In one obviously problematic but deeply relevant formulation, what opens up a world is, in a well-known essay drafted in the late 1930s, "the simple and essential decisions in the destiny of a historical people (*eines geschichtlichen Volkes*)."[22] What is depicted in *Morning Cleaning* is, on the contrary, both nonunitary and universal.

That is, we are not simply given the world of Alejandro in his workshop. In fact, it takes a while with the picture to understand that it is, at the moment, the world of Alejandro in his workshop. In a few minutes, it will become what it most obviously is for us, a monument and a tourist destination. In a strong sense, it already is that monument and tourist

1.8 Jeff Wall, *Untangling*, 1994. Transparency in lightbox. 189×223.5 cm.
COURTESY OF THE ARTIST.

destination, since our presence here—the presence of people who spend time with pictures such as this one, people who no doubt recognize the chairs from the galleries that house such pictures and from the catalogues that try to sell them to us—is already the presence of the international design tourist.

But whatever ethical commitments we might or might not have about these two incommensurate worlds, the picture does not have them. Alejandro's world is not more primordial than the tourist's or more authentic; they are simply alongside each other. The interior of the pavilion is two spaces—a place of work and a place of leisure—at the same time. This is not to say, however, that these two spaces are simply incommensurate and purely relative to each other. On the contrary, they are both held within and both relativized by the space of the picture. The picture, in other words, models the concept of totality. Alejandro inhabits not a world but a standpoint; the tourist who will shortly enter the space

likewise inhabits not a world but a standpoint. While actual or potential bodies occupy these standpoints, these standpoints cannot be reduced to bodies. Even though, empirically, the viewer of the picture is, in the world we live in (but not every possible world), more likely to be a tourist than a window washer, that viewer can project herself into one or the other of these standpoints at will. What appears in this picture, in other words, is class conflict—a class conflict that is not itself a matter of particular class positions but in which the viewer's class position is one way or another (though more likely one way than the other) implicated.

This is not the only way in which Wall depicts class conflict. But in a moment of open class antagonism (see, e.g., not only *Outburst* [plate 13] but also *Eviction Struggle*), it can, in Wall's mode of near-documentary, only appear to violate that mode as allegory. *Outburst* is an allegory of class antagonism, and we may flatter ourselves with our sympathy with the put-upon garment worker. But nothing in the picture activates what ought to be just there—namely, what structures the relationship between the garment worker and her irate boss. In *Morning Cleaning*, we see class conflict in the mode of the appearance of the everyday, in its mode of appearance as nonconflict—that is, as peace. This is the meaning of the picture and the everyday truth of our societies. At precisely this moment—the moment in which class conflict is just there rather than insisted upon—we can understand class as a matter of standpoint. What heretofore, with increasing dissimulation, had always appeared as an appeal to the viewer, as an attempted communication of an allegorical meaning, finally appears purely in the mode of just-thereness: the projected meaning is finally fully absorbed into the picture plane.

As we saw earlier in this chapter, Wall identifies the early 1970s as the end of the prehistory of photography as an art. It is no coincidence, then, that he also sees it as the end of the prehistory of photography as a commodity: "It is almost astonishing to remember that important art-photographs [by which, at this point in the essay, Wall does not quite mean photography as art] could be purchased for under $100 not only in 1950 but in 1960. This suggests that, despite the internal complexity of the aesthetic structure of art-photography, its moment of recognition as art in capitalist societies had not yet occurred."[23] Wall is making reference here to the idea, touched on in the introduction, that in a society whose social metabolism takes place solely by

means of the exchange of commodities, any social recognition of value is immediately its recognition as exchange value. For this reason, Wall takes the nonrecognition of art photographs as commodities to index their nonrecognition as art.

In fact, Sherman's *Untitled Film Stills* and Wall's *Morning Cleaning* more or less bookend the emergence of photographs both as commodities in themselves—rather than as subordinate to the photo book or to studio practice—and as things that belong in museums. Sherman's film stills are produced on a shoestring, and while they are meant to produce a meaning of their own, they can still be understood as merely documenting a studio practice that exists beyond the picture as immaterial and noncommodifiable. (That understanding would be wrong and would render the place they in fact have in the history of photography nonsensical. But it is a possible understanding. especially in their historical moment of emergence.) *Morning Cleaning*, by contrast, involved a considerable investment of money, labor time, and technology and cannot be imagined to belong anywhere but on a wall. Since the display value of a picture is a use value, there is nothing in the picture as an object that separates it from its being as a commodity.

But while its value as a commodity is dependent on its value as art, its value as art is not dependent on its value as a commodity. Wall's and Sherman's pictures are valued because curators and scholars have ascribed aesthetic value to them; curators and scholars have not ascribed aesthetic value to them because they are expensive. The commodification of photography as an art, in other words, takes place only via its bid for inclusion in the institution of art. (Even accounts that imagine themselves to be criticizing Wall's pictures for their "spectacular commodification" end up criticizing them for belonging in museums.[24])

Wall's own account of the postwar development of photography ends at the moment that its immanent dialectic demands the tableau form. Fried's (more materialist!) account understands the large-format photograph—partly a technological development—as providing the opening to break an impasse that had been troubling the development of the tableau. In either case, the entry into the museum means making an intervention into what in his account Wall calls "the Western Picture," a phrase he might not use today, but, in any case, a discursive object internal to the institution of art. In other words, the development of photography as a commodity and as an art involves the logic of the

Bourdieusian restricted field, which keeps the logic of the commodity form—the "consumer sovereignty" that is imposed by the judgment of the anonymous market—at bay by means of an appeal to judgment by experts and the institutions they represent. This does not mean that the problem of the picture's commodity character is irrelevant. On the contrary: the problem of the market is in fact a version of the problem of the tableau's beholder—both are threats to immanent purposiveness—and a picture such as *Morning Cleaning* declares, in its claim to immanent purposiveness, its autonomy from both at the same time.

But while the commodity value of the art photograph depends on its prior valuation as art by experts, other artists, critics, and curators, the commodity value of a movie does not. Critics may make a small contribution to regulating the market in movie tickets, but they are not a precondition for it. Hollywood, or mainstream, films—"the movies"—do not have a restricted field to appeal to. Their social existence, their circulation, depends not first on institutions but directly on markets. Sherman, Binschtok, and Wall confront the logic of the commodity first as the logic of the beholder. The commodity character of film—encountered both directly in the market and mediated by genre—must be confronted in a more direct way. But in the works we turn to next, it is not confronted by treating the genre as a pure given to be acknowledged and suspended (a strategy examined in chapter 4). Rather, in a move akin to Frank Stella's turn to shape in painting, the works thematize the photographic aspect of film and, in particular, the aspect generally disavowed in the movies—namely, the literal, indexical trace.

As we saw earlier, for Fried the movies appear nontheatrical (but not antitheatrical) when taken as a sequence of still images. By way of an illustration, let us turn first not to a film but to a television show in the mode of "quality television," in which the phenomenon Fried identified holds. The first season of *True Detective*, with its name actors and multiple time sequences, and most significantly its director, young but already well known and aesthetically ambitious, proclaims that the show is competing with film. But it is clear at the same time that the substantial generic cognitive-mapping potential of the detective plot is not going to be mobilized: the possibility is raised and dismissed early in the show. The first series of *True Detective*, unusually for a television show, is directed by a single person, Cary Fukunaga, whose early work emerges from a tradition of Third Cinema and Cinema Novo. The moment of

Zweckmäßigkeit, or purposive form, in *True Detective*, as opposed to the *Zweck* or purpose of entertaining (selling itself to) an audience, is not to be found in the detective plot that, from Raymond Chandler to Ngũgĩ wa Thiong'o, ties together multiple milieux and classes with a single narrative thread whose dead ends nonetheless make connections. Rather, its moment of immanent purposiveness lies in its photography.

It initially appears that *True Detective* is set in rural Louisiana. This is not exactly wrong, but if everything in the foreground of *True Detective* suggests a gothic rural South, the background insists that this is in fact an industrial landscape. Relative to its massive technological composition, the petrochemical industry we glimpse in the background employs few workers, so there can be no implied connection between the workers in the foreground and the factories in the background, because the workers in the foreground are unemployed, irregularly or illegally employed, or work for the state. The two worlds—that of large-scale industrial production and of the people one might expect to be working in it—are consistently pictured in the same frame, but without any mediating links between them. Only once, in a magnificent scene, does a character appear even to see the industrial backdrop. A police detective emerges from his car. Behind him in the middle distance rises some kind of industrial behemoth. But the behemoth moves: it is a massive container ship, gliding along on a body of water obscured by an earthwork or levy. The detective glances at it for an instant before returning to his business of asking some questions at a revival tent (plates 16–18). The relationship is not, as we might reasonably expect, between living labor in the foreground and the dead labor represented in machinery in the background, but between the movement of massive industrial development in the background and, in the foreground, the stasis of the people left behind by it.

The brutal green horizontality of the earthwork in the background might remind us of Andreas Gursky's Rhine pictures, but the inspiration for these images is probably Richard Misrach's book *Petrochemical America* (plate 19). One might not be able to shake the sense there is something obscene about transposing Misrach's socially aware imagery to the background of a popular entertainment. However, we should note that there is a sentimentality to Misrach's images that is completely absent from this aspect of *True Detective*. In Misrach's images, the placedness of the camera in effect produces the landscape as a pose: we are

being shown something, and we are supposed to feel bad about it. In *True Detective*, because it is filmlike in that the fiction is maintained that the camera does not exist, and because all of the attention is apparently given to the plot in the foreground, we are not being shown anything—or, at any rate, what we are being shown is plot twists and weird characters, not this. As in Wall's *Morning Cleaning*, the rift between worlds is presented as just there.

But this only confirms the Friedian observation. *True Detective* does not solve the problem of *Petrochemical America* because in *True Detective* the problem does not arise. *True Detective* does not have to overcome the sentimentality to which Misrach's photography succumbs because sentimentality does not impose itself as a temptation. The unavoidable placedness of the camera, which produces a problem for Misrach and for us, is transparent in the filmic space of *True Detective*. This is partly due to the rhetoric of immediacy that is native to film as a medium. But it is also due to the fact that the severance of background from foreground does not contribute other than atmospherically to *True Detective*, which is of unusually high quality but nonetheless—just as it claims—nothing more than an entertainment. The background, in other words, is just a backdrop, with no thematized relationship—not even one of severance—to the gothic murder plot in the foreground. What would be an accomplishment in photography—to produce, without sentiment, the image of the immediate relationship between living labor and dead labor as the lack of a relationship, to represent photographically the inability of contemporary capitalism to absorb labor that has been shed from the production process—is in film a problem. Taken as a sequence of still images, *True Detective*'s photography is nontheatrical (but not antitheatrical), but as backdrop to a moving image, it is just theater. What, then, would it look like for a film, rather than escaping the problem of theatricality, both to produce its own theatricality and to overcome it?

Richard Linklater can apparently generate appealing variations of the male coming-of-age story at will, and as far as the plot of his *Boyhood* is concerned, we do not get anything more substantial than the middle-brow genre film that *Boyhood* undoubtedly is. But, as is well known, the film was shot in four-day bursts over twelve years, so that the actors—particularly the child actors—do not need to act different ages, because they just are different ages. The first thing that one notices about the

naturalistic texture this produces is that the acting by adults in the film, even very good acting, registers immediately as acting: in other words, as artificial in relation to the unsurpassable naturalism of four bodies captured as they move through time, quite independently of the will of any of the actors. It is hard to imagine a filmic procedure that could better introduce the lack of artistic intention: the adults make good and bad decisions in the film, so we have a plot, and the actors and director/writer make decisions, so we have a film. But the growth and decay of the body over time is not subject to decisions in the same way.

Of course, the decision to capture the movement of four bodies through time is an intention, and we are meant to see this intention in relation to photography—we see the boy during his last year of high school developing film in a darkroom when he is supposed to be shooting digital, and he expresses a vague ambition to "take pictures." On the standard account, the film photographer exercises her intention at the moment of pressing the shutter, and again in the darkroom, but cannot be said to intend everything in the photograph in the same way. With the film photograph, intention is paradigmatically exceeded at the very moment of intention—precisely Linklater's procedure in *Boyhood*.[25]

Two related observations now impose themselves. First, four bodies moving through time is, as a theme or content, itself profoundly boring, unless one's own self or family or friends is doing the aging. Bodies aging is the accidental theme of anyone's family photo album, and our response to it is not disinterest but indifference, something that is borne out empirically every time we are asked to respond enthusiastically to pictures of other people's children or to the youthful grace of other people's grandparents. Second, the coming-of-age story turns out not to be exactly that. The children who are the primary subject of movie's photographic impulse are not the subject of the plot. It is the parents in this film who grow up in a narrative sense, making good and bad decisions that have good and bad narrative outcomes. But the children themselves hardly make any decisions, and those that they do make do not yet have any outcomes by the time the movie ends. Even momentous decisions on the part of the adults in this film do not seem to affect the children more than incidentally. In essence, the titular content of the

film, in both its photographic and its narrative aspect, is rendered in a way that deliberately robs it of all interest.

But if boyhood is not interesting, *Boyhood* is nonetheless compelling. (*Boyhood* is not the only Linklater film of which this can be said.) What makes the film compelling is the dialectic of form and formlessness, of meaning and literality, that Linklater's procedure sets into place through the interplay of narrative and photography. Indeed, the separation between the narrative aspect of the film (dominated by the adult characters) and the photographic aspect (dominated by the child characters) is thematized in its second half, as a sequence of adults—mostly but not all men, mostly but not all unbidden—attempt to give the main character, Mason, advice. In other words, they try to insert him into a coherent narrative in which good and bad choices will have good and bad outcomes. For Mason to resist these narratives would be to create a plot. But Mason does not so much resist these narratives as abstain from them. He embodies the "indecision, so full of promise, [that] is one of the greatest charms of childhood."[26] Mason's foil in this regard is Enrique, a working-class immigrant boy who takes Mason's mother's advice to go back to school at the beginning of the film—because "perforce one must make a choice"—and works his way by the end of the movie into the lower ranks of the middle class.[27] Enrique's minute or so of screen time represents, in other words, the film that *Boyhood* is not.

While aging has a shape and a direction, it does not have a form. It has neither purposiveness nor purpose; it simply is. Now this is already not quite right, since for us nothing "simply is" except inasmuch as it is understood through the category of simple being—which is not simple and not at all what we thought we meant when we said that something simply is. As paradoxical as that thought may sound when applied to everyday life, it is uncontroversial in the context of the work of art: every instance of formlessness in art is only a presentation of the idea of formlessness and, therefore, is not literal formlessness. (Literal formlessness can appear as external accident or internal flaw, but in the former case, it is not part of the work, and in the latter, it is an impediment to meaning rather than an aspect of it.) In painting, it is not quite, as Clement Greenberg had it, that "the first mark made on canvas destroys its literal and utter flatness," but that the first mark made on canvas produces both the depicted space of the picture and the depicted flatness

of the canvas.[28] *Boyhood* is not interested in producing the effect of the real, which, as much as the middlebrow plot, would be directed to the consumer as an attraction. Rather, drawn into the film's dialectic of immanent form and external determination, the literal and utter reality of bodies moving through time is made to depict itself, to be about itself in a way that the family photo album is not.

Every artwork has a literal substrate. In the movies, it is immediately dissimulated: we automatically take Toronto for Chicago, even if we are perfectly aware that what we are looking at is literally Toronto. (If it does bother us, it does so only because the immediate dissimulation fails; onstage, by contrast, it does not bother us in the slightest that Chicago is two-dimensional and made of plywood.) This is another version of Fried's claim that the movies are untheatrical but not antitheatrical. But in *Boyhood*, one aspect of the film's literalness—the actors' bodily presence—is not illusionistically dissimulated into character. On the contrary, it is brought to bear as a constraint; it is turned into an explicitly structuring element of the film. Literalness, then, is not illusionistically dispensed with but included as superseded, the way modernist painting in the post-Greenbergian account does not just supersede flatness but includes flatness as superseded, or the way Sherman's film stills do not just supersede their documentary content but include it as superseded.

While the body's movement through time in *Boyhood* is the figure of literalness from the standpoint of its supersession, Mason is the figure of determinability without determination, of free infinite subjectivity, the same content we earlier found thematized in Sherman's untitled film stills. But as Linklater is aware, the rights granted subjectivity are not equally distributed, and with this, the film's abstract thematization of autonomy acquires (minimal but unavoidable and thoroughgoing) social content. While Mason's boyhood is prolonged in college—we see him at his university sharing a pot brownie and having appropriately jejune philosophical conversations at Big Bend National Park with his new friends—Enrique earns his associate's degree to land a better job. Free infinite subjectivity—as we saw in the introduction, a presupposition of any politics as much as any art—is a universal. But in societies such as ours, childhood is the privilege of a class.

When Alejandro Iñárritu casts nonprofessional actors, shoots in a dangerous neighborhood, or uses footage of Leonardo DiCaprio gag-

ging on a raw bison liver, the point is to challenge forth a piece of the real in such a way that the authentic gesture, setting, or reflex lends verisimilitude to the plot, which, as a plot, is by nature artificial. The literal, indexical trace is folded back into the narrative, merely lending it the texture of the real, the way shooting in Chicago might render a scene more plausibly Chicagoan than one shot in Toronto. *Boyhood* rotates this reality effect, as it were, clockwise. The real in *Boyhood* does not contribute to the verisimilitude of the plot; rather, the real is explicitly depicted as the moment of external determination in the dialectic of form. Iñárritu's *Birdman*, by contrast, turns the reality effect in the other direction, problematizing the reality effect itself.

Birdman centers on the aging Hollywood actor Riggan Thompson, famous for playing the role of the superhero Birdman. Riggan has come to Broadway to stage a vanity production of Raymond Carver's "What We Talk about When We Talk about Love," adapted, produced, and directed by—and starring—himself. The very idea is, of course, ridiculous, and all of the elements are in place for the backstage farce that *Birdman* undoubtedly is. The show is shaping up to be an ordinary flop when an injury among the cast gets the plot moving, as the famous Method actor Mike Shiner is hired as a replacement. Shiner's first move is to substitute real gin for the water on set—literal gin for depicted gin—in front of a live audience. When his attempt is foiled, he goes on an off-book scenery-chewing diatribe denouncing the production as "fake." But if the opposite of "implausible" is "plausible," and the opposite of "arbitrary" is "necessary"—all aesthetic categories—the opposite of "fake" is "real," an ontological (and, for Shiner, ethical) category, not an aesthetic one. Shiner's method is to challenge forth a piece of the real—for example, working up a real erection for an interrupted sex scene, or requiring Thompson to use a real gun because Shiner cannot feel fear in front of a fake one. But the real never gets folded back into verisimilitude. Rather, the token of the real becomes an effect in itself. The audience gasps not at Mel's betrayal but at Shiner's erection. Thompson regains his audience not through his acting but through a video that goes viral after he is locked out of the theater during a performance and has to run through Times Square in his underwear to get back in the front door. When the gun goes off (as it must), Thompson shoots off his nose in an apparent public suicide attempt, thus scoring his first theatrical success.

All of these theatrical provocations are, as is typical in the back-stage farce, literally rotated ninety degrees—they are generally filmed from the wings—so that the effect for the movie audience is not dramatic but absurd. But here we do not get the contrast we expect between ordinary theatricality and, offstage, Friedian filmic nontheatricality. The conspicuous formal feature of the movie is that it presents the fiction of being filmed in one take. This is not the case, but the takes are extremely long—the longest is about fifteen minutes—so that actorly effects such as timing cannot be easily altered in the editing process. The acting, which is of a very high naturalistic quality in each of its moments, nonetheless feels, as a necessary consequence of the long takes, rehearsed. Suddenly, rather than being immersed in a world, we are looking at the world through a camera lens, and the actors are acting for the camera. We can and do suspend disbelief, but we are suspending disbelief rather than being absorbed in a world that does not ask for its suspension. We are in the theater, not at the movies. All of this is confirmed for us by the fact that the fiction of the continuous take is suspended three times, so that the action is divided into four continuous acts, and the soundtrack, for the most part, consists of a single jazz drummer whose playing is neither precisely diagetic nor extra-diagetic but, like a pit orchestra, occasionally viewed in an unobtrusive corner.

The primary disbelief we must suspend is in the fact that Riggan can fly. For most of the film, Riggan's ability to fly is a representation of Riggan's fugue state. One scene clearly suggests that a cross-town flight has in fact been accomplished by means of a taxicab, whose driver Riggan (naturally, having flown there) neglects to pay. But the final scene depends on the possibility that Riggan can fly. Having shot off his nose, which has been reconstructed overnight, Riggan awakes to find that, against all indications, he has received a positive review in the *New York Times*. The hotel is swamped with paparazzi, and he is reunited in his hospital room with his ex-wife and semi-estranged daughter. When he is alone in the room, he steps to the window and jumps. When his daughter returns to the room, she runs to the window and looks down, horrified, then looks toward the sky with a beatific expression. By not showing Riggan, the film raises two possibilities; by showing his daughter's face, it favors the second. This is, first, a condensation of the paradigmatic Hollywood ending—we know which possibility is plausible within the

logic of the world of the film and are asked to believe in the one that is not—but it is also the ending that we are, in fact, being asked to accept. If Riggan's "super-realism" (the phrase comes from the fictional review in the *Times*)—the shock value of the literal erection or gunshot wound—is nothing other than a spectacle that sells tickets (in his final scene, Riggan's bandages resemble those of the titular phantom of *The Phantom of the Opera*, whose poster can be seen littering Broadway throughout the film), then the Hollywood ending fulfills the same function for *Birdman*, forsaking the logic of the whole for the direct appeal of one of its parts.

But the logic of the whole takes its revenge, for the two possibilities are in fact identical. The meaning of Riggan's success is the opposite of what he intended, as the adaptation of Carver's dirty realism turns over into the "super-realism" that is in its essence no more than a circus sideshow. (Or performance art, as no less a figure than Marina Abramović, one of its founding theorists and, not coincidentally, of the same generation as the fictional Riggan Thompson, reminds us: "That is the difference between theater and performance: in theater the blood is ketchup; in performance, it is real."[29]) The meaning of Riggan's death or escape, then, is the same in either case. If Riggan commits suicide, it is at his moment of triumph; if he escapes into the air, he can never return. Either way, there can be no second performance, and this is so not for merely narrative reasons. Unrepeatability is part of the logic of the shock of the literal: if Riggan's attempted suicide were repeatable, it could be part of the meaning of the work, but then it would be depictive, not merely literal. Rather than being asked to choose between life and death, and to accept the less plausible possibility, we are presented with a choice between two endings that, in the light of the logic of the whole, makes no difference. In terms of the film's thematization of the dialectical theatricality of the reality effect, Riggan's success can only be a failure. To say that there can be no second performance is to say, literally, that the show will close after one night. The appeal to the viewer—which in the last analysis can be nothing other than the appeal to buy tickets—is made and unmade at the same time. The appeal and its undoing are not, however, at the same level. The latter—the logic of the whole, which derives its plausibility from its exposure of the contradictory logic that inheres in the shock of the literal, which

is both undeniably real in its ontology and irredeemably bogus in its effect—subsumes and gives meaning to the former, the appeal of the implausible happy ending. But as with the attempts to which we turn in the next chapter to produce works that run and overcome the risk of the middlebrow book market, the appeal could not, in the movies, be overcome without being made.

2 The Novel and the Ruse of the Work

Charles Ray's *Unpainted Sculpture* is a full-scale, monochrome rendering in fiberglass of a totaled Pontiac Grand Am (plate 20), duplicated piece by piece through a mechanical process.[1] The accident that wrecked the original car was a fatal one. Commenting on his sculpture, Ray asks,

> If ghosts existed, would they haunt the actual substance of a place or object? Or would the object's topology, geometry, or shape be enough to hold the ghost? *Unpainted Sculpture* began as an investigation into the nature of a haunting. I studied many automobiles that were involved in fatal collisions. Eventually I chose a car that I felt held the presence of its dead driver.[2]

It is initially difficult to imagine a nonbullshit meaning for this passage, whose form acknowledges its own nonsensicality. One cannot run an experiment on initial conditions that are themselves counterfactual: since ghosts are acknowledged not to exist, the success or failure of the sculpture cannot establish how they would act if they did. When one begins to examine the sculpture, however, it is hard not to be struck by a certain presence, physical (or, better, indexical) rather than ghostly,

in the force with which the steering wheel has been smashed in by the body of the driver, and in the tremendous crumpling of the front of the car on the driver's side. It is also hard not to narrativize this observation as a kind of shock: "Something has happened here, someone has died." But with this thought, the game Ray is playing becomes clear: of course nobody died in that car, because it is not a car but a depiction of a car. It is in this light that we should understand the fact that Ray, who often uses modifications of scale to emphasize the sculpturality of his work, employs a 1:1 scale, reserving the obvious signs of constructedness— which abound on close inspection—to details such as the broken rear headlights, which lack the bulbs that ought to be visible just as the eyes of unpainted Greek statues lack irises.

Since ghosts are acknowledged not to exist, the "haunting" can be none other than the effect of presence, which the sculpture manages to produce through its "topology, geometry, or shape" rather than its being the actual site of an event. Since this representation is produced by means of a process that includes an inescapably impersonal mechanical aspect—thus carrying through a causal chain from the initial impact all the way to the sculpture in the gallery—it is closer in that sense to a photograph than to sculpture as one might traditionally have understood it. But while one might well find a photographed automobile accident shocking, one would not even for an instant be awed at the fact that "something has happened here" because, as Walter Benjamin understood perfectly well, there is no "here and now" to a photograph, whose reproducibility strips "the here and now [from] the artwork—its unique presence [*Dasein*] at the place where it is."[3] When the great Brazilian documentary photographer Sabastião Salgado informs us about one of his images that "a person was killed through [the] hole" through which we view a young child (plate 21), any awe that the statement elicits attaches to the hole, not to the photograph, which, wherever it is, is nowhere near the hole.[4] But as we have seen, the "here and now" of the notion that "something has happened here, someone has died" is just as much absent from *Unpainted Sculpture*. The "aura" or "ghost"—it does not matter which, since both are proxies for the "here and now" of the awe-inducing ritual object, the physical trace of the unique moment in which something happened—is as stripped from the death car by *Unpainted Sculpture* as it is from the artwork by the Benjaminian photograph: "*Unpainted Sculpture* never existed in Detroit."[5]

Ray then gives us the haunted object to take it away, but he can take it away only by first giving it to us. "Rather than a ghost, it was I who began to follow the geometry of form in space. I considered how my sculpture sat on the ground, what detail was important, what areas should be left blank, where my sculpture begins and ends."[6] The sculpture ends up insisting on its own autonomy. It ceases to be about the death car, and ends up being not simply, undialectically, about "form in space" but, through form in space, about its own autonomy from the death car—without which it could, nonetheless, not exist.

The same dialectic pertains to its unique presence in a gallery. We recall that for Benjamin, art that "rejects not only any social function, but any determination by content"[7]—art that insists on its autonomy—is a mere dialectical inversion of its precapitalist foundations in ritual, an "instrument of magic."[8] There is nothing obviously implausible about this thesis, according to which the ontological uniqueness of the work of art upon which modernism had insisted was, as it were, no more than a "negative theology."[9] But what Ray's sculpture demonstrates is that the opposite is true: *Unpainted Sculpture* produces the autonomy of the work of art not as a (negative) version of its aura, but as autonomy from aura. Sculptural art does not avoid the magic of the "unique presence [*Dasein*]" of the artwork, as photography does in Benjamin's account; rather, it supersedes it. Unlike the Benjaminian photograph, *Unpainted Sculpture* does retain a certain "here and now": the here and now of the unique artwork in a gallery. The idea that "something has happened here," then, is not false. Ferreira Gullar, whom we last saw in the introduction in his popular revolutionary phase, had had this to say, just a few years earlier, about the "here and now" of the work of art:

> Mere contemplation is not sufficient to reveal the meaning of the work—and the beholder passes from contemplation to action. But what her action produces is the work itself, because this use, already foreseen in the structure of the work, is absorbed by the work, reveals the structure of the work, and incorporates itself into the work's signification. . . . Before the beholder, the non-object [i.e., the work of art] presents itself as incomplete and offers the means for its completion. The beholder acts, but the time of the action does not pass, does not transcend the work, doesn't exist and then lose itself beyond the work: it is incorporated in the work, where it persists.[10]

Something does happen in the sculpture. Something is, as Heidegger might say, at work in the work. But the time of the experience of the work "does not pass," because it is part of the work itself, "where it persists," sub specie aeternitatis. The "here and now" of the artwork is for its beholder a here and a now, but it is also enduringly present in the work. What happens in the work is, as an empirical experience, contingent; as form, it is not. This oscillation is not unique to Charles Ray or to sculpture; it is constitutive of the work of art as such. It is, indeed, precisely what Kant meant when he described aesthetic judgment as both subjective and universal. *Unpainted Sculpture* thematizes both its ontological difference from an object in which "something has happened, someone has died" and the excess of sculptural presentness over sculptural presence. *Unpainted Sculpture* is a structure that can be described as an experience; alternatively, *Unpainted Sculpture* produces an experience that can be described as a structure. The greatness of *Unpainted Sculpture* lies in the fact that it does not encounter the problem of sculptural presence as an obstacle. Instead, it produces it as a risk to be courted.

In the rest of this chapter, we turn to novelistic form in relation to the problem of experience—which is also the problem of the market. In the case of Ben Lerner's *10:04*, a particular kind of experience looks like the central feature of a "literary novel" whose liberal-stoic politics is its primary selling point. In the case of Jennifer Egan's *A Visit from the Goon Squad*, experience is thematized partly as the experience of authenticity—the commodified pseudo-other of the experience of the commodity—and partly as the experience of the commodity itself, not least in the form of the short stories of which the novel is largely (but not entirely) composed. Both of these novels foreground a kind of experience only in order to subsume it under a structure that, in giving experience a meaning, undercuts its character as experience; both books, producing the market internally as a risk to be courted, understand the problem of experience as a version of the problem of the market. Tom McCarthy's *Remainder*, meanwhile, produces in its protagonist an image of the logic of the opposition between experience and meaning. It is not at all clear that this is precisely what McCarthy set out to do in writing the novel, but the novel exemplifies the ruse of the work, operative in all three novels, by which contradictory intentions resolve, in the case of a successful novel, by way of an ironizing of ends external to the logic of the work.

Lerner's *10:04* centrally concerns a particular kind of experience in which "everything," the contents of everyday life, is encountered as "the same but a little bit different."[11] Part of the interest of *10:04* is that these experiences are not all of the same kind, but with one ambiguous exception, they are pitched away from the uncanny and toward the utopian. The book's epigraph, borrowed from Benjamin, locates this experience as fundamentally the experience of the future. In a "world to come," say the Hassidim, "everything will be as it is now, just a little different."[12] A central instance is the justly celebrated episode concerning the "Institute for Totaled Art." Based on the actual Salvage Art Institute, the Institute for Totaled Art collects and exhibits damaged artworks that have been legally declared by the insurance industry to have zero monetary value and therefore can no longer circulate as commodities.[13] For the fictional as for the real institute, the interest of these "totaled" works is that they are, in the words of the real institute, "no longer art." They have been, in the words of *10:04*, "formally demoted from art to mere objecthood" (130).

As we saw in the introduction, in the ordinary run of capitalism exchange logically precedes use: "Only the act of exchange can prove whether or not [a commodity] is useful for others" (*K* 100–1/*C* 180). That is, in the ordinary run of things the only measure of whether something has value is whether it circulates—whether it sells. Such a judgment by the market does not, however, contain any information about what kind of use the commodity has. Once the commodity character is legally removed from an art commodity, its claim to be art—a claim that was ratified by a market that in fact says nothing about its being as art, only about its being a commodity—falls to the ground along with the claim to value, and we are left with the object that, as we have seen, the art commodity already was: the same, only a little bit different in that it has neither economic value nor the claim to artistic value for which the monetary value was supposed to have been a proxy. This is how both the real institute and the fictional one understand their missions. The founder of the fictional institute smashes a Jeff Koons balloon dog. "'It's worth nothing,'" she hisses, looking "like a chthonic deity of vengeance" (132).

But the experience of totaled art is bifurcated. The protagonist of *10:04* is drawn to an "unframed Cartier-Bresson print" (132) whose damage is to the protagonist indiscernible:

Like everyone else, I was familiar with material things that seemed to have taken on a kind of magical power as a result of a monetizable signature. . . . But it was incredibly rare—I remembered the jar of instant coffee the night of the storm—to encounter an object liberated from that logic. What was the word for that liberation? *Apocalypse*? *Utopia*? . . . It was as if . . . the twenty-one grams of the market's soul had fled. . . . It was art before or after capital. (133–34)

We will return to that jar of instant coffee. But if we allow for the possibility that some totaled pieces are not just art commodities but also artworks—a little bit different in a way that is neither material in the immediate way that the objective support is material, nor material in the way that the commodity character is a mediated expression of material relationships but, rather, present only in the legibility of self-legislating form—then the legal stripping of their commodity character leaves them "the same, only totally different" (133). Totally, rather than a little, because the crucial thing is not the damage, which can be great, slight, or imperceptible, but the artwork's liberation from the obligation to be a commodity at all. The work's aura, its "magical power"—which in the protagonist's account is identical with its commodity character, the "result of a monetizable signature," another version of the Benjaminian "here and now"—is stripped, leaving behind not a banal object but a work: art "before or after" capitalism. Only by banishing its commodity character, here equated with the auratic presence of the artwork, can a work of art assert its being as art. Against Benjamin but with *Unpainted Sculpture*, magic and artworks as a distinct kind of thing for the protagonist of *10:04* are not only separable but opposites. Under the sign of the "monetizable signature," what is set aside in the totaled work is not only the unique event but immediately the monetary value that attaches to it. The commodity character of the artwork stands, in the narrator's account, firmly with aura, magic, and presence as the trace of a unique event—and against art.

Unlike *Unpainted Sculpture*, however, the Cartier-Bresson print does not supersede its auratic presence. Rather, it is delivered from it. This brings us back to that jar of coffee. In the generalized anxiety—for the protagonist, in the latently communal concern, signaling the universal "second person plural on the perennial verge of existence" (157)—attendant on the approach of Hurricane Irene, as "flashlights,

canned food, bottled water" begin to disappear from the stores, "every-thing remaining on the shelves . . . struck me as a little changed, a little charged" (18);

> the approaching storm was estranging the routine of shopping just enough to make me viscerally aware of both the miracle and insan-ity of the mundane economy. Finally I found something on the list, something vital: instant coffee. I held the red plastic container, one of the last three on the shelf, held it like the marvel that it was: the seeds inside the purple fruits of coffee plants had been harvested on Andean slopes and roasted and ground and soaked and then de-hydrated at a factory in Medellín and vacuum-sealed and flown to JFK and then driven upstate in bulk to Pearl River for repackaging and then transported back by truck to the store where I now stood reading the label. It was as if the social relations that produced the object in my hand began to glow within it as they were threatened, stirred inside their packaging, lending it a certain aura—the majesty and murderous stupidity of that organization of time and space and fuel and labor becoming visible in the commodity itself now that planes were grounded and the highways were starting to close. (19)

The "magical power"—the Benjaminian aura—that is stripped from the work of art, allowing it to say something rather than being mutely at-tached to a unique event, is here added to the unpretentious commodity, allowing it to say something. In a gratifyingly precise sense, both are "no longer a commodity fetish" (134)—the work of art, because something excessive and magical had been taken away; the jar of instant coffee, because something excessive and magical has been added. As everyone knows or should know, the fetish character of the commodity "is noth-ing but a definite social relation among people that assumes for them the phantasmagoric form of a relation among things" (K 86/C 165). The "secret" of the commodity lies in its spontaneous appearance as "a self-evident, trivial thing" (K 85/C 163): "if it could speak," what it would say is only that "what belongs to [me] as a thing is [my] value" (K 97/C 176). The "social relations that produced the object in my hand" cannot appear in the commodity as commodity, because the commod-ity, if it could speak, would tell us only its value. Therefore, when social relations appear within it, they only appear subjectively, as an acknowl-edged projection, "as if" they began to "stir inside their packaging."

The ascription of meaning to an artwork is meanwhile a social relation among people, but the exchange value of an artwork is no more a property of the thing than it is of any other thing: it is a property of the market, a social relation among people that assumes the form of a relation among things. But where the artwork is intended to embody a meaning, an ordinary commodity is intended to realize a value. Therefore, the artwork, stripped of its commodity character, looks like art; the "mundane" commodity, stripped of its commodity character, looks like magic.

The moment of the commodity's seeming to stir to life is a variation on the modernist sublime, a master trope from an earlier period, in which a banal and meaningless thing is jolted out of its context to signify something it cannot, a content that for that reason remains inchoate and unnamable. Since the whole power of the sublime is to conjure a content that it is beyond the signifier to express, the content of the sublime is in fact only the failure of the signifier itself. Rather than signifying totality, the modernist sublime is an empty stand-in for a concrete idea of the social totality, and for that reason, the sublime gesture is infinitely repeatable.[14] In *10:04*, however, neither the protagonist nor the author lacks a concrete conception of the social totality; nor is there anything uniquely Marxist any longer about the conception of the world of commodities being an organization both of "majesty and [of] murderous stupidity." Indeed, one of the hallmarks of contemporary ideology is the openness with which capitalism's murderous stupidity is openly acknowledged as a consequence and precondition of its majesty.

While the conception of totality glimpsed in the can of coffee is admirably concrete compared with that offered by the modernist sublime, the passage shares with the modernist sublime the fact that the tenor of the image is completely lacking in the vehicle: the content the protagonist finds in the coffee can only be a content that was already present in himself. The object that appears a little bit different—"a little changed, a little charged"—is, in the world that exists outside the messianic vision, exactly the same as it was before, and so is the protagonist. Indeed, the politics of the protagonist, despite the relative clarity of his world picture and the humaneness of his sympathies, turn out to be deeply conservative. The protagonist, a member of the Park Slope Food Coop, "liked having the money [he] spent on food and household goods go to an institution that made labor shared and visible and that you could usually trust to carry products that weren't the issue of openly evil con-

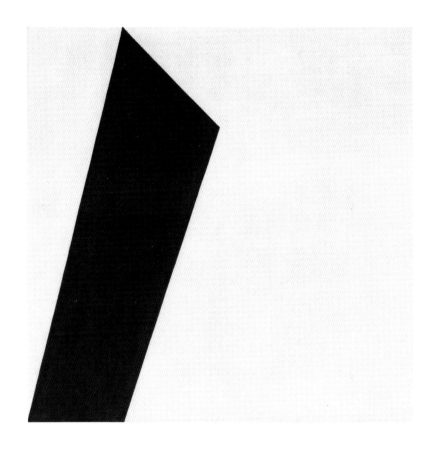

P1 Alfredo Volpi, *Composicão*, ca. 1958. Tempera on canvas. 27.375 × 27.375 in (69.5 × 69.5 cm). MUSEUM OF FINE ARTS, HOUSTON, ADOLPHO LEIRNER COLLECTION OF BRAZILIAN CONSTRUCTIVE ART, MUSEUM PURCHASE FUNDED BY THE CAROLINE WIESS LAW FOUNDATION, 2005.1035.

P2 Cindy Sherman, *Untitled Film Still #35*, 1979. Gelatin silver print. 10×8 in.
COURTESY OF THE ARTIST AND METRO PICTURES, NEW YORK.

P3 Cindy Sherman, *Untitled Film Still #3*, 1977. Gelatin silver print. 8 × 10 in.

P4 Cindy Sherman, *Untitled Film Still #53*, 1980. Gelatin silver print. 8 × 10 in.
COURTESY OF THE ARTIST AND METRO PICTURES, NEW YORK.

P5 Cindy Sherman, *Untitled Film Still #50*, 1979. Gelatin silver print. 8 × 10 in.
COURTESY OF THE ARTIST AND METRO PICTURES, NEW YORK.

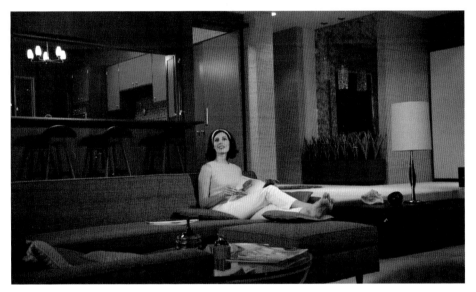

P6 Still from *Mad Men*.

P7 Still from *Mad Men*.

P8 Viktoria Binschtok, *Cutting Mat Cluster*, 2014. Framed c-prints. 91 × 100 cm, 45 × 45 cm. COURTESY OF THE ARTIST AND KLEMM'S BERLIN.

P9 Viktoria Binschtok, *Chanel Cluster*, 2016. Framed c-prints. 68×90 cm, 139×99 cm, 109×85 cm. COURTESY OF THE ARTIST AND KLEMM'S BERLIN.

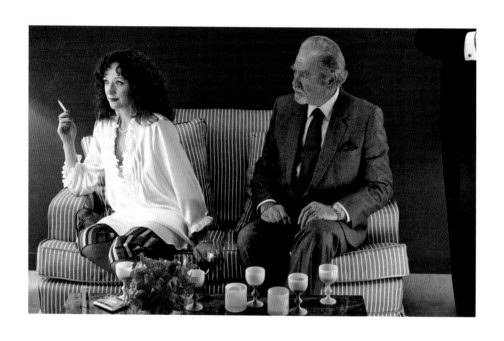

P10 Jeff Wall, *A Woman and Her Doctor*, 1980–81. Transparency in lightbox. 100.5 × 155.5 cm. COURTESY OF THE ARTIST.

P11 Jeff Wall, *The Flooded Grave*, 1998–2000. Transparency in lightbox.
228.6×282 cm. COURTESY OF THE ARTIST.

P12 Jeff Wall, *A View from an Apartment*, 2004–5. Transparency in lightbox. 167×244 cm. COURTESY OF THE ARTIST.

P13 Jeff Wall, *Outburst*, 1989. Transparency in lightbox. 229×312 cm. COURTESY OF THE ARTIST.

P14 Mike Osborne, *Aufzug*, 2009. Inkjet print. COURTESY OF THE ARTIST.

P15 Jeff Wall, *Morning Cleaning, Mies van der Rohe Foundation, Barcelona*, 1999. Transparency in lightbox. 187×351 cm. COURTESY OF THE ARTIST.

P16 Still from *True Detective*.

P17 Still from *True Detective*.

P18 Still from *True Detective*.

P19 Richard Misrach, *Trailer Home and Natural Gas Tanks, Good Hope Street, Norco, Louisiana*, 1998. © Richard Misrach. COURTESY FRAENKEL GALLERY, SAN FRANCISCO.

P20 Charles Ray, *Unpainted Sculpture*, 1997. Fiberglass, paint. 60×78 × 171 in.
COLLECTION WALKER ART CENTER, MINNEAPOLIS. GIFT OF BRUCE AND MARTHA AT-
WATER, ANN AND BARRIE BIRKS, DOLLY FITERMAN, ERWIN AND MIRIAM KELEN, LARRY
PERLMAN AND LINDA PETERSON PERLMAN, HARRIET AND EDSON SPENCER, WITH AD-
DITIONAL FUNDS FROM THE T. B. WALKER ACQUISITION FUND, 1998.

P21 Sebastião Salgado, *Migrations*. As they left the Krajina region, the refugees
were attacked by the Croatian population. Serbia, 1995. COURTESY OF THE ARTIST.

glomerates" (96). But unlike "the zealots who . . . looked down with a mixture of pity and rage at those who'd shop at Union Market or Key Food," the protagonist knows that as something he "likes," his "morally" un-trivial preference is a market choice rather than a political act. "Complaining indicated that you weren't foolish enough to believe that belonging to the co-op made you meaningfully less of a node in a capitalist network" (95). While his beliefs are more sophisticated than those of the liberal "zealots"—as with the coffee can, he sees the co-op for what it is rather than for what it says it is—his actions are indistinguishable from theirs. Moreover, if the zealots did not exist, they would have to be invented as an alibi by the more sophisticated skeptics: "For most of the members I knew . . . insulting the co-op was a mode of participation in its culture" (95).

While the material indistinguishability of art from commodity nonetheless reveals a "total" difference (the Cartier-Bresson print), here the little bit of difference (a more or less sophisticated understanding of how capitalism works) is no more than an alibi for an essential sameness. Later, when the protagonist meets with a student who has beliefs that are the same as his but a little different in that the student takes his seriously, the student can only appear to the protagonist—and to us—as "frightening" (217). Indeed, it is the signature attitude of the protagonist that, neither liberal "zealot" nor "frightening" radical, he believes what the radical believes and acts how the liberal acts. He is, in effect, a Stoic in the bad, Hegelian sense of someone who substitutes his freedom to interpret the world for the possibility of acting in it.[15] In the world of the novel, a world of potential co-op members, it is hard to imagine political beliefs making much of a difference. But the ostensible content of the novel is more or less a set of political beliefs—namely, those of the protagonist and the multiform ways he imagines the world to come "as it is now, just a little different," a weak messianism that is announced in the epigraph and plays out in every episode. One cannot immediately reject the possibility that 10:04 is a pure art commodity, selling us our own self-selection into the co-op of those too smart to be liberals and too sane to be anything else.

With this we have arrived at the center of the problem that animates 10:04, which, as a novel, is a commodity in the way a poem generally is not. "Nobody is going to give me strong six figures for a poem" (137), worries the protagonist, a poet who is, sort of, writing the novel we are

reading.[16] If the protagonist's problem is that his novel is a commodity, the protagonist's solution to the problem of the art commodity, as we have seen, is the totaled work of art, the artwork from which the "twenty-one grams of the market's soul had fled," art "before or after capital." The mode in which the protagonist understands the logic of "totaled" art is, in line with the epigraph, messianic: the work of art does not itself suspend the commodity form; rather, in being totaled, it is delivered from it in the eyes of the beholder. As with every other messianic episode in the novel, nothing changes but the subjective stance on which the perception rests.

The alterity of the totaled work is therefore paradoxically ahistorical. It represents the artwork "before or after" capitalism, art in the reconciled "world to come." But while capitalism will, one way or another, come to an end, the reconciled world will never come. The image of a reconciled world descends in a direct line from Schiller's concept of the ideal in "On Naïve and Sentimental Poetry." As a utopian horizon, its power derives from its nonidentity with the real: as György Lukács historicizes this relation, the phantasmatic *citoyen* never coincides with the flesh-and-blood *bourgeois*. But its temporal projection—effectively adding "messianic" to the Schillerian categories of the idyllic, the satirical, and the elegiac (with which, adding "after" to the "before" of capitalism, it has the most in common)—poses a problem.

In the narrator's logic, if the artwork is delivered from the commodity form, it appears as art before capitalism (Schiller's elegiac mode) or after capitalism (Lerner's messianic mode, the principal theme of the novel). But the novel itself does not have the luxury of waiting for a future that will never come. It must make its way in the present. The problem of the ahistorical future pertains to the narrator but is not the problem confronted by the novel—that is, the problem of the narrator is relativized by the form of the novel. No matter how close Ben Lerner is to Ben Lerner, the problems confronted by Ben Lerner the narrator and Ben Lerner the novelist are totally different, and this is true even if Ben Lerner the novelist understands the world in exactly the same way Ben Lerner the narrator does. The novel's understanding of the work of art is, in other words, the same as its protagonist's, just a little different.

This book has argued that art as such does not preexist capitalism and will not survive it; instead, art presents an unemphatic alterity to capitalism: art is not the before or after of capitalism but the deliberate

suspension of its logic, its determinate other. Whether or not this historical argument is correct, it is inarguably the case that *10:04* is published neither before nor after capitalism and therefore not only necessarily encounters the problem of the art commodity but produces it as a temptation to be courted. Like the unhinged student Calvin who, in discussing the potential of language to collapse into a meaningless "jumble of marks" (220)—the indexical trace of an event that *Unpainted Sculpture* would be if it were a death car instead of a sculpture of a death car that is (almost) indistinguishable from the death car—"want[s] to test it, take poison or whatever to show you can absorb it, but you don't know in that instance if it will be symbolic or spider out" (217), *10:04* deliberately runs the risk of the art commodity by assuming the form of something the market will recognize as a certain kind of novel, the kind written by "'literary novelists' who actually sold a ton of books" (154).

In Jennifer Ashton's account, *10:04* presents itself as "totaled in advance."[17] Not only is *10:04* a novel rather than a poem; it is a novel that, in the novel, has to meet certain market conditions. Primarily, it has to include in it the *New Yorker* story that was the basis of the protagonist's "strong six-figure" advance—a story that itself, in the novel, has been heavily revised to suit the editors of the *New Yorker*. Indeed, the section the protagonist "considered the story's core" (56) has to be cut. The story itself is more or less what you would expect—a finely written vignette with a tidy epiphanic tear jerk at the end—leavened only with some metafictional touches that read either as mainly decorative or as preparations for *10:04* itself. But since by the time we read the interpolated story many of its fictionalized elements, emotions, and turns of phrase—fictionalized from their already fictionalized versions in the novel, which nonetheless carry the weight of their embeddedness in the plot—have already been introduced, we have in effect been trained to see the storified version as arch and stagey and the climax in particular as a completely artificial sucker punch.

But this staging within staging is not geared, as one might expect, toward producing a reality effect in the surrounding material. Rather, the staginess of the story serves to cripple the illusionistic narrative material of rest of the book. As a novel *10:04* in effect totals itself: it cancels within itself its status as the art commodity that it is. The emotional gut punch of a climactic kiss, for example, is not only deliberately theatrical (it involves sprinting to a train platform to take

back a farewell), but "it never happened" (210)—the same phrase that accompanies the overwrought finale of the short story (81). The market paid in the "strong six figures" for a certain kind of novel, and the market got a certain kind of novel: if the protagonist is skeptical of "'literary novelists' who actually sold a ton of books," his author is nonetheless one of them. But the interpolated story trains us to see the market and subtract it from the work. In the self-totaled work, it is not the work but the commodity character that is damaged. Once we understand how the subway kiss works within the work—the immediate ("the sexiest kiss in the history of independent film" [208]) and architectural cues that alert us to the possibility that the scene diagetically "never happened"—we realize that the main sense in which it "never happened" is that it has nothing to do with what *10:04* is trying to do and everything to do with what it has to do to invoke and suspend the "literary novel," just as the car that "never existed in Detroit" has nothing to do with what *Unpainted Sculpture* is trying to do and everything to do with what it has to do to invoke and suspend sculptural presence. "The painting must have its frame, and the man his day's work"—and the idea its material support.[18]

The climactic kiss as climactic kiss is pure salesmanship, but like the exchange value of the totaled artwork, it can be subtracted as climactic kiss without touching the work. In the case of the novel, however, this negation is part of the form of the work. Indeed, realizing how it works—that the kiss "never happened" but, rather, has to happen—is the same as subtracting it (as climactic kiss). As a novel *10:04* does not assume the postmodern stoicism embodied in its protagonist or by the "totaled" work of art that was delivered without warning from the obligation to circulate as a commodity; it remains a commodity, but it suspends its own commodity character. Another way to say that *10:04* is "totaled in advance" is to say that it is self-totaling. Since the damage done to the commodity character of the work does not happen to the work but, rather, happens within it, this self-impedance is nothing other than the form of the novel itself, its immanent purposiveness. The meaning of the novel and its protagonist's ideology are in other words the same, only totally different. The protagonist's ideology hinges on an experience that consists essentially of a subjective change of viewpoint. But Lerner mobilizes the capacity of the novel as a genre, even in its most intensely first-person forms, to assign all statements to stand-

points implicated in a structure. This novel, it turns out, is not about a certain kind of experience, but about the subsumption of experience under meaning.

This disjunction between meaning and experience, between the meaning of the work and the ideology of its protagonist, is likely precisely what Ben Lerner the author had in mind; but it is also possible that Ben Lerner the author is himself committed to the same postmodern stoicism as his protagonist. The possibility that an author's intentions in writing her book are not on all fours with each other—in Lerner's case, the possibility that the unmistakable ambition to write a novel that would count as a work of art in the present might contradict an authorial belief that art is encountered in the mode of "before or after" capitalism—is a possibility that in Lerner's case and in the case of Jennifer Egan, later, cannot be dismissed. In the case of Tom McCarthy, to which we will turn shortly, it is unavoidable. However, this possibility will turn out to be of no particular methodological or epistemological concern.

The Hegelian notion of the "ruse" (*List*) operates on several levels at once. The originality of contemporary antihumanism is to claim that intentions (final causes) belong within the circle of cause and effect (efficient causes). (Alternatively, but in slightly more lunatic form, that causes and effects themselves express intentions.) But since Spinoza, it has been naïve to imagine that final causes are not themselves causally conditioned:

> When we say that being a place of habitation was the final cause of this or that house, we surely mean no more than this, that a man, from thinking of the advantages of domestic life, had an urge to build a house. Therefore, the need for a habitation insofar as it is considered as a final cause is nothing but this particular urge, which is in reality an efficient cause, and is considered as the prime cause because men are commonly ignorant of the causes of their own urges.[19]

Hegel, a Spinozist in his youth, does not propose to assert against this a naïve humanism. Equally contemptuous of individual ends, Hegel reminds us that "desire must always start again from the beginning."[20] But while the desire for a house is both unhistorical (Hegel) and purely within the circle of cause and effect (Spinoza), the tools that built the house are neither. Labor "looks on and controls [nature] through a light touch: a ruse (*List*). The broadside of force is turned back by the fine

point of cunning."[21] The final cause was just another efficient cause, but the efficient cause—the inclined plane, the keystone, the ruse—is not itself purely caused but also intended. But the tool as cause—the progressive mastery of means—was not the final cause, which was supposed to have been simply the house, whose primacy of place is usurped in history by the tools that built it. As for the genuinely unhistorical forces of nature, their "blind doing is made purposive (*zweckmäßigen*)—in opposition to themselves."[22] Nature is, as it were, ironized. What could this mean? The keystone cannot alter the law of gravity. Rather, nature, within human history, is not absolute; it is relativized, contained within the technique that opposes it. The self-opposition of nature, in other words, is not a deformation. Rather, the ruse, the keystone, causes its adversary to show itself: "Through its openness, it brings the other to show itself as it is."[23]

The purposiveness of the work of art, as we have maintained repeatedly, is identical to its purpose: there is no external end that it seeks to satisfy. The successful work can only be a means to itself. But the work nonetheless involves a ruse: an artifice that brings the other to show itself as it is. The raw, unpurposive material on which it works must be rendered purposive, without rendering this purposiveness as an external purpose. This is the insoluble problem to which every work represents a provisional solution. In this sense the ruse of the work is simply the relativizing power of immanent form. But the power of immanent form can also operate with a properly Hegelian cunning. If an external purpose deforms the material—miscalculates, as it were, the force of gravity—the edifice falls to the ground, and we have nothing but a failed work. But if a purpose conceived as external nonetheless results in a work—if its execution is such that purposiveness is successfully presented as immanent to the material—then it at the same time severs itself from the work absolutely. This is, in fact, tautological, since what characterizes the artwork is nothing other than the plausible claim that its form is immanent to a logic it both mobilizes and exposes. Like the tool, the work in this case would be a subjectively accessory intention, a ruse that objectively usurps the place of the external purpose. (Think of William Empson's claim that when proletarian fiction succeeds, it succeeds as pastoral.)[24] Any internal traces of the original purpose are now merely parts of the work, subject to the relativizing power of the whole. The ambition to produce something that counts as a work of art sets the logic of the work to work—even if

the formal principle is one of incoherence, and whether or not this logic is present in the mind of the artist as she works. What is more, which of the two versions of the ruse of the work is operative—whether external purpose is subjectively present—is, from the standpoint of the work, a matter of indifference, both epistemologically and methodologically. It is epistemologically indifferent because the external purpose as an event in the mind of the artist is a matter of speculation, even to the artist herself. (As an event in the world, it is the work if the work is successful, but then it does not appear as external.) It is methodologically indifferent because the criterion is the same in either case. Either the work has the power to compel our conviction or it does not; either the work is a vibrating string that resonates with our intuition of something in the world or it is not. If it is, we are obliged to bring close interpretive attention to the work—attention that may deepen that conviction or dispel it. If it is not, we are in some other business.

In the case of *10:04*, we have seen that the ambition to produce a work of art that must find its way, in the present, on the market is not on all fours with postmodern stoicism, which occupies a position of "before or after." It is the coherence by which this incoherence is made legible, the self-totaling of the commodity character of the work, that encompasses, subsumes, and gives meaning to all of the other meanings at work in the work, exposing the contradictions of postmodern stoicism. It is unlikely that Ben Lerner the novelist wanted his novel to be an apologia for postmodern stoicism. But if he did, the accessory intention—the novel we have—usurps the place of the external purpose about which we can only speculate.

When a work fails to hold as a work, however, its purposiveness appears externally imposed; incoherence in the work is the corollary of a legibly external intention imposed on it. Cormac McCarthy's *The Road*, for example, certainly has the feel of a work. Its untimely commitment to a personal style at the level of the sentence seems to position it, along with the rest of McCarthy's output, as a lonely outpost of modernist seriousness. But on closer examination, the McCarthyan sentence looks less like the modernist will to style as a mode of coherence than like a kind of decorative gingerbread. *The Road* is dominated by dialogue between an unnamed man and his son, dialogue that is narrated in the mode of Joycean naturalism: apparently transcribed speech, full of dead ends and banal repetitions, repurposed to the context of a narrative. But

when the man encounters an old man who calls himself Ely, the dialogue assumes a different kind of density:

Do you wish you would die?
No. But I might wish I had died. When you're alive you've always got that ahead of you.
Or you might wish you'd never been born.
Well. Beggars can't be choosers.
You think that would be asking too much.
What's done is done. Anyway, it's foolish to ask for luxuries in times like these.[25]

The episode ends "then all went on," and we recall that the post-apocalyptic scene looks like a literalization of the "dim void" of Beckettian settings like that of *Worstward Ho*, which, in a complicated way, concerns the journey of a dying man and a child: "Hand in hand with equal plod they go."[26] But part of the point of *Worstward Ho* is that it is a response to the problems of Joycean naturalism, a development out of it or, what amounts to the same thing, a critique of it, since the development is understood by Beckett to be a one-way street. Joyce's deliberate burying of content beneath, first, diligently collected everyday speech; and later, more elaborately conceived but nonetheless found linguistic logics (the later episodes of *Ulysses*, of which the "Eumaeus" and "Ithaca" episodes are the epitome) simultaneously depends on and exceeds a recognition procedure. *Worstward Ho*, however, narrativizes the absolute abhorrence of any kind of recognition procedure as a kind of permanent aesthetic crisis. These are, in other words, two different and incompatible solutions to the same problem—as is, in a historical epoch in which the market is the specific form of the problem that both Beckett and Joyce confronted as the pre-cognizing reader, Lerner's novel totaling. There is no reason that multiple approaches to the same problem cannot be assembled into a coherent whole. A set of procedures for doing just this will the substance of the chapter on music later in this book. But absent any kind of legible frame that would contain and relativize Joycean, Beckettian, and Faulknerian techniques—absent a way to understand them except as convenient for producing certain effects at certain moments—we are left with a book that overpaints its generic postapocalyptic narrative with portes cochères, "gelid" motor oil, and lyrical descriptions of fish rather than, as we will see of *The Wire* in the

chapter on television, exploiting a generic form whose constraints must be acknowledged and overcome rather than merely elevated stylistically. What remains is a genre novel that appeals to people who remember liking Faulkner in college or, worse, a fable about innocence, human nature, and environmental disaster. In Kantian terms, it seems that we are left with either the agreeable or the good, but here even the good is brought under the sign of the market and the agreeable, since without a commitment to the work, the ostensible message has no plausible claim to authority—invokes no criterion—and is therefore just something you happen to find appealing or annoying about the book.

While *The Road* makes claims at the level of the sentence that it has no interest in sustaining as a work, Tom McCarthy's *Remainder* is a work that declares the impossibility of a work. *Remainder*, as befits its title, is a novel about "surplus matter," the excess of matter over thought.[27] However, the novel itself clearly not only thematizes the excessiveness of matter but introduces it as a formal principle. Like Funes the Memorious, the protagonist may or may not owe his peculiar mental condition to an earlier brain injury; unlike Funes, his accident has led to a legal settlement large enough that he can turn his condition into a very expensive hobby. Essentially, the protagonist, who has had painstakingly to relearn how to perform previously natural actions such as picking up a carrot, has developed or become aware of a hypersensitivity to self-conscious behavior in himself or others, such that any evidence of self-consciousness strikes the protagonist as "crap: total crap" (60). His predicament could have been lifted from a well-known vignette by Heinrich von Kleist:

> About three years ago, I began, I was at the baths with a young man whose bearing was suffused with a remarkable gracefulness. He must have been about sixteen; one could faintly make out in him the first traces of vanity, raised by the favor bestowed on him by women. It happened that we had just seen, in Paris, the youth who pulls a splinter from his foot; the sculpture is well known and a copy of it can be found in most German collections. A glimpse of himself in a great mirror—caught in the instant this young man raised his foot to a stool to dry it—reminded him of the sculpture; he laughed and told me of the discovery he had made. In fact I had, in this same moment, made it too; but whether it was to test the reliability of that grace

that attended him, or to provide a little healthy check to his vanity, I laughed and replied—he must have been seeing ghosts! He blushed, and lifted his foot a second time, to show me; but the attempt, as could have been easily foreseen, miscarried. Flustered, he raised his foot a third and a fourth time, as many has ten times he raised it: in vain, he was incapable of bringing forth the same movement again— what am I saying? the movements he made had such a comic aspect that I had trouble holding back laughter:—

From that day, even from that moment on, the boy underwent a remarkable transformation. He began to spend whole days before the mirror; his charms abandoned him, one after another. An invisible and incomprehensible power seemed to settle like an iron net over the free play of his gestures, and after a year no trace could be discovered in him of the sweetness that had otherwise delighted the eyes of those around him.[28]

The protagonist of *Remainder* does not want to represent natural grace, as the sculpture does, but to experience it, as does the unhappy young man. Since the problem for both young men is, in Kleist's words, "how consciousness can disturb natural grace," the problem does not admit a stable solution. Consciousness can be made "inconspicuous"—a dancer in Kleist's essay, the figure to whom the narrator is speaking, prefers marionettes to human dancing—but the moment consciousness is located, we are once again confronted with, in our protagonist's words, "total crap," or, in the word of Kleist's dancer, "affectation" (*Ziererei*). The consciousness that is displaced in the marionette from the human dancer to the puppeteer has to be displaced, within the space of a sentence, yet again onto an imaginary mechanical puppet controller, which as someone's device is no more a surefire hedge against affectation than any other absorptive technique.

In *Remainder*, the protagonist's allergy to the affectation or self-consciousness he finds everywhere is relieved by two kinds of experience. First, it is relieved by a "tingling" that is associated with the experience of risk; and second, by a "calm contentedness" that is associated with the experience of "gracefulness" as it is understood in Kleist's essay—that is, the effect, toward which increasingly complex and expensive pains must be taken, of producing something that shows no sign of having been produced for an effect. Both would evade affectation or self-consciousness,

but in opposite ways. The first is the experience of an exposure to contingency; the second requires the elimination of contingency, since every instance of contingency will mar the consistency of the noncontingent and expose its essentially self-conscious, rhetorical aspect. This is precisely the paradox produced by Kleist's dancer, for whom grace appears as either total contingency or total mastery, in either "no consciousness or infinite consciousness, in the puppet or in the god." But as we have already seen, the puppet does not really solve the problem, because for dance to be dance, consciousness has to come into play, while the opposite possibility—infinite consciousness or complete mastery of the contingent—is given the name of an entity that, if it exists, does not dance, or if it does dance, dances as . . . unconscious matter.

The version of the problem confronted by the protagonist of *Remainder* is that, on one hand, contingency by definition cannot be planned, and on the other, the complete elimination of contingency is impossible. Thus, these two experiences are going to enter into a dialectic. The protagonist's first project, the "reenactment" of a boardinghouse down to the minutest behavior of its inhabitants and the "sandy dust" encrusted in the new-old varnish, is abandoned when the changing angle of the sun alters the length of time a sliver of light takes to grow to fill a staircase. The changing of seasons is not, in the ordinary run of things, a contingent event, but since it appears contingent from the standpoint of the boardinghouse project that neglects to take it into account, it reveals a flaw in the entire project. Henceforth, the protagonist will be chasing a "mixed sensation" (178), one that is "halfway between the gliding one I'd felt . . . during the first re-enactment in my building and the tingling one that had crept up my right side on several other occasions" (177). In other words, the protagonist is going to try to produce a frame durable enough to account for contingency in advance. When he runs across a crime scene, we get a sense of what this is going to look like:

> Forensic procedure is an art form, nothing less. No, I'll go further: it's higher, more refined, than any art form. Why? Because it's real. Take just one aspect of it—say the diagrams. With all their outlines, arrows and shaded blocks they look like abstract paintings, avant-garde ones from the last century—dances of shapes and flows as delicate and skilful as the markings on butterflies' wings. But they're not abstract at all. They're records of atrocities. Each line, each figure,

every angle—the ink itself vibrates with an almost intolerable vio-
lence, darkly screaming from the silence of white paper: something
has happened here, someone has died. (184)

This is not the first or the last time in the book that art will be enlisted
as a metaphor. The project of the boardinghouse had been sculptural,
to "get rid of . . . the surplus matter" (91). Here the forensic procedure
is completely unaffected or graceful, since it is meant as a pure com-
munication. The beauty of the diagram is understood as accidental.
For this reason, it is "higher," certainly other, than an artwork, whose
beauty cannot be understood as accidental and is therefore too self-
conscious. However, the diagram is "real," which means here that the
here and now of the contingent event is not the problem but the point:
"something has happened here, someone has died."

In *Unpainted Sculpture*, the contingent facticity of the death scene,
once it becomes the content of a work of art, turns immediately into the
hyperbolic drama of a haunting—a drama that the sculpture in turn
suspends. But the problem for the protagonist of *Remainder*, while it
partakes of the dialectic that animates Ray's *Untitled Sculpture*, is totally
different. Ray's sculpture is interested in the contingent event to over-
come it in the noncontingency of form. The protagonist of *Remainder*,
by contrast, is interested in the contingent event to experience it in its
contingency, even as his interest in it removes its contingency. Inhabiting
both sides of Kleist's paradox at once, *Remainder*'s protagonist is only
after a certain effect of the real. *Remainder* itself, however, produces a
kind of realism despite the strangeness of its premises: a narrative that
convinces us that its logic is immanent to its material, a vibrating string
that awakens a recognition of something we do not yet know. This nar-
row band of experience is the problem of "total crap," "affectation,"
or "how consciousness can disturb natural grace"—in other words, the
problem of deliberately producing the experience of nondeliberateness
or, in yet other words, the unattainable experience of the plenitude of
the real, the insoluble problem of authenticity. The resonance of this
logic, the novel's moment of realism, then, has nothing to do with the
effect of the real. Indeed, it is durable enough to withstand sometimes
substantial violations of surface verisimilitude.

While for the protagonist the forensic diagram might be higher than
an artwork since it is without affectation, it is still a trace of an experi-

ence, not the experience itself. To experience this contingent, real event, it has to be planned, and the dialectic is under way yet again. The protagonist's next project will be to inhabit the diagram rather than to look at it, a project that escalates into a bank heist and, ultimately, a plane hijacking and involves the deaths of at least several and presumably scores of people. Perhaps we are meant to understand that the attempt to eliminate surplus matter, to submit matter to the idea, radically to enframe contingency—in another register, the will to system, the concept of totality—is violent and illiberal. Maybe, and McCarthy would not have been the first to have thought so, not by a couple of centuries. But while the older McCarthy's lessons and their stylistic elevation are the only things that could possibly be interesting about *The Road*, the younger McCarthy's lessons are the least compelling thing about *Remainder*, which is a work of art, even of genius.

In chasing an experience, the protagonist is no different from any billionaire who wants to jump from a balloon. There is no history to the protagonist's project, no normative field in which it participates, no universal or social machine in which it is intended to intervene. In short, it has no meaning. "I didn't need to make them share my vision, and I didn't want them to. Why should they? It was my vision, and I was the one with the money" (113). The protagonist's expensive habit, in other words, is a peculiar kind of commodity. His enjoyment of his projects does not even involve a private significance. Each project exhausts itself in the "tingling" or "contentedness" it produces. Needless to say, this cannot be the attitude of *Remainder*, which is a novel. This means that its "vision" only exists to be shared; that is, it is intended to mean something, even if what it is intended to mean is a critique of the intent to mean something.

The beauty of *Remainder* resides almost entirely in the plot, which produces the protagonist's metamorphosis from slightly pathetic guy to terrorist as an inexorable and entirely logical progression, as a series of attempts to solve a problem that is presented as given; as, in short, a dialectic. That is, the novel presents itself as simply following a logic that is already present in the material, as though the novel were not written by an author but dictated by the inner logic of the problem of "total crap," or the conspicuousness of external intention. It is this logic to which all of the novel's narrative material is submitted. In other words, while totalizing logic may be illiberal, it is the very mode of the work

of art. It is not that *Remainder* solves Kleist's dancer's dilemma, which is the problem of producing the effect of the real. Rather, it solves a different problem—namely, how to present, in a work of art that, like all works of art, is restricted to a vanishingly narrow band of experience, a logic that exists in the real. Realism's ancient and nondogmatic core—the unity of an action as the ruse of the work, that which through its apparent guilelessness "brings the other to show itself as it is"—does not solve the problem of the reality-effect, but rather ironizes it.

In the reenacted boardinghouse, the parts that the protagonist has not thoroughly worked out in advance are left as "blank stretches" or "neutral space" (120). Recall that, for Ray, one of the primary problems of *Unpainted Sculpture* was "what areas should be left blank." The novel abounds in such neutral space—the nature of the accident that sets everything in motion, the friend and love interest who disappear after the first act—as must every novel. In a first-person novel such as *Remainder*, we do not know what goes on in the minds of the other characters, and what we do not know about does not happen, even if we fill that neutral space in with the assumption that they must be thinking something. But in *Remainder*, one such neutral space is heavily marked. The protagonist ends up on a plane he has hijacked, ordering the captain to turn figure eights in the sky. Presumably, the plane eventually crashes, as the protagonist is not interested in bringing the sequence to an end. After telling the captain to continue the pattern, the protagonist suggests that the pattern will go on until the sun burns out. "Or maybe, before then, we'd just run out of fuel" (308). However, the protagonist seems to be writing the novel in the present. Not only is the novel written in the past tense, but the protagonist considers the events of the novel "with the advantage—as they say—of hindsight" (111), and to emphasize the point, the phrase is repeated almost verbatim 150 pages later (263). In other words, what happens after the last words of the novel is marked as blank space: what in a logical sense must happen next can, in a narrative sense, not happen next. While "surplus matter" in the form of a lack of matter (a "running out of fuel" that is no doubt meant allegorically, as a disastrous consequence of technological enframing) will ultimately bring down a plane in real life, we cannot say the same thing about the plane in the novel, which both falls to the ground (the concept "airplane" includes the aspect of falling to the

ground if it runs out of fuel) and does not (the narrator tells us about the plane's holding pattern in hindsight). This can mean only that matter does not matter in the same way in a novel as it does outside it. This brings us to the matter of cordite.

The protagonist appears obsessed with the smell of cordite, which is dropped in like a clue early in the novel—in the first act, as it were (37)—and is repeated at intervals throughout. But when somebody finally asks him about it near the end of the novel, he responds, "I don't think I've ever been near cordite" (280), which is more plausible than the reverse, since cordite has not been used since World War II. However, we all know from detective novels that cordite is somehow associated with ammunition, which, for more or less obvious reasons (the explosion in a piston or bullet being another version of the enframing of matter, the making noncontingent of the contingent), becomes an obsession of the protagonist. The reference is oblique but clearly to the dictum attributed to Chekhov, which in one popular version goes like this: "To make a face out of marble means to remove from that piece of marble everything that is not a face. Remove everything that has no relevance to the story. If you say in the first chapter that there is a rifle hanging on the wall, in the second or third chapter it absolutely must go off. If it's not going to be fired, it shouldn't be hanging there."[29] While guns will fire in *Remainder*, the cordite will not. It remains something that has "no relevance to the story," marble that is not a face, "surplus matter," a meaningless remainder. This would seem to suggest that the novel puts itself on the side of the nontotalizers against totalizers such as the protagonist. But there are two things to be said about this. First, of course, thematizing meaninglessness is the very opposite of meaninglessness, and since it plays into the theme of the book, the pointless cordite can hardly be considered extraneous. Rather, it is part of the system of details that give the book its extraordinary intentional density. The second, however, is that Chekhov was a playwright, not a novelist. For Lukács, we recall, drama and novel were not only different narrative forms but compositionally opposite forms. Where drama requires condensation, the novel requires the illusion of infinite expansion and, therefore, a host of elements that must be "superfluous from the point of view of the drama."[30] Indeed, the proliferation of surplus matter as essential to the production of novelistic plausibility—and therefore not,

from the point of view of the novel, superfluous at all, even though it must appear superfluous to serve its purpose or, in other words, to be in fact nonsuperfluous—has been an essential element of novelistic form from the beginning. Recall *Robinson Crusoe*, with its redundant and mildly contradictory journal version of the main narrative and its cultivation of dead ends and remainders of all kinds: "I never saw them afterwards, or any sign of them, except for three of their hats, one cap, and two shoes that were not fellows."[31] But as we have seen, the plausibility of *Remainder* derives primarily not from such deliberately superfluous elements, but from the logic of the protagonist's progression. The superfluity that is not a superfluity of the cordite tips the hand of what appears to be McCarthy's external purpose, the official, anti-idealist ideology of the work. Along with some fancy intertextual footwork near the end of the novel, the cordite plot is a rare moment of evident self-consciousness, and as such, "total crap." But since the strength of the novel lies not in obsessive attention to surface detail—that is the narrator's problem—but in the rigor of its narrative logic, such lapses do not destroy the beauty of the plot.

Remainder betrays a wish to be, without remainder, a novel about remainders as a check on the pretensions of consciousness. But without the activity of consciousness, there can be no check: consciousness remains the active factor. *Remainder* is therefore—necessarily—a novel about the impossibility of experience unmediated by self-consciousness. The difference between *Remainder* and its protagonist, a self-described "addict" (264) chasing a certain affect—the point at which the ruse of the work asserts itself—is therefore not the official one between totalization and nontotalization, totality and remainder, idea and matter, but the one between meaning and experience. In terms of literary history, it is the difference between something like realism and something like naturalism. Or, as *Unpainted Sculpture* has taught us to think, the difference between an experience that is the equivalent of a structure and an experience that is not.

The substitution of experience for meaning—of "something has happened" in the literal, contingent sense for the kind of happening that happens in a work of art—has been a common trope in the fiction of the past decade and a half. We see it in spades in *Remainder*, where the experience of a simple object "fired up, silently zinging with significance" (142) is the whole point of the protagonist's post-accident existence,

and in *10:04*, in the example of the coffee can. One thinks here also of Benjamin Kunkel's hapless Dwight B. Wilmerding, for whom, under the imagined influence of a nonexistent drug, "all the commodities on their shelves had seemed to brim and gleam with imminent disclosures."[32] Or of the protagonist of Teju Cole's *Open City*, who, under the influence of Mahler's *Das Lied von der Erde*, experiences a "new intensity in even the most ordinary things. . . . Every detail had somehow become significant."[33] In every case, and this is the distinction from the modernist sublime proper, the "significance" of the sublime object is not a subreption, a meaning actually (for the character or work) but falsely (for the work or critic) attributed to the thing. Rather, the significance is understood to be a purely affective experience by the one who experiences it, the very opposite of Virginia Woolf's "a match burning in a crocus; an inner meaning almost expressed," which pertains to moments of intimacy in which Clarissa Dalloway "felt the world come closer, swollen with some astonishing significance."[34] The protagonist of Reinaldo Moraes's *Pornopopéia*, in a passage that parodies this movement—his target is a passage in *O amenuense Belmiro*, whose closest English-language equivalent might be the vision of the bird girl in *Portrait of the Artist as a Young Man*—sees the matter somewhat differently. "I was struck by the need to *understand* the nudity of that girl," he insists. But the girl's meaning, "a Christian epiphany . . . a fugitive vision of the Hegelian zeitgeist . . . a sudden traversal of the Lacanian fantasy," in the end "consists in the hard-on itself, nothing more."[35]

In this mode, Sasha, the first thread through Jennifer Egan's deviously brilliant *A Visit from the Goon Squad*, counteracts the tedium of "life-as-usual" by stealing things:

> Opening her eyes, she saw the plumber's tool belt lying on the floor at her feet. It had a beautiful screwdriver in it, the orange translucent handle gleaming like a lollipop in its worn leather loop, the silvery shaft sculpted, sparkling. Sasha felt herself contract around the object in a single yawn of appetite; she needed to hold the screwdriver, just for a minute. She bent her knees and plucked it noiselessly from the belt. . . . She was good at this—*made for it*, she often thought, in the first drifty moments after lifting something. And once the screwdriver was in her hand, she felt instant relief from the pain of having an old soft-backed man snuffling under her tub, and then something more

than relief: a blessed indifference, as if the very idea of feeling pain over such a thing were baffling.

"And what about after he'd gone?" . . .

"Normal," she said. . . . "Like any other screwdriver."[36]

Crime, with its interaction of planning and risk, attracts Sasha for much the same reason it attracts the protagonist of *Remainder*. After a theft, "the scene tingled" (5).

The peculiar form of *A Visit from the Goon Squad*—a set of thirteen loosely but insistently connected vignettes culminating in two separate endings, one of which is written as a PowerPoint presentation—will not have escaped anyone's attention. Of the novel's thirteen chapters, eight appeared previously as short stories, many of them in the *New Yorker*. They are told in different voices, not all of which connect strongly to the central threads, are by no means stylistically uniform, and exhibit a certain amount of deliberately legible pasticherie. The first thing that one would have to say about these stories is that they are individually unendurable. Not that there are any failures of craft—as we shall see, this is very far from the case. Rather, they appear to be the fictional equivalent of, say, Norah Jones: pure professional competence in the service of a middlebrow pop aesthetic, the very aesthetic that the protagonist of *10:04* is suspicious of: "describe faces . . . make sure the protagonist undergoes a transformation" (156). Sasha has "high cheekbones [elsewhere delicate and lightly freckled] and narrow green eyes, wavy hair that ranged from reddish to purplish, depending on the month" (27), and the novel will take her from Xanax-popping New York shoplifting post-punk underemployed former personal assistant to happy southwestern suburban mother, housewife, and amateur sculptor. As she says herself, a little desperately, it is a "story of redemption, of fresh beginnings and second chances" (9).

Taken separately, the stories are delivery systems for exquisitely timed emotional effects. The most brutal example is "Safari," which saves the fact of a son's eventual suicide until the penultimate page, reserving for the last sentence a mild punch line as a consolation for having had the wind knocked out of you seconds before. In *A Visit from the Goon Squad* we find the sharpest discontinuity between short story and novel. This discontinuity is intrinsic to the two forms. (Think of the short stories written by Machado de Assis during the period in which

he published his last, great novels, with which they share a great deal, particularly in terms of narrative voice. But in *Dom Casmurro* and *The Posthumous Memoirs of Brás Cubas*, the narrative voice that dominates the foreground is relativized by the form of the whole, something that Machado does not accomplish in the stories. For this reason, Kafka's stories are far more successful than Machado's, while Machado's novels are infinitely more accomplished than Kafka's.) The originality of *A Visit from the Goon Squad* is that the disjunction between short story and novel is mapped onto the distinction between art commodity and artwork: the former fulfills its commercial purpose, while the latter exceeds it. But this excess will not be at the level of serious, book club-ready content, which is in fact easy to find. "Time's a goon, right?" (127) asks an apparently mortally sick former punk rocker who will end up as a dairy farmer—and his producer asks another former punk guitarist the same question two hundred pages later (332). So the novel is on one hand about growing up and growing old, and on the other about the afterlife of punk. The first of these is more of a demographic than a theme; so is the second. We will return shortly to the specificity of punk as it functions in the novel. But for now, with regard to such apparently substantial thematic material, it is worth noting that in the final chapter, set in a near future in which the culture industry—which in this future means culture as such—is entirely oriented toward attracting the attention of small children, a musical performance manages to attract adults' interest by mobilizing "double meanings and hidden layers, which were easy to find" (335). "Meanings" that are hidden just deep enough for adults to find them easily—think of A. O. Scott reviewing a Pixar film—are understood to be just good culture-industry product. On the level of serious content, the novel knows that it is nothing more than the sum of its parts.

While music is central to *A Visit from the Goon Squad*, nowhere in the novel is the standpoint of a working musician adopted. The narrative point of view tends to stick close to fans, people who were once in a band, publicists, personal assistants, talent agents, half-tame journalists, producers. Where the narrative point of view does approach a musician, the standpoint adopted is always that of the music industry: a failed guitarist's resentment of a successful record executive, another guitarist's petition to a publicist to help with his comeback. (What music does get made is reliably described as "unlistenable" [33, 36]

or some similar adjective.) *A Visit from the Goon Squad* is, in other words, a novel about the culture industry, and the happy endings for its two main characters are by no means happy endings for the book.

Bennie Salazar, the former punk, now music producer, and, with Sasha, the second main thread through the narrative, works "tirelessly, feverishly, to get things right, stay on top, make songs that people would love and buy and download as ring tones (and steal, of course)— above all, to satisfy the multinational crude-oil extractors he'd sold his label to five years ago. But Bennie knew that what he was bringing into the world was shit" (23). Bennie ascribes the shittiness of the music he makes to digital technology, but beneath this diagnosis lies a deeper relationship to the musical event. "Hearing the music get *made*, that was the thing: people and instruments and beaten-looking equipment aligning abruptly into a single structure of sound, flexible and alive. . . . Bennie experienced a bump of anticipation; something was going to happen here. He knew it. Felt it pricking his arms and chest" (29). "Something was going to happen here" is precisely what excites Sasha about stealing things: "It seemed so dull, so life-as-usual, to just leave it there rather than seize the moment, accept the challenge, take the leap . . . live dangerously . . . and *take* the fucking thing" (3–4). And for Bennie, something does happen: "Then the sisters began to sing. Oh, the raw, almost threadbare sound of their voices mixed with the clash of instruments—these sensations met with a faculty deeper in Bennie than judgment or even pleasure; they communed directly with his body, whose shivering, bursting reply made him dizzy. And here was his first erection in months" (30). Meanwhile—earlier in the book, later chronologically—Sasha's relationship to her stolen objects has the same bodily effect. She had been "tired of Alex" (12), her date. But "watching Alex move his eyes over the piles of [stolen] objects stirred something in Sasha. She put her arms around him from behind, and he turned, surprised but willing" (15). For both Sasha and Bennie, what is missing in life (or contemporary music) is a certain kind of experience, an experience of "something happening," which is supplied by stealing things (or another kind of music).

A minor character, an art historian, has, like Bennie, a visceral re- action to an artwork, "a physical quickening . . . that verge[s] on the erotic" (214)—in this case, a bas-relief of Orpheus and Eurydice. "What moved Ted, mashed some delicate glassware in his chest, was the quiet

of their interaction, the absence of drama or tears as they gazed at each other." While Ted's reaction has an affective, bodily element, the bodily element is experienced in relation to the structure of the sculpture, its setting aside of the drama of Orpheus and Eurydice's parting. But since this will always be there, the effect does not, as it does with that of Bennie's rehearsal, wear off: "Ted left the room and came back. Each time, the sensation awaited him: a fibrillating excitement such as he hadn't felt in years in response to a work of art" (214–15). Bennie's experience of music, by contrast, is not the equivalent of a structure. When, in the scene cited at length earlier, Bennie has to step outside because of a panic attack, Sasha ascribes it to the sisters' "awful" performance. "'Unlistenable,' Sasha went on. 'No wonder you were having a heart attack'" (33). Bennie, who until then had not formed a judgment— in fact, his "deeper," bodily experience explicitly exempts him from judgment—has to agree: "Of course. They were awful. That was the problem" (33). But for Bennie and for us, the panic attack has no more to do with the music than did his initial enthusiasm: "And from the zenith of lusty, devouring joy, he recalled opening an email he'd been inadvertently copied on" (31). Bennie turns out not to require much in the way of the "structure of sound" that the novel's free indirect discourse ascribes to his interior monologue; his "pricking" anticipation of the sisters' singing has nothing to do with music in particular and everything to do with the experience of contingency and risk that go along with performance. His displeasure is with being distracted from that experience. Bennie's experience does not correspond to a structure. It "consists in the hard-on itself, nothing more."

Both Sasha and Bennie get their happy endings. But while the first two chapters, from which we have been reading, were published as short stories, the last two belong only to the book. The final chapter is narrated in a future world that is, though comfortable for its characters, a nightmare around the edges. Global warming has provoked the construction of a massive seawall around New York and somehow altered the Earth's axial tilt; the sound of helicopters patrolling the city cannot be escaped. Most important, the culture industry has so invaded every nook and cranny of social life that "'who's paying you' was a retort that might follow any bout of enthusiasm" (315). This is the world, which we return to shortly, in which Bennie thrives. Meanwhile, Sasha's happily ever after, the book's penultimate chapter, is of such a treacly,

sentimental quality that if it were written out, it would reveal itself too obviously as a parody of a "story of redemption, of fresh beginnings and second chances": a minor character from an earlier chapter is imported as a white knight of impossible goodness, and a moment of impatience on his part (under the weight of that impossible goodness) is magnified such that the episode's resolution has an almost magical capacity to jerk tears. But the chapter is not written out. It appears in the form of a twelve-year-old girl's "slide diary," so that the sentimentality is somewhat obscured by the form and somewhat deflected onto the fictional diarist.[37]

What we learn from this chapter, however, is that from the standpoint of the novel's central concerns, Sasha's transformation is not all that transformative. Her life seems to be occupied with two hobbies, or "art" projects (the scare quotes are her daughter's), which happen to be—not coincidentally, since they represent two unsatisfactory ways to produce the effect of the real, two kinds of naturalism—static versions of the options confronted by the protagonist of *Remainder*. The first is a kind of three-dimensional scrapbooking: "found objects" from "our house and our lives" are pasted onto boards and shellacked. "They're precious because they're casual and meaningless," but they "tell the whole story if you really look" (265). In other words, they function in precisely the same way as Sasha's tables full of stolen stuff: "a heap of objects that was illegible and yet clearly not random. . . . It contained years of her life compressed" (15). The second is to make "sculptures in the desert out of trash and our old toys" (242). This project bears a family resemblance to the first, except that no story, meaning, or structure is ascribed to the larger sculptures. Rather, "eventually her sculptures fall apart, which is 'part of the process'" (242). The analogue of the first project is short-story naturalism, from *Dubliners* to Raymond Carver. The second, however, is precisely how Sasha understands the liftable object, and how Bennie understands music: rather than meaning something, the sculptures are a site where something happens.

Now, of course, something does happen—or can—in a musical work, which is why a performance of, say, Shostakovich's Eighth Symphony can be just a little different from even a very fine recording of the same symphony, where the happening of the work of art has already happened. But the happening we experience in musical performance is the kind of happening we saw in *Unpainted Sculpture*, a happening that can

equally be described as a structure, a happening that is in the score even if it does not always happen or does not always happen in the same way. The apotheosis of the work of art as a space where "something happens" in Bennie's or Sasha's sense—where it is the happening, not the happening of a structure, that counts—is the comeback tour of Bosco, a protégé of Bennie's who has gone "from being a rock star to being a fat fuck no one cares about" (127). He is not only fat, but "huge—from medications, he claimed, both postcancer and antidepressant. . . . An unsuccessful hip replacement had left him with the lurching, belly-hoisting gait of a refrigerator on a hand truck" (125). We can safely assume that his music is awful: "Bosco's recent album consisted of gnarled little ditties accompanied by a ukulele" (122). But it turns out that the music is the least important aspect of his comeback tour:

> She was dancing around the fact that Bosco wasn't remotely capable of performing in his old manner, and that trying to do so would kill him—probably sooner than later.
>
> "Don't you get it, Steph?" Bosco finally exploded. "That's the whole point. We know the outcome, but we don't know when, or where, or who will be there when it finally happens. It's a Suicide Tour." (129)

In the end, the tour ends up getting Bosco back in shape instead of killing him (another happy ending!). But the point is made: "'Reality TV, hell—it doesn't get any realer than this. Suicide is a weapon; that we all know. But what about an art?'" (129). Marina Abramović's blood, Riggan Thompson's nose. For Bosco, as for Sasha and Bennie, the "whole point" of art is that something happens—and what happens is "real." It pertains to the "here and now" of something happening, a unique event; Benjaminian aura as we have understood it in this chapter: "Something has happened here, someone has died."

This brings us to Bennie's climactic final chapter and the heart of the matter. For on one hand, this kind of happening really is the "whole point" of Bosco's tour. It is why people will come to it. In other words, the market value of the tour lies in its kind of "reality." On the other hand, a reality that is staged to sell tickets is a funny kind of reality, one that requires something like the possibility of death to have any plausibility at all—the extremity of the event is in fact the only point of superiority to the reality TV with which Bosco compares it. (It is here that we

realize that when *Unpainted Sculpture* sets aside the contingent event at its origin, it also sets aside the market.) The final chapter concerns another comeback, this one triumphantly successful and engineered by Bennie. The real work of the comeback has once again nothing to do with the music. In his triumphant performance the guitarist is described as "unsteady" (335), which reminds us of the earlier girl group's "threadbare" voices and their "erratic" rhythm (31). Bennie seems to love it, "every part of him alive with the palpable act of listening" (312). But what does he hear? "'He's absolutely pure,' he said. 'Untouched'" (312). But "untouched" is an ethical category, not a musical one. This is the real referent of "something about to happen," and of the constant ascription of authenticity by characters in the novel to others among the punks in their youth, when each knows herself to be only performing her identity but ascribes real identity to others ("Our sweat is mixed up with real punks' sweat" [46]): something that would lie outside the circuit of commodification, of the ambit of songs made so that "people would love and buy" them. But "untouched" is not something you can hear the way you can hear a musical idea. All you can hear in terms of distinction from what is not untouched—that is, in distinction from music that is loved and bought by others—is its difference from music loved and bought by others. To the vaguely indie young man listening with Bennie, the music sounds "dire" (313). This may be an ambivalent term in hipster-speak circa 2121, but it was not three hundred pages earlier when it described an awful evening (5).

The real work of the comeback comes in the form of a massive viral campaign run by our vaguely indie guy who, in agreeing to take the job, reckons that he "has sold himself unthinkingly at the very point in his life when he'd felt most subversive" (316). Initially, the title of the chapter, "Pure Language," is hard to make sense of; the earlier chapter titles all have a straightforward relationship to their material. The clue comes well into the chapter, as a relentless publicist attempts (successfully) to get the young man to turn his vaguely indie circle of friends into a vast marketing machine. After committing a faux pas, a publicist complains, "All we've got are metaphors, and they're never exactly right. You can't ever just *Say. The. Thing*" (320). You can't say the thing, but you can sell it. The "pure language" of the title is the language of the market. After sealing the deal, the publicist "looked almost sleepy with relief. 'It's pure—no philosophy, no metaphors, no judgments'" (321).

If everything is marketing, if the presumption is that all speech is paid speech, then we know what everything means whether or not we understand what it says.

The problem to which the aging punk Bennie is the solution is that if everything has to be understood as immediately a commodity, then things that look like noncommodities are extremely rare. If they are rare in a world that consists of an enormous mass of commodities, they are valuable commodities—as long as they maintain the appearance of being noncommodities. The young man's viral campaign works only as long as everyone involved pretends not to be involved, and the performance of our unsteady guitarist, Scotty Hausmann, works only as long as he appears "untouched" by the music industry. And, indeed, the concert is not only a success but almost a historical event. The massive audience "gaze at Scotty Hausmann with the rhapsodic joy of a generation descrying someone worthy of its veneration" (336). But again, Scotty is not venerated because of his music, but because he appears as "the embodiment of their own unease" (335), because he had been "forgotten and full of rage, in a way that now registered as pure. Untouched" (336)—in other words, as advertised.

This aporia—the noncommodity being, from one standpoint, the only commodity worth having—is all too familiar to us from the culture pages, where it is the dialectical mirror image of the other ever present position (that of our publicist) that everything is already a commodity anyway, and there is officially no reason to look for anything else. But while *A Visit from the Goon Squad* might thematize this aporia, it does not occupy it. *A Visit from the Goon Squad* obviously cannot make any kind of claim to be "pure, untouched." On the contrary, the market niche to which the individual stories appeal is made pretty clear by the magazines acknowledged on the copyright page, and the generational appeal they make—the identificatory call to people who used to go to shows, or wish they had, and who now read the *New Yorker*—is just as obvious. More consequently, the formal consistency of the novel lies in the intense cross-threading of narratives, a technique that, if anything, very occasionally crosses the boundary into distracting virtuosity: Kleist's dancer's "affectation," the very opposite of punk authenticity. But it cannot occupy the pure culture-industry position, either, precisely because, as we have seen, it understands the consequences: in a world where the work of art is a commodity like any other, there is no speech,

only salesmanship and its dialectical other, the perpetual search for authenticity. "Story" is one of the words that, in the pure culture-industry world of the 2120s, "had been shucked of their meanings and reduced to husks" (324). Most important, its aesthetic commitments—centrally, the effort to subsume its moving parts into a structure that relativizes all of them—do not fall on either side of aporia but, rather, frame it.

The work of art makes its way in the world of commodities, not outside of it, and exceeds the commodity not by way of an ideology of authenticity—which, as we have seen, is just another commodity—but only by invoking the institution of art. During his period of exile from the music industry, Scotty, working as a janitor, spends his evenings in front of the television. "You might say I created my own show out of all those other shows, which I suspected was actually better than the shows themselves. In fact, I was sure of it" (96). Now, as we will see in the final chapter of this book, Scotty gets the phenomenology of television exactly right: rather than presenting works, TV in its classical form accompanies an evening. In one way, Scotty's claim is a standard cultural-studies line on what people do with all culture: meaning lies not in the work but in its appropriation. But Scotty does not just claim to make these shows his; he claims to make them better. He claims that in his evenings, he makes works that subsume the nonworks on TV. Whether or not Scotty can make television into art by simply casting a glance, his account of his evenings describes the mode of *A Visit from the Goon Squad*: it is an invocation of the ruse of the work, whereby the logic of the whole subsumes the logic of its parts.

At the end of the novel, the young man who has turned his circle of friends into an advertising machine closes his eyes and listens to the sound of the urban night. What he hears is "the hum, always the hum, which maybe wasn't an echo after all, but the sound of time passing" (340). So far, so obvious. But where have we heard this before? Sasha's mildly autistic son, Linc, collects "Great Rock and Roll Pauses." He plays various games with them, including looping them and allegorizing them: "a sort of rushing sound in the background that I think is supposed to be the wind, or maybe time rushing past!" (249)—not an implausible interpretation given the song from which the pause is taken. But like everything else in music, only more obviously so, a pause only means anything—only is, in fact, a pause—in relationship to what comes before and what comes after. In other words, it is a pause only

in relation to the logic of the whole. And the climactic moment of the chapter's individual logic—the scene following the flash of impatience on the part of the impossibly good father—is also, from the standpoint of the whole, the moment that the logic of the whole reasserts itself, as Sasha has to explain Linc's fascination with pauses: "The pause makes you think the song will end. And then the song isn't really over, so you're relieved. But then the song *does* actually end, because every song ends, obviously, and THAT. TIME. THE. END. IS. FOR. REAL" (281). Linc's pauses do not have an immediate meaning ("time passes") but have, rather, a meaning mediated through the whole ("this sounds like an ending, but it's not"). In the same way, "the sound of time passing," the aging of the punk generation, the moment "they had stopped being themselves without realizing it" (317)—in other words, the sentimental theme of growing old and selling out—is only a pop pseudo-meaning, of which punk authenticity is the necessary corollary. *A Visit from the Goon Squad* does not occupy this dialectic. Instead, it sets it in motion, bringing it to show itself as it is. Egan's goon is the equivalent of Charles Ray's ghost. *A Visit from the Goon Squad* is about producing a work of art, a novel in which no part, including its official themes, can be understood without reference to a totality that relativizes them. The opposition of authenticity and selling out is only an apparent opposition; both are ways of being in the market. But while in our society there may be nothing to consume that is not a commodity, a work of art calls for interpretation, which means that it is both a commodity and something totally different.

Sometime between 2006 and the 2020s, Bennie "had returned to producing music with a raspy, analog sound, none of which had really sold" (312). It is an odd moment, perhaps the only false note in the book, since the post-punk music Bennie is producing is, at the historical moment he is supposed to be making it, selling reasonably well. The White Stripes, to whom we return in the next chapter, are a kind of nodal point in this development, formalizing more diffuse developments that preceded them and spawning a whole raft of often unabashedly commercial imitators banking on a "raspy, analog sound" that in the fictional 2007 has no audience. In the real 2007, the White Stripes have a Top 40 hit. Egan, sufficiently savvy to show both that grunge was a simulacrum of itself and that her characters do not know that, surely knew what was on the radio. This appears, then, to be deliberately counterfactual.

Why include it? It does not contribute in any obvious way to Bennie's story. As we have seen, the logic of the world produced by Egan's novel, the world its characters occupy, is the logic that plays out between the non-alternatives or dialectical pair of commodification and authenticity. The possibility of overcoming both the nonmeaning of commodification and the nonmeaning of authenticity by soliciting close interpretive attention—the possibility pursued by *A Visit from the Goon Squad* itself—is therefore necessarily excluded. As we see shortly, the White Stripes were interested not in producing a "sound," a market quality that is essentially inimical to musical values, but in throwing a musical idea on a market that is indifferent to it—because in our popular musical culture there is no mode of distribution and therefore no public outside the market, and therefore no way to count as a musical idea without risking the market—while legibly securing it as a musical idea. With the music industry serving, plausibly enough, as the synecdochic vehicle for a world in which the culture-industry dynamic is finally total, there is no room for music that might plausibly qualify as art—a word and a concept that has as little place in our vaguely indie young man's vocabulary as it does in Bennie's. In the system of Egan's total (and fictional) culture industry, there are only two modes: the commercial and the authentic, which is also commercial. In a world in which the work of art is really subsumed under capital, the White Stripes cannot sell and must be excluded from the frame, a kind of Lukácsian "necessary anachronism," which suggests that in the process of artistic constraint getting the logic right means sometimes presenting the facts wrong. In fact, as we see in the next chapter, the White Stripes were trying to do what Lerner and Egan are trying to do: create works that assert the autonomy of art against the determination of the market.

3 Citation and Affect in Music

If it is art, it is not for everyone, and if it is for everyone, it is not art. —ARNOLD SCHÖNBERG

Almost forty years after Theodor Adorno delivered what had seemed to be a death blow to some of Bertolt Brecht's most attractive claims, the great Brazilian critic Roberto Schwarz had the audacity to return to a very basic question: how does Brecht mean what he means?[1] The problem is precisely that of autonomy and its others: in Adorno's essay on the question, the problem of "commitment," or art's heteronomy to politics.[2]

Brecht's theater aims explicitly at autonomy from the market. Entertainment precedes the market historically: opera "was a means of pleasure long before it was a commodity."[3] But under present conditions, Brecht writes, "art is a commodity" whose value derives, in the case of opera, from "the social function of the theater apparatus, namely to provide an evening's entertainment."[4] In *Mahagonny*, this pleasure is artistically neutralized by framing it: "As for the content of [*Mahagonny*], its content is pleasure: fun not only as form, but as subject matter. Pleasure is at least to be the object of inquiry, even as the inquiry is to be an object of pleasure. Pleasure enters here in its present historical form: as a commodity."[5] The two sides of the chiasmus are not symmetrical. The inquiry as an object of pleasure (*Mahagonny*) is a commodity; pleasure

as an object of inquiry (*Mahagonny*) is not. Supported by the theater apparatus, epic theater is all the same within it a "foreign body."[6] But autonomy from the market is understood to be heteronomy to something else. The goal of epic theater is "to develop an object of instruction out of the means of enjoyment, and to convert certain institutions from places of entertainment to organs of publicity."[7] Even as the culinary is retained, in other words, Brecht turns the ancient defense of poetry ("delight and teach") more fundamentally into a choice of priorities: "Vergnügungstheater oder Lehrtheater?" (theater for pleasure or theater for learning?).[8]

Adorno raises an objection to this orientation that is in its essence very basic and that returns to Hegel's critique, in the introduction to his lectures on aesthetics, of the possibility of defending art by referring to its ends. From the standpoint of aesthetic autonomy, the choice Brecht imposes is no choice at all. Both theater for pleasure and theater for learning are theater "for" something—that is, both are to be judged by their effectiveness as a means to some external end. If the work of art is not to "have its end and its aim in itself," but is, rather, to be valued as a means to some other end, then the appropriate focus of judgment shifts away from the work of art both to the end it claims to serve and to its efficacy as a means.[9] For Hegel's critique, it matters not at all whether the purported ends are noble or base. Hegel's offhand list names "instruction, purification, improvement, financial gain, striving after fame and honor"; later, he will throw in "superficial pastimes and pleasures" and "political agitation" for good measure.[10] The point is, rather, that neither moment—neither the work of art's status as a means (necessary, contingent, or implausible?) nor the status of the ends to which it is subordinated (desirable or not?)—is self-evident, and neither judgment is in any way particular to the work of art. Hegel's critique applies as well to today's academic empathy peddlers, armchair subjectivity-modelers, community do-gooders, artistico-political fantasists, and civic boosters as it does to yesterday's radical theater.

In the early 1950s Adorno is, to say the least, suspicious of the ends to which Brecht is committed. More devastatingly, however, Adorno points to the implausibility of the work of art as a means. To do what it claims to do—namely, to "strike in images the being of capitalism"[11]—Brechtian theater has recourse to the technical means available to drama as a medium. But from the perspective of proposi-

tional truth, of the revolutionary doctrine the work of art is supposed to contain, these technical means are distortions. And here Adorno does not merely disagree with Brecht; he shows Brecht necessarily disagreeing with himself. In *Saint Joan of the Stockyards*, for example, Brecht legitimately requires a certain level of coincidence to condense an entire ensemble of contradictions onto the single figure of Joan. But "that a strike leadership backed by the Party should entrust a decisive task to a non-member is, even with the greatest latitude for poetic license, as unthinkable as the idea that through the failure of that individual the entire strike should fail."[12] The point here is not that Brecht should have written a treatise on revolutionary action rather than a play but that a play cannot at the same time be a treatise on revolutionary action—or, at least, not a good one. Indeed, the very requirement that *Saint Joan* be a play falsifies the treatise it also claims to be. The ostensible thesis of *Saint Joan*—that individual do-gooding is a compensatory substitute for collective action—is subverted by the fact that everything hinges (necessarily, since this is a play) on the success or failure of Joan's individual do-gooding.

The brilliance of Schwarz's late intervention is to see that Adorno's critique is devastating to Brecht's claim to didactic effectiveness, but not to the play for which this claim is made. The loss is not as great as it might seem. After all, Schwarz reminds us, the Brechtian "lessons" are "of modest scope," and it is not obvious that they remain today ahead of historical developments.[13] "Thus, against claims to the contrary, the truth of the plays would not lie in the lessons passed on, in the theorems concerning class conflict, but rather in the objective dynamic of the whole."[14] This is not to say that Brecht's plays have no cognitive content or that they have no political potency. Rather, their content and their politics are mediated by the self-legislating nature of the autonomous work. As a corollary, when the work falters as a work, as *Mother Courage* does in its third act, the ostensible contents and politics of the play scatter to the wind like so many good intentions.

Schwarz's revelatory rereading of *Saint Joan*, which indeed brings this objective dynamic forward, deserves careful attention on its own account, but one aspect is particularly important here: "Relying on his exceptional gift for pastiche, [Brecht] presented the vicissitudes of class conflict and the calculations of the canned-goods cartel . . . in verses imitative of Schiller, Hölderlin, *Faust II*, expressionist poetry, or

Greek tragedies (perceived as German *honoris causa*)." In Hölderlin's "Hyperion's Song of Destiny," for example, which Schwarz highlights as central to the play's system of citation, human destiny is figured as heroic errancy: to wander without consolation, "Like water from crag / To crag hurled down." In Saint Joan, it is instead falling stock prices that are "Thrown like water from crag to crag."[15]

Modernist pastiche as a reciprocal commentary between the heroic past and the prosaic present is hardly new with Brecht. In terms of conspicuous virtuosity, the "Oxen of the Sun" episode in *Ulysses* had already developed this mode much further than Brecht ever cared to. But the Brechtian difference is a profound one, which in Schwarz goes by the circumspect label "unity of process," otherwise known as history.[16] In other words, the peculiarly Brechtian sting lies not in the difference between the canonical source and the modern material but, rather, in their identity, which is not only in the design of the artist. The petty brutality of the businessman is the mature form of romantic striving rather than its negation: speaking of the cutthroat but tenderhearted monopolist in *St. Joan*, Schwarz remarks that "something of Mauler already existed in Faust."[17] But there is no lesson in this identity, no external end to which the dramatic image is subordinated; rather, the two moments of Faust and Mauler are posited as an identity in the dramatic image, which is submitted to our judgment. That is all. What is presented is not a doctrine but a figure: Faust-as-Mauler, a poetic idea. The question that pertains to a poetic image is not whether or not it corresponds to information available elsewhere, but whether or not it is compelling, whether it resonates with an intuition of social life.

None of this blunts the materialist edge of Brecht's critique. Meaning is produced through a poetic critique of poetry, but this does not mean that meaning is restricted to the realm of poetry. The meaning of Brecht's image, that is, is deeply compatible with the set of extractable lessons that Brecht is prevented from presenting without crippling distortion by the limitations of the form. Brecht's appropriation of Hölderlin and Goethe is along the lines of Marx's critique of Hegel or, indeed, Adorno's critique of Heidegger. By introducing concrete content back into abstract language, Brecht posits an identity between vulgar, everyday social content and sublime, abstract thought. The sublime existential risk of a world universally without guarantee becomes the risk of

losing some money. (For others its endpoint, the "Unknown" in Hölder-lin's song, is simply unemployment.) Brecht's poetic idea—the petty ma-nipulation of the stock market (petty in its motivations, if not in the damage it wreaks) narrated in the language of human destiny—requires no particular accuracy in its depiction of the operations of the stock market and is entirely produced by, rather than hindered by, dramatic condensation. When *St. Joan* is regarded, perversely, as being about po-etry rather than about capitalism (or about revolutionary organization), it loses none of its Marxist sting, because the ground that unites Faust and Mauler is the historical identity (Schwarz's "unity of process") of a class: "Unheroic as bourgeois society is, it nonetheless required heroism, sacrifice, terror, civil war, and the subjugation of nations to bring it into being."[18] The bourgeoisie emerged in blood and glory but soon enough had to subordinate its grand ideas, and anyone who still thought them, to the business of making money.

Pastiche—again, quite different from the pastiche that is practically standard modernist operating procedure and entirely different from the postmodern reanimation of dead forms—functions similarly in *The Threepenny Opera*. Macheath is a version of Schiller's Karl Moor, with the "stealing, murdering, whoring, brawling" aspect transposed to the essential, and the romantic aspect ("My spirit thirsts for action, my breath for freedom—*murderer, robber!*—with these words I tram-ple the law underfoot") transposed to the inessential.[19] The dominant *Gestus* in *Threepenny* transposes class-typical behavior across classes, most obviously bourgeois industry transposed to lumpens: Peachum's begging industry and, climactically, Mac's "What is the robbing of a bank against the founding of a bank?"[20] The example on which Brecht seems to have expended the most energy, at least following his "hints for actors," is that of love—or, more accurately, the ideology of love, that discredited "damned 'can-you-feel-my-heart-beating' text" (239). When Mac, the notorious criminal, marries Polly, daughter of the begging agent, his second concurrent wife, in a horse shed, catered by members of his gang, the elements are in place for broad parody. Indeed, we get some of that: a bit about the distinction between Chippendale and Louis Quatorze (244), sometimes omitted from contemporary productions, is pure buffoonery. But the irony is not as straightforward as it appears. Brecht writes, "The actors should avoid representing these bandits as a

gang of those pathetic individuals with red kerchiefs about their necks who lively up fairgrounds and with whom no respectable person would drink a glass of beer. They are naturally dignified men: some portly, but all (aside from their profession) sociable" (433). The spectacle of criminals putting on a bourgeois wedding in a stable is absurd not because the criminals are buffoons but because they are, aside from their profession, bourgeois. Even the genuine buffoonery conforms to this pattern. The omitted laugh line mentioned earlier comes at the expense of "Captn" Macheath, the pretentious lumpen, who does not know the difference between Chippendale and Quatorze but pretends he does. The buffoonery seems to operate in the expected direction. But his henchmen, who do know the difference, allow themselves to be corrected: Mac's ignorance is a luxury, not a deprivation. He is not an ignoramus but a philistine.

So when Mac, in the midst of setting up house in a barn with a stolen Chippendale grandfather clock, intones, a few moments later, "Every beginning is hard," he is not citing Goethe's famous line from *Hermann und Dorothea* but repeating the cliché the line has become. Brecht, however, is citing Goethe. Goethe's line continues: "Every beginning is hard; hardest is beginning a household"—this last word translating *Wirtschaft*, with its strong economic overtones. This entire scene, with its semi-rustic setting in the middle of London, is a commentary on *Hermann and Dorothea*: disreputable Mac, in the position of the refugee Dorothea, is repeating the words of the respectable father (and, indeed, is making a practical match), while it is Polly, at the center of the conflict between the household as centrally an enterprise and the household as centrally a love match, who occupies the position of the son and who, indeed, embodies the contradictory impulses embodied in Goethe's "Wirtschaft": "It is absolutely desirable that Polly Peachum should impress the audience as a virtuous and agreeable girl. If in the second scene she has demonstrated her entirely disinterested love, now she exhibits that practical outlook without which the first had been mere frivolity" (434). The manifold overtones of this parody—which, as with Schwarz's observation about Faust and Mauler, involves only a small but vicious shift in emphasis from Goethe, who saw the contradiction but sought to reconcile rather than emphasize it—could be pleasurably pursued into the deepest nooks and crannies of the scene. But the import of this mo-

ment for now is that, while the scene is clearly about class—specifically, the economic content of bourgeois sentiment—it is only about class by being about poetry.[21]

"Epic theater is gestic," wrote Walter Benjamin. "To what extent it can be poetic in the traditional sense is a separate matter."[22] But what is the Brechtian *Gestus*? For Benjamin, it is a matter of interruption—that is, a question of framing. Benjamin draws the appropriate conclusion from this:

> In short, the action [is] interrupted. We may go further here and consider that interruption is one of the fundamental procedures of all form-giving. It reaches far beyond the sphere of art. It is, to pick out just one aspect, the basis of quotation. Quoting a text implies breaking ties with its context. It makes sense, therefore, that epic theatre, which is based on interruption, is quotable in a specific sense. The quotability of its texts would be nothing extraordinary. That of the gestures it makes use of is another matter entirely.
>
> "To make gestures quotable" is one of the essential accomplishments of epic theatre.[23]

But the issue of citation, far from being "a separate matter" from that of Brecht's traditional literariness, is the core of his traditional literariness. The quotation—the twisting and turning repetition of Hölderlin's "crag to crag," the ironic repetition of Goethe's "Every beginning is difficult"—is precisely gestic. "From where does epic theater take its gestures?" asks Benjamin. "The gestures are found in reality."[24] Surely correct, but not very helpful. From what order of reality does epic theater take its gestures? Brecht "makes gestures quotable" precisely by quoting them—which is to say, they are already quotable. The order from which they are taken is textual. The "damned 'can-you-feel-my-heart-beating' text" (239) may refer to the Romantic inflation of affect, just as "Every beginning is difficult" refers to Goethe. But it belongs equally to the ways lovers act with each other, just as uttering platitudes belongs to the way people act at a wedding. These are two different kinds of text—the gesture proper may experience itself as spontaneous, while the literary gesture is part of a self-legislating whole—but they are both texts, or else they would not be quotable. When in *The Godfather* Michael Corleone, played by Al Pacino, fleetingly registers the fact that

his own hands do not shake as he lights a cigarette during a life-or-death bluff, this is a powerfully effective actorly gesture. But since it belongs only to the narrative situation, it is not a social citation and therefore not a Brechtian gesture—a fact that does not preclude an esoteric citation of other filmic cigarette lightings. As Brecht's notes for actors make clear, narrowly gestic elements are a matter of embodied ideology, a social script: "Efforts not to slip on a slick surface become a social gest as soon as slipping would mean losing face."[25] The procedure followed in both Brechtian pastiche and gestic acting is the same—namely citation, or framing a preexisting text to create a unit of meaning that will be relativized by the "objective dynamic of the whole."

It is with reference to music that the question of citation acquires its greatest density in contemporary culture. Indeed, it will, in the postmodern era, develop into the positive historicism whose possibility was anticipated in the introduction. In "On the Gestic Character of Music," which precedes Brecht's first published comments on gesture, Kurt Weill proclaimed that "today the composer may no longer approach his text from a position of sensual enjoyment."[26] Weill is contending here with the Brechtian problem of the entertainment commodity. But what is proposed is both more radical and less prudish than his statement suggests. The target of Weill's criticism is the "theater of the past epoch," which was "written for sensual enjoyment. It wanted to titillate, to irritate, to arouse, to upset [*kitzeln, erregen, aufpeitschen, umwerfen*] the spectator."[27] So "to irritate" and "to upset" are included under the heading of "sensual enjoyment." Indeed, what Weill seems to forbid to what he calls "gestic music" is the provoking of any kind of affective state in the spectator. This is not really a surprise, as it is in line with Brecht's anathematization of such theatrical effects as "coerced empathy."[28]

But the production of affective states in listeners is part and parcel of what music does. To take only the most basic element, any perceived musical beat is enough to organize the internal or external movements of a listener.[29] This aspect of music's specific difference from the other arts is the difference from poetry that allowed (some) music into Plato's *Republic*.[30] For Aristotle, it was a commonplace he saw no need to dispute.[31] Hegel, no expert on music, did, however, understand that while poetry expresses feelings (*spricht die Empfindungen*), music arouses

(*erregt*) them in listeners.[32] Weill seems to have painted himself into a corner: the thing music is forbidden to do is precisely the thing that distinguishes music from the other arts.

We will come to Weill's solution in a moment. But we should take a minute to appreciate that any solution to Weill's dilemma will also solve a dilemma for us. The fact that music can directly provoke affective states is not under all circumstances a threat to music's status as an art in the modern sense, a kind of entity whose purposiveness is immanently determined. If the passage from Ferreira Gullar from the previous chapter were paraphrased as a comment on Mahler, for example, it would be uncontroversial: "The listener feels, but the time of the feeling does not pass, does not transcend the work, doesn't exist and then lose itself beyond the work: it is incorporated in the work, where it persists."[33] Weill is, however, concerned with music in a particular context—namely, as an accessory pleasure in the theater. When music is understood as part of an evening's entertainment, the listener is conceived as a market, and if music is to be written for the theater "without giving up artistic substance," then its affective capacity suddenly needs to be confronted as a problem.[34] When the listener is a market, any provoked effect is simply an external purpose, the selling point of a commodity. Its social circulation is not ratified through judgment of its immanent purposiveness, but is instead dependent on a use value whose very existence is established only in exchange. In our own moment, when the market as the horizon of cultural production is both received ideology and a real tendency, Weill's specific concern takes on a much wider significance.

For Weill, moreover, a solution to the problem of the market was ready to hand: the purely music-immanent self-definition and development of music as a medium, supported by a restricted field. Trained at major conservatories and having achieved some early success with his chamber and symphonic music, Weill emerges from this field, but it is precisely the confines of the restricted field that the Weill we know seeks to escape. Weill risks the market by choice:

> The recent development of music has been predominantly aesthetic: emancipation from the nineteenth century, struggle against extra-musical influences (program music, symbolism, realism), return to absolute music. . . . Today we are a step further. A clear separation is

taking place between those musicians who . . . as if in a private club, work on the solution to aesthetic problems, and others who will undertake to engage any audience whatever.[35]

Even as the moment of music-immanent development is seen as a forward step, two contrary imperatives are suggested at once: to engage an audience beyond the specialized restricted field of musicians and experts and to produce meanings beyond those that only the restricted audience cares about, meanings that are not purely music-immanent. Indeed, it is for the sake of producing these meanings that reaching beyond the restricted field is understood to be important. These two imperatives seem to be aligned, and they have a certain populism in common. In fact, as Weill is aware, they are deeply in conflict. In a market society, the first imperative (to reach beyond the restricted field) can be satisfied only by risking the market—"any audience whatever." But the second imperative, to produce political meanings of the kind Weill is after, is one to which the market is indifferent; one that, in fact, is unmarketable. If such meanings were marketable—if there were an audience whose desire to receive them constituted a demand—there would be no reason to produce them, since your market is already of the party. Or rather, there would be no pedagogical reason to produce them, because, as with any demand, there would be a market reason to satisfy it. Meanings that can be sold—meanings for which there is a demand—are not meanings at all but commodities. A political meaning that satisfies a demand is not a meaning, but a purchasable point of social identification, like an NPR grocery bag.[36]

Weill's solution to this problem is made clear in his musical practice. The "Cannon Song" from *The Threepenny Opera* is a martial variant of a barroom sing-along, what might be classified generically as a barrack-room ballad. Like all good sing-alongs, it may well move a listener familiar with the piece to want to sing along, and the reason that it has this power may lie in something that brain science or some other discipline can one day explain. Then again, some listeners may not be so moved, and the failure to be moved is in principle susceptible to explanation. But for the meaning of the song, this effect or its lack is irrelevant. The "barrack-room ballad"—the phrase is Kipling's—is in Weill's hands a gest, a citation. "Cannon Song" frames the gesture and, in so doing, creates a meaning.

Brecht's text is also a citation, a pastiche of Kipling's martial ditties such as "Screw Guns":

For you all love the screw-guns—the screw-guns they all love you!
So when we call round with a few guns, o' course you know what
 to do—hoo! hoo!
Jest send your Chief an' surrender—it's worse if you fights or you
 runs:
You can go where you please, you can skid up the trees, but you
 don't get away from the guns.[37]

In Brecht's text, racism and genocide move from (barely) subtext to text in a way that is deliberately unsubtle. On the page it falls a bit flat, but in Weill's rousing mess-hall setting it is quite spectacular:

The troops live under
The cannons' thunder
From cape to Cooch Behar.
And if it rained one day,
And they had chanced to stray
Across a different race,
Brown or pale of face,
They made them, if they liked,
Into their beefsteak tartare.[38]

What is the source of the musical creepiness of "Cannon Song"? Like so many of the songs in *Threepenny*, the tempo marking is already a citation: "Foxtrot-Tempo."[39] The basic rhythm is indeed a foxtrot (foursquare rhythm with accents on the offbeats), and the introductory trumpet part develops a jazzy motif, culminating in the ragtime cliché of the sixth measure. But the "swing" of the initial motif is written in as a dotted eighth note followed by a sixteenth note, and it is meant to be played as written, so it jerks rather than swings. The antiphonal saxophone line recalls jazz call and response—except it arrives a beat early, interrupting and disrupting the trumpet line rather than repeating and endorsing it. The introductory bars do not lead to the tonality of the verse; instead, they have no obvious tonal center or direction. The angular melodic line of the introduction—as becomes clear when, in the first repetition of the initial idea, the interval of a fifth is tightened up to an augmented fourth in bar three—is not about to subordinate itself

to the business of dancing. Meanwhile, the instrumentation—in particular, the use of the lower brass—emphasizes the relationship between popular dance music and marching music, a connection that bears on the meaning of the song. When the song lands on a tonal center (bar seven), the underlying harmonic movement becomes conventional, tied to the cycle of fourths (see particularly bars 14–16), which can be intuited or arrived at analytically. But this structure is estranged by avoiding triads, and the movements they imply, almost entirely: the harmonic surface consists of paired sets of fifths juxtaposed on the on and off beats. The result is both estranging—the movements are conventional but now robbed of any illusion of necessity—and vaguely Orientalizing, which is emphasized by the largely pentatonic melody.

The song finally becomes diatonic and tonally centered only with the martial refrain, which, in a series of descending half notes ("cape to Cooch Behar"), spells out a minor chord (F-sharp minor) and lands on its dominant, the first conventionally outlined chord of the song. This is the music of the beer hall—or the recruiting station. But the middle voice, a teetotaler or a pacifist, already puts this tonality in doubt. The dominant lasts disorientingly long, tightening up into a diminished chord rather than resolving. Finally, at the height of the barbarism of the lyrics, a cadence arrives that centers on another fully spelled-out dominant, which occurs in bar 34, at the climax of the song (the "beefsteak" before "tartare"). But the implied cadence is doubly false, misleading about both where it is going and where it is coming from. It ought to lead to A minor but leads to D minor instead. And while the melody at "They made them, if they liked" (measure 32) suggests that we are still essentially in F-sharp minor, measure 33 is already in D minor. So not only is the false cadence false, but, rather than leading somewhere surprising, it leads exactly nowhere. The overall effect, if one cares to look at it this closely, is to remove all sense of naturalness from the underlying conventional structures. The song hews just close enough to conventional forms—foxtrot, march, barrack-room ballad; cycle of fourths, easily singable melody, climactic cadence—to borrow their effects while denaturalizing them by formal means that are not effects except inasmuch as they aim at the variously translated Brechtian "disidentification effect," which in the terms of this study is not an effect but a set of techniques for forestalling or framing effects and

subordinating them to interpretations. Cited, forms assume meaning as gestures. All this is simply to read as immanent to the song what it is hard to imagine any listener denying—namely, that the product of these formal distortions is deeply creepy.

"Today the composer may no longer approach his text from a position of sensual enjoyment." If one imagines setting a war anthem in a state-sanctioned patriotic film, the first thing on the composer's mind would be producing the sing-along effect, an identificatory esprit de corps, in as many people as possible. If one imagines setting such an anthem in a commercial film, the first thing on the composer's mind would be the same, but for a different reason: to appeal to as many people as possible who already want to experience identificatory esprit de corps. Brecht's and Weill's version functions entirely differently, since you need not feel the force of the sing-along (though you do need to intuit something of its system of citations, though not with any specificity) to understand Weill's meaning, which is to fuse the brutality of Brecht's lyric with the social cohesion of military esprit de corps, not after all so different from that of the dance hall, and in doing so to impose an interpretation.

But chances are that you will feel its force. "Cannon Song" remains, all this aside, a rousing air. This is irrelevant to the meaning of "Cannon Song" as a work of art, but it is far from irrelevant to its success as a popular entertainment. As Brecht puts it, "Theater remains theater, even when it is didactic theater; and as long as it is good theater, it is entertaining."[40] If "Cannon Song" failed as a rousing air, that would not change its meaning, but neither would *Threepenny*, in the five years before the Nazis came to power, have been translated into eighteen languages and performed more than ten thousand times. Nor would we be talking about it today.[41] "Up to the stable scene the audience seemed cold and apathetic, as though convinced in advance that it had come to a certain flop. Then after the *kanonen* song [*sic*], an unbelievable roar went up, and from that point it was wonderfully, intoxicatingly clear that the public was with us."[42]

"No opera here!" (245), demands Mac, in a work called an opera, a word intended as little ironically as the "threepenny" that precedes it.[43] The gesture is echoed (but not cited) some twenty years later, in Rio de Janeiro, by Janet de Almeida and Haroldo Barbosa:

Madame says the race won't improve
That things are going downhill because of samba
Madame says samba brings sin
That samba should be put out of its misery

Madame says samba is nothing but race mixing
Color mixing and *cachaça*
Madame says that the democratic samba
Is cheap music with no value

Let's be done with samba
Madame doesn't like anyone to samba
All she can say is samba is shameful
Why argue with Madame?

Doo doo doo
Doo doo doo doo
Doo doo doo doo
Doo doo doo

Next Carnaval, sure,
My block from the hills will sing opera
On the street among the press of thousands
You'll see us all singing a concerto

Madame has a screw loose,
She only talks poison, my God what a shrew
Samba, democratic, Brazilian
To the roots, that's what has value.[44]

The cast of characters seems straightforward: Madame; the protagonist, who lives in a working-class neighborhood, belongs to a samba school, and presumably is in Madame's employ; and the samba school, a metonym for the "press of thousands" at Carnaval, itself a metonym for the Brazilian people. Digging a little deeper, one learns that "Madame" was a real person, the conservative cultural critic Magdala da Gama de Oliveira, otherwise known as "Maggy," who occupied highly visible perches on radio and at the journal *Diário de Notícias*, and whom the journalist and composer Fernando Lobo had recently apos-

trophized in a critical essay as "Madame."[45] So from a historical per-spective, the position of the protagonist becomes more complicated: he is still working class, but the conflict between him and Madame is only metaphorically a class conflict, since the cultural conflict on which it centers takes place entirely among journalists. Not only "Maggy" and Lobo but also Almeida and Barbosa were journalists, as well as, in the case of the latter three, composers.

As suggestive as it is, this historical meaning is essentially a private one. It is a professional spat, not without interest, on which a little re-search allows us to eavesdrop. It is symptomatic of a recognizable ideo-logical field. But no attempt is made to inscribe this historical meaning in a normative field, and as far as the meaning of the song goes, we are pretty much back where we started.

Or we would be but for the little, wordless interlude before the final stanza, which is a close paraphrase of measures 20–24 of Tchaikovsky's Piano Concerto No. 1.[46] Here the historical weight of the song's lyric—the appropriation of the political subjectivity of the working class by the progressive bourgeoisie—is inscribed directly in the musical mate-rial. Not content to be more democratic and sensible than Madame (and presumably a better dancer), the protagonist must show himself to be more erudite, as well, an advantage not available to denizens of the hill neighborhoods. Without the interlude, "singing a concerto" is the approximate speech of one who does not have any very precise idea of what a concerto is. With the interlude, "singing a concerto" is a wink-ing reference, in case we missed it, to what has just been accomplished. In other words, the lyrical voice identifies with the working class, but only when "Madame" is in the third person—that is, when he addresses himself to the "people," comprising the lower orders and the progres-sive bourgeoisie. The borrowed passage from Tchaikovsky is, out of earshot from the hills, addressed only to Madame.

Much more can be said about this peculiar combination of popular identification and ironic distance than is relevant to the argument at hand. What is important for the moment is that musical form acquires meaning here as citation, of which there are now two: the borrowing from Tchaikovsky and what, in the light of the Tchaikovsky, appears as a borrowing of the samba form. However, citation works here in a way that is precisely the opposite of how it works in Brecht and Weill. In the earlier case, citation is a technique of disidentification; it frees the

dramatic or musical work from the obligation to produce an empathic relation to the action and replaces it with a relation that is distanced and that therefore opens up a space for judgment and interpretation. In the later case, citation is a technique for producing a double identification: the first one, public and universal (the identification of the lyrical voice with the people); the second, private and particular (the identification of the lyrical voice with the cultural elite). In Weill's hands, ironized by the form of the whole, the duplicity of the narrative voice would be what the song is about. But in Almeida and Barbosa's version, the wink behind the back of the "press of thousands" is just duplicity.

When João Gilberto, the foremost interpreter of the bossa nova generation, rescues the song from oblivion, he does not so much ironize the singer's duplicity as abolish its duplicitousness. Gilberto sings the interlude closer to the way Tchaikovsky wrote it, so he recognizes the citation. In Almeida's version, the interlude introduces a brief coda consisting of the second verse repeated a whole step higher. In Gilberto's, the interlude is brought into the form itself, between the first and the second verses, so the song itself modulates between D and E as it repeats. The interlude becomes the key structuring element of the song itself. As we will see more clearly in a moment, it no longer functions citationally. But if it is no longer important that it is a citation, it is important that the new structure makes a better piece of music.

Gilberto's version follows a set of procedures that is typical for his approach. The chord structure is highly textured with elaborations from the upper extensions; the guitar rhythm is complex, derived from samba, with the thumb operating, on the pulse, independently from the other fingers, creating an interplay that structures the rhythm in syncopated variations that suggest (though this is an illusion) a complete improvisational freedom from repetition; the vocal line combines a vibrato- and glissando-free technique, an almost conversational vocal quality, extraordinarily precise intonation, and, most important, the constant suggestion of an unfettered relationship to both the pulse and the syncopated line. When these elements are all performed by one person, such that the relationship among the three central elements of pulse, chordal rhythm, and vocals is at every point intended, the result is a performance of exceptional musical density.

In other words, it is finally no longer important that two different musical forms are cited in the original version, because they are both

submitted to a new set of procedures that renders their diverse origins irrelevant. In Gilberto's performance, the social conflict that Almeida and Barbosa's lyric thematizes is turned—as is the case with bossa nova generally—into a problem that musical form attempts to supersede. Unfortunately, there is not nearly enough space here to enter into the politics of bossa nova, which is the musical exponent of a developmental populism whose central ideologeme, full of contradictory implications, is the development of productive forces in the interests of the entire national population. In other words, the project of the bossa nova generation is to exploit fully the real advances made possible by class segmentation, while creating a music that in principle does not depend on that segmentation for its reception. Bossa nova was to be a popular music of sufficient musical density that it was also an art music; alternatively, it was an art music that was to be accessible enough not to be an elite music, a music that is samba and Tchaikovsky at once.

Although both the approach and the politics are quite different, the problem invented and confronted by the bossa nova generation is Weill's: "to create a music capable of satisfying the musical needs of broader strata of society, without giving up artistic substance."[47] But while Weill abandoned the restricted field to "engage any audience whatever," the aesthetic ideology of bossa nova was that a modernist restricted field could itself engage any audience whatever. The eclipse of bossa nova was not, then, an artistic endpoint but a historical one, as developmental populism was decisively displaced by military coup, dictatorship, and integration with North American capital. Bossa nova itself continued to evolve after its historical relevance faded, reaching an artistic zenith in the early 1970s with Tom Jobim's "Águas de março."[48] But by the time "Águas de março" was recorded in 1972, a new movement, Tropicália, had already come and gone. Indeed, bossa nova had already become a subject for pastiche by the musicians of the Tropicália movement: Caetano Veloso's "Coração vagabundo," from 1967, is a fine bossa nova, but it is a master's thesis on Jobim's compositional technique, not a development of it or out of it.[49]

The new music of the dictatorship period brutally reoriented the dialectic of the most ambitious Brazilian music. After the military coup of 1964, the drive to modernize the Brazilian economy continued, but it had been severed from the drive to develop the economy to meet the needs of broad strata of society. The elements to be drawn together

musically were no longer high and low—between which no identity, real or ideal, present or future, was imagined. Instead, modern and archaic elements were not to be synthesized but allowed to exist in patent contradiction.[50] The effect is one of brutal, mutual ironization: the truth of each lies in the other, which is false in itself. As Schwarz says of this Tropicalist effect, which exposes tacky content to "the white light of the ultra-modern" (and the ultra-modern to the embarrassment of the tacky), it is "like a family secret dragged into the street."[51]

Tropicália, which has been glossed over far too quickly here, marks a pivotal moment. The brutality and rapidity of the transition from a proto-socialist society to military dictatorship integrated with northern capital having taken place practically overnight, Tropicália registers all of the contradictions of what would come to be called postmodernism in a form that still stamps them as monstrous. However, the mark it left on Brazilian music was probably less in the music itself than in the training (in terms of both aesthetico-political ambition and musical range) it afforded a generation of Brazilian musicians. The music that followed Tropicália, though developed largely by the Tropicália musicians, has quite a different tenor: more in line, in its easy appropriation of multiple Brazilian styles, with paradigmatic Jamesonian postmodernism than with its bitingly antisocial predecessor. Schwarz characterizes the position of Veloso, one of the most important musicians to come out of Tropicália: "[The] reconciliation of the present with itself, in all its levels, without exclusions, was the—more satirical than complacent?—imitation of or subjective assimilation to the point of view of commercial cultural programming. Radio stations and TV also cover the gamut of the public's interests, without regard to what is regressive or advanced, so long as they are profitable. A world full of differences and without antagonisms begins to look like an enormous market."[52] Indeed, Veloso embraces market heteronomy. In concert, before singing a song in Spanish, Veloso launches into a digression about how singing in foreign languages grants a kind of privileged access to the other. A beat. Then: "It's also good for market exposure." Veloso means both statements sincerely, but the laugh line works only because of their asymmetry: the second puts the first in doubt, but not the reverse.

Since the ruse of the market is not to be countered by good intentions, a cynical position is preferable to a naïve one, and Veloso recognized

early on that not recognizing market considerations—"many times the only decisive ones"—was no longer an option.[53] "The important thing for us," wrote Weill in a letter to the *Musikblatter des Anbruchs* in 1929, "is that here, for the first time, the breakthrough into a consumer industry has been achieved."[54] Thus, to reach "broader strata of society," both Weill and Veloso skirt the edges of *Gebrauchsmusik*, music that fulfills a certain (in this case, affective) need. Weill risks the market by choice. But while Weill makes a conscious decision to leave the restricted field and music-immanent formal development behind, Veloso understands the choice as having been made for him. After the dramatic foreclosure of the real possibility of a nonmarket society, he understands himself as already contending with a situation in which artworks circulate only on the market. In an interview in 1974, Veloso outlined with remarkable concision the cultural situation with which this book began: the overpowering of restricted fields by the culture industry. "On one hand, Music, violated by a new communicational process, is forced into both innovation and slavery; on the other hand, Music [is] protected and impotent."[55] Cynicism and clearheadedness, both present, become difficult to unyoke.

As we saw in the introduction, the practice of pastiche is directly implied by the real absorption of culture into the market, a process that Veloso both celebrates and observes with impressive clarity. The old meanings—primarily, as we shall see, the modernist developmental line presumed and enacted by bossa nova—are suddenly irrelevant, not because they have ceased to signify or to evolve (or, indeed, to sell, which is why they are absorbed into the miscellany) but because the networks that found their significations and developments relevant have been overpowered by a market, which does not. When bossa nova retreats into informal amateur networks that no longer seem to have any relevance when confronted with the explosion of the Brazilian culture industry, a new set of possibilities, bound up with the relativization and appropriation of superseded styles, emerges. This logic is precisely the logic of real subsumption that was outlined in the introduction. Consequently, we have every reason to expect that what will follow is a properly postmodern irony, a grab bag in which, due to the absence of a metanarrative sustained by nonmarket networks, the principle of selection would be nonexistent (pure market heteronomy) or weak (the whim of the artist). Indeed, the latter option is the ideological weak

point of Tropicália, whose advantage over paradigmatic postmodern culture—that this shift from autonomy to heteronomy is registered as intolerable—is mitigated by the fact that its universal irony is in the end a function of class privilege.

Veloso, however, seeks to overleap this logic: "The inevitable issue from bossa nova is commercially stillborn and, culturally, insulating itself from the market, which it nonetheless needs to survive. We are trying to resume the lost trajectory."[56] Astoundingly, Veloso conducts his autopsy in the name of continuity rather than of a radical break. Markets socially ratify value only through exchange, which is based on external purpose rather than immanent purposiveness; therefore, market heteronomy, which Veloso is recommending here, directly implies the end of developmental trajectories in favor of the drift of fashion. But the new set of possibilities is seen in terms of a "lost trajectory," which is none other than the *linha evolutiva*, or modernist developmental line, of bossa nova that is snuffed out with the dictatorship. Apparently paradoxically, Veloso has been at the forefront of retrospectively projecting this evolutionary line and introducing it into Brazilian musical discourse as an unavoidable horizon:

> It is with great difficulty that a few moments of organicity are achieved in our work; every once in a while something recognizable condenses, only to be lost in the confusion soon after; we make a samba without even thinking about it, it turns out to be so beautiful, we rejoice, believing we've realized something fine in the trajectory of this language—but there are so few musicians who are able to hear it, enrich it, understand what it can mean, learn from it, or, in the course of history, reteach it, and even those that there are have few opportunities to respond to one another.[57]

One wonders whether, despite being central to Tropicália, Veloso was ever a Tropicalist at all: the post-Tropicalist project is already expressed here, full-blown, complete with liberal-nationalist overtones, in 1965. But the important thing to note is that the market cares about the "evolutionary line" or "lost trajectory" that Veloso is committed to recovering about as much as it cares about second-wave protest bossa nova. Veloso writes, as usual, with remarkable precision. What is at stake is not what music means but what it "can mean" in the hands of people who understand it—people, in other words, who can interpret

it in both the musical and the exoteric senses. The substantial social entities that could plausibly care about such an evolutionary line are precisely two. First, the nation, the referent of "we" and "our," but purely in the sense of an imagined community, not the actually existing national culture, because the actually existing national culture is none other than the "confusion" in which the evolutionary line gets "lost." Second, the musicians who are able to discern in their practice a matter in hand to be developed, or in other words, a Bourdieusian restricted field of musicians "responding to one another"—and yet it is precisely the lack of this field that Veloso laments. Neither of the entities to which an evolutionary line could plausibly matter exists. The market, however, does exist. As we saw earlier, music "needs" it; there is no longer, in Veloso's understanding, any other mode of distribution equal to the culture industry. But despite everything, Veloso is not making music for the culture industry, which, again, is the confusion in which everything worth saving is lost. Veloso seeks a musical practice that would resume a lost trajectory—that is, produce a modernist developmental line—in a musical field that would seem to foreclose the possibility of any such thing.

In Veloso's *Caetano Veloso* (1969, popularly known as his "white album"), a version of that project appears in its full outlines.[58] The first thing one notices about *Caetano Veloso* is the album's diversity of covers: a traditional Bahian maritime song, a cynical tango from the 1930s, an overwrought ballad from the 1940s, and a recently recorded bossa nova. Then there are pure pastiches: a march in the style of the electric Carnaval bands; a Portuguese fado; and a stab each at Brit-pop psychedelia and album rock.[59] Only with the final two tracks on the album—one by Veloso and the other by Gilberto Gil, his primary collaborator and the guitarist on the album—do we approach recognizable tropicalist procedures. "Acrilírico," a portmanteau word that combines "acrylic" (new and synthetic) and "lyric" (ancient and organic) and between them produces "bitter"—is a spoken concrete poem that includes taped sound fragments. Gil's "Alfômega," perhaps the distillation of the gleeful antisociality of Trópicalia, cruelly builds concretist wordplay around the Portuguese word for illiteracy and sets it within what is essentially a rock song, performed here in a way that can be described only as groovy—leaving the question open as to whether the setting is a specimen of advanced or peripherally derivative culture. But in light

of what came before, these last two tracks are not to be understood any differently from the other ten. Tropicália is included in the miscellany, not the principle of the miscellany itself. From the standpoint of the 1969 album, the logic of Tropicália has already been superseded.

Except where to do so would deform the musical material beyond recognition, the album's material is treated uniformly throughout, so "Chuvas de verão" (a *samba-canção* by Fernando Lobo from the same period as "Pra que discutir com Madame") can serve to illustrate the procedure followed in the album as a whole. The orchestral embellishments and interludes in Francisco Alves's 1948 recording are dispensed with. (The flute line is alluded to in a brief whistled introduction which, unlike the original, does not deviate from the structure of the song itself). The entire rhythmic and harmonic structure—the former greatly diversified and loosened up, though aligned closely with the pulse and still, like the original, a samba-canção—are brought within Gil's guitar line, whose virtuosity is entirely unobtrusive. The vocals are sung without vibrato or glissando, pitched very precisely, and recorded close to the microphone, such that the vocal quality is intimate: even when the vocals sweep upward (for example at the first vocal line and particularly at "trazer uma aflição"), the dynamic range is kept narrow, so that the dramatic effect of the wide interval emphasized in the original recording is minimalized and, as it were, internalized. Even in "Atrás do trio elétrico," the vocals are double-tracked rather than sung loudly.

In other words, although the song is not a bossa nova, the procedures followed so far follow bossa nova sensibilities. The studio production is peculiarly noteworthy. Rogério Duprat adds an orchestral part that is, on its own, a tasteful accompaniment, less clunkily obtrusive than the original to which it also occasionally alludes. But the aural qualities of the orchestral line are completely different from the guitar and vocal parts: it is as though the latter were recorded in a bedroom and the former, in a cathedral. The overall effect is the opposite of most studio production. Instead of producing the illusion of a seamless performance, where "the process of fusion reaches out to the spectator, who is fused right in and now represents a passive (suffering) part of the total work of art," the result is a "radical separation of the elements."[60] And this is accomplished for entirely Brechtian reasons. The orchestral line is far too high in the mix. Since the orchestral accompaniment is intermittent, this serves to separate it further from the guitar and vocal basis rather than

drowning it out, but it also dramatizes the "great primal war" between structure and embellishment, which cannot simply be eliminated, as it is part of the popular form. Instead of being combined to produce an effect, the elements are separated to problematize a relationship.

In confirmation of all this, the orchestral parts are mixed down in just one channel, so that if one earphone is removed, or the balance is turned all the way to one channel, they can be completely eliminated. (The guitar and vocal parts are mixed down in both channels and cannot be eliminated.) The struggle between structure and embellishment is thus decided in favor of structure. This is too easy, but what is important to note at present is that this procedure is quite different from the Tropicalist one. Whereas earlier Duprat and his collaborators used the recording studio to ironize brutally the cultural raw materials that were brought into it, here the studio frames the musical material—which now appears as structure rather than as raw material—without assuming a position superior to it. There is, in other words, an internal distancing from and a relativization of musical material but no irony at the expense of the cited material in this new relation to it.

The one possible exception makes an interesting case. The recording of Chico Buarque's "Carolina" was received scandalously, as an ironic attack on Buarque. Without context, it is hard to see why. Buarque's recording is dominated by an orchestral accompaniment that is by turns saccharine (strings) and tacky (muted horns), and with an embarrassingly—for a Brazilian recording, almost unbelievably—lame percussion line, played on hi-hat. Indeed, the whole recording is not a bad approximation of a bad American approximation of bossa nova. Buarque himself does not do much with the vocal line except occasionally sing it out of tune. Not even Buarque himself much cared for "Carolina," which comes out as a far more interesting piece of music in Veloso's version.[61] The song is stripped bare in precisely the same fashion as "Chuvas de verão" (the orchestral line does not even enter until the final fifteen seconds or so of the song), with Gil producing a marvelous distillation and revision of the rhythmic and harmonic structure on guitar, adding some color and complexity to the basically uniform pulse—a discreet rock shuffle is briefly introduced—and diatonic structure of the source material.

Nonetheless, it is hard to see Veloso's "Carolina" as other than parodic. Buarque was at that moment a hero of the large and culturally

hegemonic left, which was friendly to Marxism even where Marxism was not fully incorporated conceptually. Although he emerged from this left—one of his first musical commissions was incidental music for a production of *The Exception and the Rule*, a *Lehrstück* of Brecht's—Veloso stands for what looks, in retrospect, like an ascendant antileftist liberal pluralism. Buarque, meanwhile, was and is a talented amateur, but an amateur nonetheless. "Professionalism" is a privileged term in Veloso's vocabulary, as it was for Brazil's first "cannibal" modernisms; the term presumes the market, without doubt, but it more immediately refers to the anti-imperialism of cultural import substitution, the development of a local culture industry sufficiently specialized to be able to compete with progressive first-world culture on its own terms. This is the aesthetic ideology of peripheral modernists from James Joyce to Oswald de Andrade to Chinua Achebe, and it relegates amateurism to "dilettantism" (according to Júlio Medaglia, a vanguard composer and Tropicalist arranger) and putatively authentic culture to "macumba for tourists" (according to Oswald de Andrade, in a phrase the Tropicalists were fond of citing). When Veloso sings "Carolina" with lazy intonation—heard nowhere else on the album and virtually nowhere else in his oeuvre—it is hard not to see the gesture as deliberate. Further, the lyrics, a reminiscence of a failed seduction, lend themselves easily to a political interpretation, the cold Carolina representing the bourgeoisie that turns its back on "a blooming rose, everybody dancing, a falling star" and the lyrical voice representing the revolutionary vanguard trying to show it all these things. Whether the song is taken as purely romantic or a political allegory, the lyrical voice paints himself in a flattering light. Veloso's interpretation, sung barely above a whisper, provides just enough internal distance from the lyric to turn it into a dramatic monologue, the dashing revolutionary revealing himself as a lazy lothario whom Carolina may have been wise to ignore.

In an early account, Veloso claimed that the inspiration for the recording was a girl, the "antimuse of Brazil" ("antimusical" being a key word in the bossa nova manifesto song "Desafinado" [Out of Tune]), singing "Carolina" on a televised amateur talent contest.[62] As improbable as this is, it is an attempt to make "Carolina" conceptually consistent with the rest of the album. A later account is more plausible, and more interesting still: "When I recorded 'Carolina' in an estranging way . . . it was not necessary to attack Chico to affirm our position. We were

certain that Chico's creation itself would benefit by its own relativization."[63] To "relativize" without "attacking," to estrange (is the Brechtian term intentional?)—in other words, to cite as a gest. This is the mode of the album itself. Indeed, it is this account that finally fits the musical facts. Veloso's "Carolina" is no longer simply itself but about itself. While Buarque's version is an attempt to foster a social identification on the basis of a shared superiority to bourgeois complacency, Veloso's is about the self-regard that inheres in the attempt. Veloso's version, in other words, bears cognitive content, making a truth claim where Buarque's offers a point of identification.

All of the affective content of the album, like that of "Carolina," is cited rather than expressed. "Os Argonautas" may move you to a beautiful seafaring resignation ("To navigate is necessary; to live is not"); "Atrás do trio elétrico" may make you want to dance behind a massive Carnaval bandstand ("Behind the electric trio, only the dead stay home"); "Alfômega" may fill you with a properly rock euphoria that is entirely inappropriate to its content. Because they are good songs of their kind, they probably will, and the affective jolt they provoke is their market raison d'être. But whether they do or not, they are unavoidably about these affective states—a map of Brazil as a survey of affective intensities—which are now drawn into the immanent purposiveness of the work rather than serving as an external end.

The approach to producing musical meaning is quite in line with that pursued by Weill and Brecht; the meaning produced is, of course, quite different. The post-Tropicália project, as Veloso and Gil write in "Cinema Novo," a song from their album *Tropicália 2* (1993), centrally concerns "conversas sobre jeitos do Brasil," conversations about characteristic Brazilian ways and attitudes. What emerges from the album as a whole is a musical portrait of Brazil, elaborated from a certain standpoint, necessarily incomplete, and by no means excluding foreign influences.[64] This is the mode of Veloso's career henceforth, and it has become in no small measure that of ambitious Brazilian music itself.

In principle, there is no reason these ways and attitudes cannot be class attitudes, professional attitudes, historical attitudes, and so on, as they are in Brecht and Weill. But in that case the national frame would be relativized, and in practice the relevant categories tend to be regional and historical in the very limited sense of being credited with having contributed to the Brazilian national character. The project sits entirely

comfortably with Veloso's liberalism (and with contemporary global, yet American, cultural pluralism). Veloso exhibits a worldview of profound sympathy with the lower orders, who, after all, make most of Brazil's music. But sympathy is not the same as sharing political or economic power. A rather better son of the bourgeoisie than he imagined in 1964, Veloso's attitude toward a real democratization of political and economic power can, in the balance, hardly be viewed as progressive.[65] But Veloso's musical practice entails a politics quite separate from his appeal to the market, which veers uneasily between realism and cynicism, and despite his liberal nationalist ideology, which veers uneasily between empathy and paternalism. Veloso discovered, in the market, in the availability of pastiche as a mode that the market both entails and rewards, a condition of possibility for a mode of self-legislating form that, in principle and of necessity, is autonomous from the market. In a moment when the market as the horizon of all human endeavor is the strongest (but also practically the only) arrow in capital's ideological quiver, and universal valorization practically its only (but also its most socially devastating) imperative, Veloso reinvents Brechtian citation as a "foreign body" within the culture industry.

Despite some relatively recent and only rarely successful attempts at rock, Veloso's "sound"—as we saw in the previous chapter, the relevant aspect from the standpoint of the market—could not be further from the White Stripes' "Hello Operator."[66] Although a suggestion of private meaning seeps through, the lyrics make as little public sense as the children's rhyme "Miss Susie," from which the song's first two lines are borrowed.[67] They are not set to a melody, the pitch being determined by English speech patterns, as is the rhythm, which is regularized just enough to conform to a beat. The vocal quality is an assertive juvenile whine. The drum part under the lyrics consists entirely of quarter notes, on the beat, four to a measure, with the bare minimum—accented snare on beats 2 and 4—to qualify it as a rock beat. The guitar part is also minimal: two open chords, a fourth apart, each held for half a beat on the first beat of each measure. (The guitar will fill some of the empty space with simple blues lines; elsewhere, the drum part will add exactly one eighth note to the straight quarter note pattern). There is nothing in the basic structure of the verse that an able-bodied nonmusician could not learn to play—indeed, nothing that a nonmusician could not come up with on her own—in a pair of afternoons.

The verse of "Hello Operator" is, in other words, the precise minimum organization of sound required to make a rock song—but not necessarily a rock song to which there would be any reason to listen. Once the rock song has been stripped down to its minimal constituent parts, the question is: what is the minimum necessary to make a compelling rock song? The answer is stated, as clearly as a Beethovenian theme, immediately following the verse, in the drum solo.[68] The words "drum solo" in a rock context summon all the wrong connotations, as this one is played entirely on the rim of a snare drum, is short (four bars and an introductory bar), is repeated twice, and consists in its second half entirely of quarter notes. It is also quiet, so quiet that the hum from a guitar pedal can be heard under it until the hum is muted at the beginning of the first full measure—an apparently nonmusical sound that reads as accidental, but, since it could have been fixed in the studio, must be understood as intentional. The solo is, in other words, emphatically framed. It consists of two ideas. The first—two quarter notes constituting half a measure—barely counts as an idea. The second is a cliché about as old as recognizably American popular music: it is none other than the ragtime cliché from bar six of "Cannon Song," the rhythm Debussy hammers to death in "Golliwog's Cakewalk." What "Hello Operator" is about, then—what reverberates back to the beginning and culminates in the climax of the song—is the exploration of this idea, the relationship between an absolutely minimal musical phrase, two quarter notes, and a minimal syncopation with the same duration.

After the idea is presented by the drum, the guitar displays the pattern in a different light. Leading out of the drum solo, the guitar, transposing the syncopated pattern a half beat, changes its value and its musical function: rather than beginning on a downbeat, it ends on one. The initial statement of the idea on the snare drum is quiet and tentative, beginning from nothing, wavering from the pulse; the chordal guitar line, tightly aligned with the pulse, asserts the shifted pattern at volume, landing hard on a downbeat, and a new section develops the transformed idea. The relation between the two statements is that of premise and inference. As the transformed pattern is repeated, the guitar introduces a new chord: the subdominant, whose introduction has the expected effect of confirming the other two chords as tonic and dominant, and produces the unexpected illusion of opening up the harmonic possibilities of the song. In Lou Reed's immortal words, three chords and you're into jazz.

The song is bookended by elaborations of the central idea. The first is a two-bar guitar introduction based on an impure fifth scalar tone. Since it precedes the first explicit statement of the idea, it initially reads as an improvisation. But in retrospect there can be no doubt that the introduction is composed. It sounds moderately complex, but it is assembled out of precisely four elements, which derive from the two simple ideas presented in the drum solo: straight quarter notes, the syncopated pattern (what we will first hear on its own as the drum version), the same pattern transposed half a beat (which we will first hear on its own as the chordal guitar version, but which has yet a third value here, landing on a backbeat instead of a downbeat), and straight eighth notes, a variation on the minimal straight-quarter-notes phrase. The break is repeated precisely halfway through the song and provides an ecstatic climax. What ought to be a guitar solo, essentially postponing the climax once all the ideas have been stated, is played on a heavily distorted harmonica. To end the song, the single guitar line reenters, in unison with the harmonica, with a third variation on the developed two-bar idea from the introduction. The unison is rough; again, this could be accidental, but since another take or two would fix the problem, it must be regarded as intentional. After the rigorous separation of elements throughout the song, the climactic gesture of the convergence of guitar and harmonica is that of two lines of thought—the harmonica and guitar are mixed down into separate channels—simultaneously leading to the same conclusion. The affirmative value of these two bars is hard to exaggerate: it is a musical QED.

As if to confirm this, the name of the album on which the song appears is *De Stijl*, a movement that famously championed the abstraction, simplification, separation, exposed articulation, and balance of elements. The album title does not tell us anything we do not know already, but it is a useful reminder that the simplification involved in "Hello Operator" aims at abstraction rather than primitivism.[69] As De Stijl's foremost theoretical exponent put it, "Arms, legs, trees, and landscapes are not unequivocally painterly means. Painterly means are: colors, forms, lines, and planes."[70] The first thing one would want to say about the reading of "Hello Operator" undertaken here is that, unlike in our earlier analyses of Weill and Veloso, the esoteric meaning of the song—it is about the musical potential of a rhythmic cliché, about what musical means are unequivocally proper to rock and why—has

no obvious relationship to an exoteric meaning. The adolescent aggression of the vocal quality could almost qualify as a kind of social gesture. But the nonsense lyrics and the fact that the development of the idea occurs only elsewhere than the verse are designed to undercut this possibility, though they cannot foreclose it entirely. (We return to this issue later.) As one of the narrators in Jennifer Egan's *A Visit from the Goon Squad* remarks, "The songs . . . have titles like 'Pet Rock' and 'Do the Math,' and 'Pass Me the Kool-Aid,' but when we holler them aloud in Scotty's garage the lyrics might as well be: *fuck fuck fuck fuck fuck fuck*."[71] Aggression is, tautologically, social. But as much as possible, aggressiveness is reduced here to a timbral quality, a tenor whine. "Hello Operator" is, in this sense, abstract: its musical idea is developed in nearly complete isolation from nonmusical or referential content, to which it can therefore no longer be subordinated. Simplicity then becomes a gesture of attention rather than inattention. If a country song is, in the great songwriter Harlan Howard's famous formulation, three chords and the truth, then the White Stripes' conception of a rock song is three chords and an idea.

Weill turned away from music-immanent development and Veloso understands it as unavailable. The point of the White Stripes' neoplasticist songs such as "Hello Operator," by contrast, is to produce an account of rock that is purely music-immanent. But the White Stripes' project continues along another axis, that will probably be more obvious and is closely related to the strategies Weill and Veloso did pursue. White Stripes albums are larded with historical citations (the B-side of the "Hello Operator" single is a cover of Dolly Parton's "Jolene"), and it is instructive to compare the function of these to Weill's and Veloso's.[72] The most conspicuous example on *De Stijl* is a simplified but basically straight cover of Blind Willie McTell's "Your Southern Can Is Mine." An affirmative relationship to the material in Veloso's vein would be hard not to read as claiming an identity with McTell that would be difficult to defend. A negative, disidentificatory one in Weill's vein would be equally indefensible: from what perspective, exactly, would a Piedmont blues song be ironized? The lyrical material—a song that, at least on the surface, celebrates domestic abuse—raises the stakes along the same ethical axis, but with the polarity reversed. At the level of musical form, identification is dishonest and disidentification is unthinkable; at the level of lyric, identification is unthinkable

and disidentification is dishonest. The performance is infused with a mischievous glee (but McTell's is infused with a similar glee) at raising the same sets of hackles for completely contradictory reasons.

The White Stripes give up the game in the last twenty seconds of the track, but we will return to that in a moment. The riddle to the presence of "Your Southern Can Is Mine" on *De Stijl* can be solved entirely immanently. The relationship to the social material behind "Your Southern Can Is Mine" is neither affirmative nor critical but nonexistent; it is raised only to be refused. The relationship is, rather, purely musical. In both McTell's original and the White Stripes' cover, the guitar part is built out of two elements: a quarter note pattern, accented on the offbeats (in McTell's version, the effect is like stride piano played on guitar) and a syncopated pattern of the same length: none other than the second, shifted statement from "Hello Operator" of the ragtime rhythm we first saw in bar six of "Cannon Song."[73] In other words, both "Your Southern Can Is Mine" and "Hello Operator" work on the same musical material. The relationship to the material is unironic in the sense that McTell's music is taken absolutely seriously. But there is no nonmusical identity asserted (or denied) between the White Stripes and McTell, precisely because no nonmusical identity is asserted of either one separately. The only identity asserted is between McTell's musical material and the White Stripes'—a musical identity between ragtime guitar and rock— and that identity is not so much asserted as demonstrated.

A nonmusical clip appended to the end of "Your Southern Can Is Mine"—and to the end of the album *De Stijl*—confirms all this. Without context, the clip is mysterious. One man asks another if something is wrong, why the other is acting so uncomfortable. The second man responds that he was in a traffic accident the night before, but nobody got hurt. The clip sounds old; there is a difference of power and class between the two men, but the accents are hard to place. The staginess of the first voice suggests nothing so much as a 1940s film. In fact, the first man is Alan Lomax, and the second is Blind Willie McTell himself.[74] The moments that precede the included clip give the context. McTell has just recorded songs for inclusion in Lomax's folk song archive for the Library of Congress in Lomax's hotel room in Atlanta. As Lomax apparently cannot tell, but is obvious to contemporary listeners, McTell is uncomfortable because Lomax has been trying to bully him into singing some "complainin' songs." By the time Lomax asks expressly for "Ain't

it Hard to be a Nigger, Nigger?" (McTell responds, cautiously, "Well . . . that's not . . . in our time"), a modern listener will be squirming almost as uncomfortably as McTell. The clip included on *De Stijl* begins, "You keep moving around, like you're uncomfortable." Why include this clip? Because Lomax is asking McTell to do what we tend to want McTell to do, which is to connect his music to a historical experience, as the product of a historical identity. But historical experience, as we see in the next chapter, is another kind of external cause; the same is true of identity, which, according to its concept, is something McTell simply has, whether he wants it or not, and that he expresses, whether he means to or not. McTell refuses Lomax's request for reasons that may have something to do with this, or that may be pure cautiousness, or there may be some other reason altogether. But the clip is not about McTell. It is about Lomax. His position is the undeniably false one, requiring someone to assert an identity that is instead being forced on him— "Ain't it hard to be a nigger, nigger?"—but it is also the position we are in as long as we take the ethical bait of "Your Southern Can Is Mine." The musical relationship is not between the White Stripes and McTell but between rock and Piedmont blues, between "Hello Operator" and "Your Southern Can Is Mine." On the ethical plane, "Your Southern Can Is Mine" is the analog of Charles Ray's *Unpainted Sculpture*: it is not about identity, but it is about not being about identity.

The straight, genealogical covers are to be distinguished from another aspect on which we will not spend much time here—namely, the deformative covers, or covers that turn a country song ("Jolene"), a pop song (Burt Bacharach's "I Don't Know What to Do with Myself"), and a camp pseudo-bolero-cum-tango (Corky Robbins's "Conquest," a hit for Patti Page in 1952) into a rock song.[75] There is nothing pure about any of these aspects: a swamp-rock cover of Robert Johnson's "Stop Breaking Down," which takes a fleetingly brief (two second or so) slide-guitar coda from Johnson's recording and turns it into the principle of the new performance, is both deformative and genealogical and very far from merely domesticating like the Rolling Stones' version.[76] As with Veloso and despite expectations, there is nothing satirical about these covers or any position of superiority taken with regard to the material. Despite the violence done to the appearance of, for example, "Jolene"—to its "sound"—the idea at its core is preserved and taken seriously. It is not difficult to see that the idea of the deformative cover lines up with the

pure rock constructions, asking the same question from a different angle: What makes some songs amenable to this treatment and not others? What constitutes, in other words, a musical idea appropriate to rock?

Spotting musical references, borrowings, and influences—real, imagined, and misunderstood—is as endemic to pop music criticism as hypercharged ekphrasis. But the White Stripes make extensive use of pastiche proper—songs whose musical content is "This is what a Bob Dylan (Led Zeppelin, Cream, Jane's Addiction) song sounds like." These, together with the genre exercises—from blues shuffle to Scottish reel—add up with the straight covers to a project remarkably like Veloso's: a collection that assembles itself into an account and, in so doing, produces a meaning behind the back of the market. But once the similarity is pointed out, the difference becomes immediately clear: the meaning is of an entirely different order. The internal consistency of the album *Caetano Veloso* both makes a claim about and claims to be endowed by the internal consistency of Brazil, even if the principle of that consistency is contradiction. Non-Brazilian elements are not shied away from, but they are understood as sources and, in that sense, internal to Brazil after all. The unifying principle behind *De Stijl*, a relationship between its parts that it appears to discover rather than to impose, does not immediately appear that different, as rock is an American genre. But the hallmark of Veloso's nationalism, his generous musical catholicism—which has both positive and negative implications—is completely missing from the White Stripes. The genealogy they produce is a genealogy of rock, not of the United States. Music from outside the history of rock is included only if it can be reduced to an idea that can be the basis of a rock song. Nonrock music that is also descended from the blues—funk, R&B, soul, to say nothing of jazz—is excluded. As the White Stripes' cover of "Lord, Send Me an Angel" shows clearly enough, this has nothing to do with a fear of treading on racially sensitive territory.[77] Once the paths that lead out of the blues diverge, the White Stripes have nothing to say about the ones that do not lead to rock.[78] Indeed, even the history of rock is, given the formal restrictions imposed by the imperative toward abstraction, a limited one: missing subgenres, particularly those that require more expansive musical elaboration or ornamentation, are relegated to later projects and different bands.

Until now, we have more or less ignored or derogated lyrical content, in keeping with the White Stripes' practice, which tends to suppress the

importance of lyrical content by restricting it to private obscurity, nonsense, or purely generic meanings. But lyrical content cannot be ignored entirely: it can be reduced to "fuck fuck fuck fuck fuck," but not to "darn darn darn darn darn." Adolescent aggressiveness is clearly an indispensable element. But adolescent aggressiveness is framed or otherwise relativized rather than expressed. When Jack White says categorically, "I never write about myself. I'm not going to pretend like 'Oh, I'm waitin' on a train, and my baby's comin' back,'" he is not saying anything that is not already true of every lyricist, including many who are taken to be, or let themselves be taken to be, expressing some kind of train taking or other authenticity.[79] But the White Stripes internalize the literary frame, so that any imputation of expression is not only a categorical mistake but also an interpretive one. To take an almost arbitrary example, the bridge of "There's No Home for You Here," with its perfectly simple, perfectly direct hatred of bourgeois normalcy, is distilled rock sentiment:

Waking up for breakfast
Burning matches
Talking quickly
Breaking baubles
Throwing garbage
Drinking soda
Looking happy
Taking pictures
So completely stupid
Just go away

Although the target in the bridge and the title might just as easily be tourists, the song is generically a kiss-off song, so the hatred is aimed at a specific person, as well as at monogamy in general:

I'm only waiting for the proper time to tell you
That it's impossible to get along with you
It's hard to look you in the face when we are talking
So it helps to have a mirror in the room

I've not been merely looking forward to the performance
But there's my cue and there's a question on your face
Fortunately I have come across an answer
Which is go away and do not leave a trace

The situation is clear enough. But the speaker's self-regard, apparent already in the self-understanding of breaking up as a performance, is literalized in the fact that he is looking not into his adversary's face but into a mirror as he delivers the coup de grâce. Adolescent aggression is presented as inseparable from adolescent self-regard—hardly a novel thought, but one that serves its purpose, which is to relativize the content of generalized antisociality that is at the same time necessary to the song as a rock song. The point is not to write great poetry—great poetry is not part of the logic of rock—but to write a rock lyric that is minimally self-framing.

A second technique—and one that may also be at work in "There's No Home for You Here," with its hatred of soda drinkers and picture takers—is the substitution of a private meaning for the public one that ought to be the core of the song. "Ball and Biscuit," in the song of that title, evidently refers to an illicit sexual practice, a drug recipe, or some kind of mind-blowing combination of the two:

> Let's have a ball and a biscuit sugar
> And take our sweet little time about it

The lyric, mostly spoken in a bullying drawl over a slow blues rock, hovers—the vocal equivalent of Jim Morrison's image on an album cover—between sexually threatening and ridiculous:

> Right now you could care less about me
> But soon enough you will care, by the time I'm done

> Go read it in the newspaper
> Ask your girlfriends and see if they know
> That my strength is ten-fold girl
> And I'll let you see if you want to before you go

The drug-related possibility quickly loses plausibility as the song turns out to be, more than anything else, about the gestic content of guitar solos. There are three guitar solos in the song—an absurd number for anyone, much less the White Stripes, who tend to avoid them or keep them short. All three are spectacularly hyperbolic, the middle one introduced by "I can think of one or two things to say about it," with "it" having the same grammatical referent as "take our sweet little time about it"—namely, "a ball and a biscuit"—and concluded by "Do

you get the point now?" immediately before a third solo is launched into. The gestural equivalence of rock guitar solos and sexual swagger has never been lost on anyone, but again, it is self-framing rather than profundity that is aimed at, and if ever a work of art managed to fuse fun as an object of inquiry and inquiry as an occasion for fun, this is it. However, it takes only a moment's research to discover the literal referent of the lyric's "it": "ball and biscuit" is slang for an old omni-directional microphone formerly used by the BBC, one of which was hanging from the ceiling at the studio where the song was recorded.[80] This does not change the meaning of the lyric, which says nothing about microphones and still promises a "girl" as a transcendent and dangerous sexual experience. But that experience, the lyrical core of the song, is nothing, just a suggestive piece of language: a fact that evacuates the meaning of the lyric and heightens the meaning of the social gest of the form itself, since the meaning of the form insists with-out a literal signifier. If the form is insistent enough, "darn darn darn darn darn" will do just fine.[81]

Why is this derogation of lyrical content necessary? Beethoven is said to have remarked to his student Carl Czerny that mediocre poetry was easier to set than the greatest, because "the composer must know how to lift himself far above the poet." As long as music accompanies lyrical content, it is liable to become a matter of giving bodily ampli-fication to a sentiment that is aimed at by the lyrics, which assume primacy. If Schumann's "Abends am Strand" gives some sense of the possibilities this fact opens up at an earlier moment in music history, a glance at any journalistic pop review will confirm the limits it imposes on music whose social circulation is dependent on the market.[82] To the degree that the function of a pop song (the reason there is a market for it) is to amplify, monumentalize, and universalize an experience that is of necessity (because appealing to a market) general—which is to say, trivial—then the White Stripes' containment of lyrical meaning is a straightforwardly Brechtian-Weillian disidentification technique. "There's No Home for You Here" and "Ball and Biscuit" present the "fun," or affective charge, of adolescent antisociality and swaggering male sexuality, but by making themselves about the affective charge of adolescent antisociality and swaggering male sexuality, they wrest their autonomy from the requirement to produce that effect, which still ex-ists but that otherwise would subsume them.

Two kinds of meaning are aimed at by the White Stripes. The first is purely music-immanent meaning, the formal exploration of rock as a disposition of musical ideas in the way neoplasticism aims at the isolation of properly painterly ideas. The second is a kind of historicism, which is a matter not of "situating" rock in its social context but of understanding it as a set of limiting conditions whose contours can be explored and tested. For both kinds of meaning, lyrical content has to be retained but neutralized, and the logic is straightforwardly Brechtian. Fun—or whatever other affect—is to be included, but an internal distance from it is required as a prerequisite of taking it into account.

Kurt Weill, Caetano Veloso, and the White Stripes produced music under substantially different historical conditions. Nonetheless, the family resemblance of their approaches is not coincidental. All three understand musical meaning to be either music-immanent or gestural-citational; all three understand the obstacle to musical meaning posed by the market as something that nonetheless is not to be avoided. While all three recognize the horizon of purely music-immanent meaning, the first two turn away from it in practice; it is only the White Stripes who attempt to produce it from within a market-circulated form. This is apparently paradoxical, as the White Stripes are the furthest from the possibility of a modernist, medium-immanent form of meaning sustained by a restricted field—a form of meaning that is rejected by Weill for political reasons and by Veloso for what he takes to be historical ones. But perhaps there is no paradox. Only when the classically modernist horizon is all but forgotten does the attempt to "struggle against extramusical influences" within a cultural field saturated by exchange value begin to seem like a plausible and attractive project.

This return to the ambition of music-immanent meaning, from the perspective of the current study, is conceptually the most unexpected development among the three projects. But it comes at a cost. White Stripes concerts ended with a rock version of the variously titled "Boll Weevil Song," best known through a Lead Belly version recorded by Alan Lomax in 1934.[83] There is a certain pedagogical force to the exercise, which is made explicit when the song is taught to the audience as a sing-along. In a typically self-aware move, the act of teaching the song is (as it was in Lead Belly's version) incorporated into the lyrics. But while the pedagogical element of the White Stripes' project is not negligible, it has no ambitions beyond purely musical ones. Of course, if

what was said earlier is true, musical pedagogy is the only kind of pedagogy music can be expected to accomplish. But there can be no mistaking the fact that the White Stripes' project is, in terms of its political content, the least substantial of the three. Indeed, it is hard to imagine it having a politics at all. There is nothing that exempts political messages from the logic of the White Stripes' project. A political message must either be relativized—because it is a politics that is interesting only as far as it is a rock politics, and thus no longer means what it says—or immediately fall prey to a market logic where it becomes a consumable point of identification, no different from a feminist T-shirt by Dior.

But it is the aim of this study to show how, under present circumstances, the production of artistic meaning—that is, the production of an unvalorizable value within a society that subordinates every activity to the valorization of value—itself has a politics. It is not merely a matter of producing a line of flight along which artists can, within a value-saturated cultural field, produce nonvalues, meanings—though artists may certainly experience it that way. Rather, in a regime whose essence is the demand that everything be valorized, the production of the unvalorizable lodges a "foreign body" at capitalism's ideological weak point. The political effectivity of such an act is necessarily beyond the scope of this book. We are concerned with the problem of securing the specificity of art against the ideological horizon of a fully market-saturated society. Meanings circulate or fail to circulate, compel or fail to compel. Success in the former, which is easily quantifiable, does not guarantee success in the latter, which is not. Nonetheless, one would want to avoid repeating Schönberg's dogmatic error that because *Threepenny* was popular, it must not have been understood.

4 Modernism on TV

The 1963 short feature *Stopforbud*, the first film by the great Danish experimental filmmaker Jørgen Leth, is, in its refusal to identify musical form with its social determinations, the filmic equivalent of the White Stripes' cover of Blind Willie McTell's "Your Southern Can Is Mine." A portrait of the bop pianist Bud Powell, *Stopforbud* refuses what will become the unavoidable question of the music documentary: how did *this* (music) come from *that* (person, group, society, subculture, historical juncture)?[1] Not that *Stopforbud* merely refuses to provide definitive answers to this question, a refusal it would presumably share with all but the most insipid examples of the genre. A film about art that amounts to a critique of the music documentary genre largely *avant la lettre*, *Stopforbud* insists that the question is not worth asking. The principles underlying the construction of *Stopforbud* emerge from Leth's own formal convictions: principally, that narrative is not essential to the film medium, which consists in "a series of images, nothing more."[2] But the meaning of the film is bound up in its refusal of the question of how *this* comes from *that*—a refusal that is more or less immediately implied by Leth's antinarrative credo—a refusal it performs in three ways.

The first refusal occupies most of the film, as we watch Powell, an expressionless cipher for most of the film's eleven and a half minutes, walk on a gray afternoon through downtown Copenhagen—through King's Garden, along the docks, over a landfill—without ambient sound, accompanied only by his own spellbinding performance of "I'll Keep Loving You." For its first seven minutes the film simply presents *this* and *that*, without suggesting any connection between them. The spell is broken around 7:40, when Dexter Gordon's voiceover takes over from Powell's piano; shortly afterward, the images shift from Powell in Copenhagen to Powell in performance. We prepare to be doubly disappointed, or perhaps relieved, at this turn to what will soon be requirements of the genre—namely, authoritative explanation and performance footage. Both are meant to illuminate the question of how *this* comes from *that*, in the first case through expertise, and in the second through the representation of the bodily practice, ripe with expressive potential, of musical performance.

But our expectations are doubly defeated. The documentary voiceover gives us one-and-a-half unrelated anecdotes. The half-anecdote, about an interaction between Powell and Art Tatum, concerns the origins of bop piano, which Gordon implicitly credits (without explaining what the accomplishment means) to Powell as Powell's central achievement. Gordon relates that one evening, Tatum (renowned, as Gordon does not tell us, for his left-hand technique) complimented Powell but asked what had happened to his left hand. The omitted punch line of the anecdote—that Powell plays the next song entirely left-handed—would demonstrate the point of the story, which is that the subordination of the left hand is an innovation rather than a technical limitation. Gordon, who knows this—as does Leth, who had been a jazz critic—waits instead for an image of Powell's left hand (Gordon has apparently seen the edited footage) and says what the camera tells us just as well, which is that it is large. So the voiceover is not going to explain the music to us. The second anecdote, concerning racism, is sociological rather than musical. But no connection is made to segregation or to Harlem or even to Powell's well-known, brutal mistreatment at the hands of the police and its apparently devastating, ultimately mortal psychological effects, or to any other context for Powell's music. Rather, the anecdote relates Powell's indignation, surely justified, that he is paid less to perform than George Shearing—an external fact that, not incidentally, reminds

us that the "judgment" of the market and the judgment of a restricted field are entirely different things. The fact is clearly galling but tells us no more about the music than does Powell's meandering path around Copenhagen.

The third refusal is more or less simultaneous with the second. As the images shift from Powell in Copenhagen to Powell in performance, we expect synchronized audio: the filmic representation of *this* coming from *that*, a requirement that has cost Hollywood well over a century's worth of crash music lessons. But Dexter Gordon speaks over silence, commenting, as we have seen, on the visual element of Powell's hands rather than on his music. Just as Powell's music reenters, the camera turns its focus from his hands to the expressions—apparently involuntary, occasionally grotesque, and anything but expressive in the usual sense—that Powell makes while absorbed in performance. Showing that the lack of synchronized audio is not merely a technical limitation, we do get one moment of it, but it is not musical: Powell asking, "Is that all right?" possibly referring to the cinematic quality of a drag he has just taken (apparently at Leth's instruction) from a cigarette. When, finally, near the end of the film we see Powell's hands and hear his music at the same time, the hands are playing a different song from the one we hear. Leth once again refuses to give us *this* coming from *that*. Instead, he gives us a work of art about another work of art, asserting about Powell's "I'll Keep Loving You" what is equally asserted of *Stopforbud* itself: that whatever in it can be causally explained—by Powell's own enigmatic subjectivity, by the development of jazz, or by the racial history of the United States, three determining factors that make for a virtually irresistible mutually implicating contextual matrix—does not pertain to the workness of the work. The work, as work, is autonomous from what otherwise determines it.

It is this thesis that Leth's younger and better known colleague and admirer Lars von Trier attempts to disprove in *The Five Obstructions*, a brilliant film about his own, failed attempt to sabotage Leth's short masterpiece *Det perfekte menneske* (The Perfect Human [1968]).[3] The premise of the film is simple: Leth has to remake his own film five times, each time following a set of protocols established by von Trier. The film is itself an allegory of the restricted field. What is at stake is the question of where the meaning of film resides: in the "perfection" of the work, by which von Trier means Leth's commitment to self-legislating form,

or in the wounding, errant detail. The valence of *perfekte* as it describes *menneske* in Leth's Danish title, however, is far from straightforward. Since individuals are always already differentiated—as dramatized by the fact that there are in fact two "perfect" humans, one male and one female—what would the singular "perfect human" look like? But in von Trier's usage, applied to Leth's work in the film's dialogue, it refers to the successful assertion of autonomy—that is, the successful assertion of freedom from accident, of the suspension of the contingent character of external conditions, an assertion von Trier sets out to undermine: "My plan is to move from the perfect to the human. . . . I want to banalize you." It is clear that the stakes for each artist are high, because the experiment has the potential to be compelling: that is, to render the question of preference—the only question the market can address—irrelevant.

Von Trier's first set of obstructions is formal. Dramatizing the freedom from accident that von Trier is interested in undoing, *The Perfect Human* takes place in a featureless white room into which elements are added and subtracted as necessary. The new version must be shot in Cuba, and no sets or screens are allowed. *The Perfect Human* is constructed in long takes—the longest of them last from just under to just over a minute, or, in other words, in the neighborhood of 1,440 frames. In the new version, no single edit can take up more than twelve frames—that is, there must be at least a seemingly unbearable two cuts per second. The narration of the 1968 version asks several questions, which go unanswered; the new version must answer them. But these formal constraints, no matter that they are opposed to the ones he originally set for himself, turn out to be catnip to Leth. The answers can, of course, suggest new questions—"Why is he moving like that? Because women like it when he moves like that"—thus evading the banality that von Trier aims to produce. National particularity—a tobacco pipe, a salmon dinner, even the bare white space—are already built into the earlier film as one of the ironizing particularities that attach to the "perfect" human, so the Cuban setting—a Cohiba, a cafecito, peeling plaster walls—rather than intruding on the film, can be seamlessly subsumed into its structure. Finally, and most important, the twelve-frame limitation can be used to foreclose identification with both the framed figure and the camera's gaze as effectively as Leth's signature pseudo-anthropological long takes. The unspoken final obstruction is the ultimate banality, and the ultimate intrusive accident (already familiar to

us from its mobilization in *Boyhood*)—namely that Leth's voiceover is spoken by a voice that, thirty-five years after the earlier film, is no longer that of a young man. After he views the new film, von Trier's dismay and admiration are transparent, as even this last, tacit obstruction has been neutralized: "It was like watching an old Leth film. Interesting!"

For the second obstruction, von Trier, prematurely, lays his cards on the table. The film must be shot in the "most miserable place on earth," which must be of Leth's own choosing. The location, however, is not to be shown; rather, Leth is to tell the story of the shoot upon returning to Denmark. Finally, the perfect human must be singular, and he must be played by Leth himself. Von Trier is explicit about his goals: "Would anything rub off?"—that is, would some wounding detail deform the fabric of the film? "I want to make you empathize"—that is, to commit the Brechtian sin, to allow the realm of affective motives to interrupt the realm of (here, aesthetic) reasons, to short-circuit interpretation by means of identification. "Pure romanticism," replies Leth. "There is no physiological law" that determines that there must be a point beyond which reasons must be overwhelmed by affective causes.

Leth chooses the "horror scene" of Falkland Road, a squalid red light district in Mumbai, a "picture from hell" he had witnessed six or seven years earlier—thereby including, without breaking protocol, the female half of the original film. Leth is not a sociopath—he brings valium with him on the shoot as a failsafe and has nightmares for two nights after filming—so there is no question of his not actually empathizing. Rather, the trick will be to prevent that empathy from becoming the content of the film. Where von Trier wants to move Leth from "the perfect" to "the human," understood as opposed conceptions of the work of art, Leth wants to use the opportunity to crank up the dialectic between "the perfect" and "the human," between universal and particular, understood as contradictory aspects of the same thing, whose interplay is the content of the work.

The primary measure taken is to introduce a scrim between the action and the setting so that curious onlookers crowded behind it and behind the actor's back—looking, therefore, in the camera's direction—appear as a huddled mass. The main theme is the dinner scene: Leth, as "perfect human," must eat a sumptuous meal on a silver platter in front of an audience of, presumably, third-world sex workers and their children. The soundtrack includes an apparently ambient recording of

the crowd, as well as "Va, pensiero" (Chorus of the Hebrew Slaves) from Verdi's *Nabucco* (the title character being Nebuchadnezzar, the humbled and converted king). The air functions most immediately, like the *Blue Danube* in Os Mutantes' Tropicalist song "Panis et Circencis," as a mere marker of bourgeois taste, but it also works as a reference to Leth's desire to be elsewhere and to von Trier as the (presumptively humbled and converted) tyrant. No Claus Nissen, Leth nonetheless pulls off the role, which does not prevent him from worrying that in doing so he has made a pact with the devil.

Upon viewing the film, von Trier categorically rejects Leth's solution. At first this appears to be nothing more than a quibble over the meaning of "show": does the inclusion of some onlookers huddled behind a screen count as showing Falkland Road? But there is a deeper logic to this rejection. "I have to think the way I do," insists von Trier. "I'm sorry, it's not just because I'm being stubborn." If Leth is allowed to represent the location, no matter how elliptically, the second obstruction will be nothing more than a radicalization of the first. In effect, Leth's solution renders the success or failure of his performance as an actor irrelevant in advance: any wounding detail can be integrated into the structure of the film, subsumed under its fundamental tension between "perfect" and "human." Indeed, Leth's two infinitesimal slips demonstrate the point. Twice Leth glances anxiously off camera. But with the crowd behind him, this is immediately legible as the thinly veiled vulnerability of the (male, bourgeois, European, tuxedoed) "perfect" human when confronted with his others, something Nissen had projected by purely actorly means: a fleetingly troubled expression, an ambiguous grimace interrupting a love song. With that recognition it is no longer clear that these sidelong glances are to be understood as slips at all, since what they say is nothing other than what the meaning of the work was in the first place.

The second obstruction is, as it were, fought to a draw. The fourth obstruction is already a denouement and a lark—the film is to be re-made as a cartoon, a sadistic requirement, but not one that advances von Trier's case and, perhaps, a year after Richard Linklater's *Waking Life*, one that is not so difficult to overcome after all. The fifth is von Trier's official concession speech.[4] The climax of the film, and the obstruction most relevant to the problem of television, is the third: Leth has to make the film again, but with no external rules. But *The Perfect*

Human was already made under a set of nonarbitrary constraints governed by Leth's understanding of film as a medium. That is, in Leth's understanding, the constraints he imposes on himself are just as much imposed by the medium. Von Trier's obstructions, as attempts to disrupt these original principles, are nonarbitrary in their very arbitrariness: arbitrariness was the point, and the success or failure of Leth's conversion of externally imposed contingency into internal consistency marks the strength or weakness of his response. Any new constraints that Leth imposed on himself, by contrast, would be purely capricious, illegitimate not by some external standard but by the criterion of formal necessity established by the film itself, since the constraints he operated under for the original film were the ones Leth understood to be nonarbitrary. How could the new film fail to fail?

Genre conventions, however, are not capricious, even though as formulas they appear arbitrary from the standpoint of the self-legislating work: they carry normative force, even though that force has in the first instance nothing to do with film as such and everything to do with the market—the force, that is, of audience expectations. If the genre requirements are satisfied, the result, in Jean-Luc Godard's words, is "a sure-fire story that will sell a lot of tickets." As is well known, Godard (attributing the insight to D. W. Griffith) boiled the problem of audience expectations down to two elements: a girl and a gun. And in a split-screen montage just a minute into the film, we are presented with a girl and a gun. Later there will be a McGuffin—a silver briefcase left on a dock—and the female perfect human becomes a femme fatale or Irene Adler role played by the Belgian actress Alexandra Vandernoot. Set in Brussels, a city that retains a certain mystique despite its geopolitical centrality, the film seems to end on the Orinoco River. For the lead, Leth cast Patrick Bauchau, a French New Wave figure (also Belgian) whose later career includes American television and a James Bond villain. Here the male perfect human is "Monsieur Rukov," a mysterious Russian who speaks flawless French—in short, a spy.[5] Constrained to capriciousness, Leth chooses instead the constraints of a genre, constraints that are, in their givenness, immediately legible as externally imposed. In doing so, he demonstrates that genre requirements are not different in kind from the obstructions imposed by von Trier. Like von Trier's obstructions, they can be freely taken up, acknowledged as constraints but suspended as determinations. Backed into a corner, Leth

produces the model of the "aestheticization of genre," postulated in the introduction, that will reach its most accomplished form in the American television series *The Wire*.

The first thing one notices about the third obstruction is that, for the first time, the links to the original film are not obvious. What remains of the original—a man touching his own face, some lines of a prose poem, Henning Christiansen's score—has been thoroughly repurposed, retaining none of its original meaning in this new, slick context. It takes a moment to realize that this is the game: the sui generis elements of *The Perfect Human* are converted into genre elements, where they change meaning. The tuxedoed "perfection" of the perfect human becomes a James Bond suavity; his sexual pathos is transposed into the femme fatale plot (condensed into about ninety seconds) and the serial encounters of a professional anonym. The existential mystery of the central prose poem hints now at disturbing events. The observant, pseudo-anthropological curiosity of the voiceover becomes the watchfulness of a handler; unexplained elements become clues we are not yet ready to decipher; the vagueness and abstraction of what can be said about the perfect human becomes cautious euphemism: "He goes out, and takes care of things."

How is this, then, the "same" film? Unlike von Trier's formal impositions, which are known to us from his framing conversations with Leth, the rules that underlie what we see can, as genre conventions, be understood because the conventions themselves are already known, and can, as in a movie trailer, be telegraphed in seconds. Leth's procedure cannot, then, be a matter of borrowing genre elements or using them as mere stylistic means. Rather, the ensemble of generic constraints has to function as an immediate, intuited given, like the external boundaries of a painting. (Not even the most naïve museumgoer is surprised to see a painting end where its frame begins). The conventions, then, are not motivated in the usual sense, fleshed out with illusionistic content. There is, in diagetic terms, nothing in the silver briefcase. The conventions are the framework that, like the frame in painting, must be neutralized by the work for immanent purposiveness to hold sway. The ensemble of genre elements, despite having deformed their original referents beyond easy recognition, are in turn repurposed toward producing a new meditation on the original theme. The perfection that is the central conceit of the original film—"We will see the perfect

human functioning"—is transposed into the anonymous efficiency of the James Bond or Jason Bourne type. The casting of the sixty-four-year-old Bauchau—"He looks great . . . well bruised," says Leth—does a great deal of the work of the "human." The film, in other words, still concerns what subjectivity, irreducibly bound up in particularity and difference, looks like when perfection is imposed on it, whether by the ethnographic voice that narrates *The Perfect Human* or by the professional discipline of the master spy. This is what *The Bourne Identity* or *Quantum of Solace* would be about, if they were about anything.

When Leth says in an interview "I really don't think about the audience," this comes as no surprise.[6] It turns out he does care about "a discriminating audience"—in other words, the response from a restricted field (embodied in *The Five Obstructions* by von Trier), so his lack of concern for "the audience" is nothing more than a repetition of a standard modernist line. As Eugene Jolas put it in the peroration of his 1929 manifesto for *Transition*: "The plain reader be damned."[7] Leth is completely clear about what allows him the freedom to make films that, as he writes, "cannot be translated into use value" and do not need to take the market into account: "Since we are fortunate enough to have a system that legally guarantees the development of film art in Denmark, I think it's important to make the films one wants to make, without thinking in terms of what may or may not be popular."[8] Indeed, the Danish Film Act specifically supports "film art" as a domain separate from, but feeding into, the "film industry."[9] Of course, this guarantees nothing, just as, complementarily, it has been part of the burden of this book to show that in the case of genres and media that are strongly conditioned by production for the market, the possibility of suspending the logic of the commodity cannot be foreclosed a priori. Even in television, "real subsumption" is an ideologeme, not simply a condition of production as it is for shoes, road salt, or wallpaper. Nonetheless, American premium cable television is pretty much the exact opposite of a state-supported zone of freedom from the market. How can David Simon, the creator of the HBO series *The Wire*, proclaim in an interview before the show's final season, in an apparently sui generis paraphrase of Jolas, "Fuck the average reader"?[10]

It becomes clear in the course of that interview—as will be clear to anyone who has seen the show—that *The Wire* is consciously developed in the light of two imperatives that have nothing obviously to do with

each other. The first, "embracing the ultimate network standard (cop show)," is oriented toward the market—or, more accurately, toward its proxy, HBO network executives. The second is a realist imperative so classical that Lukács would recognize it: "a show that would, with each season, slice off another piece of the American city, so that by the end of the run, a simulated Baltimore would stand in for urban America, and the fundamental problems of urbanity"—elsewhere "untethered capitalism run amok, about how power and money actually route themselves in a postmodern American city"—"would be fully addressed."[11] There is no mystery to this dual imperative. The first gets you on the air, and the second is what you want to say.

But matters are not quite so simple. What gets you on the air and what you want to say are both external purposes that invoke no internal criterion. The first, as we have seen throughout this book, tends to render the second null; in any case, the second imperative is only, as an external purpose, what one person happens to think about the way power and money route themselves in an American city, and there is no guarantee that what makes a good writer and show runner also makes a good sociologist. In fact, a certain form of the realist imperative is already a genre element—the cop show's audience or its proxy, genre conventions, demands something like a "mapping effect" that can be satisfied without any bearing on the real. Every cop show since *Dragnet* has been hailed for its verisimilitude—no matter that such claims inevitably seem absurd ten years later. Part of the attractiveness of crime as a narrative engine is that crime does not confine itself to discrete social strata, so that a cognitive-mapping or totality-projecting function is a possibility native to the genre itself. With few exceptions, cop shows are set in a particular location: think of the CSI franchise or the German series *Tatort* (*Crime Scene*), which has been set in a different city (with repeats) every year since 1970. And, even if only as a source of new narrative material, "social problems"—from plots borrowed from newspaper headlines to sociological commonplaces about this or that at-risk population, up to "how power and money actually route themselves in a postmodern American city"—have always been a central feature of the cop show genre. A substrate of "realism" is part of the genre, without, from the standpoint of realism, particularly compelling results.

Without an internal criterion, the ostensible social content of the cop show looks like just another appeal to a market niche. There is no

reason, for example, why there cannot be liberal and conservative cop shows—*Justice* at 8:30, *Dragnet* at 9—to satisfy audiences with different political beliefs or to satisfy contradictory libidinal demands in the same audience. Even if everyone who worked on *Justice* was sincerely committed to procedural justice and defendants' rights, and if everyone who worked on *Dragnet* was as conservative as Jack Webb himself, the "liberal" or "conservative" plot functions publicly not as a meaning but as either an alibi for the cop show commodity or as a feature of it. This is true even of the most immediately discomfiting "reality": there is comfort in confronting the worst, especially if you suspected the worst anyway.

David Marc correctly notes that in the network era (and still on network television) "television programs are created primarily to assemble [eighteen- to fifty-five-year-olds] for commercials."[12] A perspicacious observer of television, Marc realizes that classical network "television is made to sell products" but, following a familiar cultural-studies line, he insists that it is nonetheless "used to quite different purposes" by different kinds of people in different circumstances, as if these two imperatives were in contradiction.[13] They are, instead, perfectly aligned. It is because television can be used in different ways by different people—because it does not claim any particular meaning for itself—that it can sell products to all of these different kinds of people, and it is precisely in its lability that it reveals its heteronomy to the market. A meaning is inescapably normative: no matter how manifold and complex, a meaning excludes other meanings. A commodity is inescapably nonnormative: since the commodity is produced for exchange, all that is required is that someone find a use for it, and all of these uses, not matter how contradictory they might be as meanings, do not contradict one another because they are not meanings but uses. Marc's apparent dialectic—on one hand, network TV is only a host for advertising; on the other hand, people use television for "different purposes"—in fact describes the simple identity of the art commodity. Television, in its classical network form, has no meaning because it is a commodity, and it can be used for different purposes because it has no meaning.

The networks are, of course, no longer the only mode in which television shows are distributed, and the effect this has had on the shows themselves has not escaped anyone's attention. As Raymond Williams saw with perfect clarity, network television succeeded where the his-

torical avant-gardes could not in undoing the logic of the work. In the classical (postwar network) television process, there is no unity that corresponds to the work. As Williams puts it, the concept of the "programme" must be abandoned in favor of "programming," which in turn is supplanted by "flow," where the pseudo-discrete units that make up the sequence are entirely subordinated, under the pressure to "capture" viewers, to the programmed experience of a sequence.[14] Since the sequence, which includes advertising, news breaks, "bumpers," and so on, is built into the planning and writing of each of the pseudo-discrete units, and accepted as the appropriate mode of reception, the idea of a televised "work" loses all validity.

With the new modes of reception offered by cable television and then Internet distribution, the notion of the work is made at least formally accessible to television for the first time. It is worth noting how quickly this change is registered in the programs themselves: where a pilot is unnecessary, the pandering aspect of the initial episode immediately disappears; where a whole season can be filmed at once, aspects of the whole season immediately appear in the title sequence, framing the season as a unity from the outset. This does not mean that television is suddenly flooded with works of art the moment it becomes available à la carte. On the contrary, it is the status of the television program as a commodity like any other that plays havoc with the notion of the work: network logic is only one way to mediate the relationship of art commodity to the market, of which the cable networks, streaming services, and whatever comes next are others. What does happen is that abstract "quality" appears as a selling point: the transition of television distribution from advertising oligopoly to relatively anarchic competition has meant a new centrality of "content," which must now, as in the movies, attract viewers rather than fail to repel them. But attracting an audience is, of course, simply a less mediated (though paradoxically but logically more limber) relationship to the market, of which bait for advertising is another. Ironically, then, the imperative to abstract "quality" becomes as much an external constraint as an earlier imperative to inoffensiveness.

As can already be seen from Nick Hornby's interview with Simon, the content of recent television is still determined by the genres that have dominated network programming: cop show, situation comedy, and soap opera. Marc has suggested that those three genres constitute something like the dominant species in the television ecosystem, such

that each type of show exists in a space defined by the other two genres. Some of the formal attributes of the cop show genre, in other words, derive not from relations internal to the genre or even from the genre's immediate relation to an audience, but from its position in the ecosystem. For example, the central figure of the driven police detective, too consumed by "the job" to maintain a stable family life, is an awkward and internally unmotivated borrowing from the hardboiled private investigator, whose generic anomie and suspicion of authority sit awkwardly not only with the conservatism of the cop show in general, but also with the police detective's actual function as a public servant within a large bureaucracy. Nonetheless, the pilot episode of a network police procedural will generally see the protagonist served with divorce papers. (In *Fargo*, both the film and the series, the police stand logically enough both for order and for family. But *Fargo* is not a cop show.) The central figure of the cop show is determined by the fact of sitcom on one side and soap opera on the other, such that any domestic life for the protagonist brings with it an unwelcome suggestion of one of the other genres. And indeed, Marc closes with the observation that on network television the only place for innovations in the genre to go was to move into space occupied by one of the other two genres: *Barney Miller* and *Hill Street Blues*, if you remember those. The cop show as a genre, then, is not only externally conditioned by (better or worse informed guesses about) audience expectations, but also historically conditioned by wholly contingent factors such as the industry ecosystem. Under the weight of such contingencies, interpretation would seem to be an entirely pointless exercise.

Contingency is, however, not itself a problem for the work of art. Or, more precisely put, it is a constitutive problem rather than a mere barrier. The twelve tones of the chromatic scale and the flatness of the canvas and its frame are historically contingent and have functioned as external preconditions in European arts from the sixteenth or seventeenth centuries until relatively recently. Indeed, the entire history of a given medium confronts each new work as a massive edifice of merely given conditions, even as each work of any ambition confronts this edifice as subject to reconfiguration—that is, as subject to its elements being recast as necessary or not from the standpoint of the new work. As we have seen, Leth deflects the arbitrariness of given constraints with relative ease; most relevantly, when confronted with an absence

of constraints, he mobilizes genre as a legible ensemble of such arbitrary constraints.

The problem of the cop show is not simply that its generic elements are contingent, since every art form is founded on the basis of a welter of contingencies. The problem is that these contingencies are not taken up freely. They manifestly determine the content of the art commodity rather than, as we saw with Alfredo Volpi's 1958 *Composição* in the introduction, the artwork appearing to determine the form of the contingent substrate itself. This is what Simon means when he insists not just on "embracing the ultimate network standard (cop show)," but also on "inverting the form." Any cop show that wanted to present a meaning rather than an appeal to a market (rather than have its meaning subsumed under its appeal to a market) would have to produce an answer to the question of how to make that distinction legible, how to defeat its market theatricality.

Charles Ray's *Hinoki*, a massive carved-cypress sculpture of a fallen oak tree, presents a version of this problem. A found object—not exactly a contingent one, since the artist finds its shape compelling, but one whose noncontingency is not legible in the object, in this case the massive fallen trunk—is to be the subject of a sculpture. If the form of the tree is, for the artist, compelling, then for the artist its shape had already been freely taken up. But how can this free assumption become part of the work? The tree itself is simply an object that might or might not appeal to this or that individual encountering it in a museum gallery in the same way that it appealed to the sculptor. Even if it did so appeal, it would at best reproduce the sculptor's attitude toward it; more likely, it would provoke other, equally contingent attitudes. It would not be about the tree and its form. It would simply be the contingent tree that it is, in which case it would have no meaning. So the tree is instead carved in new wood (hinoki, or Japanese cypress) down to the minutest detail. The legible difference between the tree and the sculpture is the joinery that holds the sculpture together, which is finely done but not difficult to discern. The joinery is the internal frame that converts the contingent object into a freely assumed form and, in so doing, produces itself as self-legislating form. If the logic of the market is not to be sidestepped, any more than a work of art can sidestep the qualities of its material support or the weight of the history of its medium, then the contingencies this logic produces—in the form

of genre conventions—must instead be freely assumed. As we saw with Leth, and now see with Ray, to say these constraints are freely assumed means that they must be legibly subordinated to the logic of the work.

The Danish series *Forbrydelsen* (*The Killing*) announces its ambition to subordinate the cop show form to its own ends in the first minutes of its first episode. We know from the opening credits that something horrible has happened to a young woman. Detective Sarah Lund wakes up with a start before dawn. She checks on her teenage son and hugs her Swedish boyfriend, with whom she is about to move in. The phone rings, and she is called to a crime scene—on what we soon find is her last day on the job—at an abandoned factory. A young woman has been murdered and apparently mutilated. As Detective Lund explores the abandoned building, elevator doors close behind her, isolating her; the lights are accidentally turned off; a flashlight beam pierces the gloom; rats scamper; squalid signs of habitation are discovered; water drips; bloodstains mark the walls and floor; a bloody ax and low block are discovered. Lund approaches a hanging body—how a body can be both beheaded and hanged is not clear—which is covered by a bloodstained cloth. She pulls back the cloth to find an inflatable sex doll, with a note from her colleagues congratulating her on her move to Sweden.

In *Forbrydelsen*, the girl from the title sequence has indeed been brutally murdered; Lund will indeed pick up a big case on her last day on the job; and there will be no shortage of dark abandoned buildings, bloody evidence, and bright blue flashlight beams piercing the gloom. Without these, or some similar constellation of genre elements, we would not be watching a crime show, and it would not be on television. But the initial scene, which we had been happy to accept, immediately reads as phony the instant it is revealed that it was staged for us (and for Lund). More important, the set piece is not just a parody but a commentary on its own genre, the gears and pulleys of the network set piece instantly rusting and scratching to a halt, the hanged-and-beheaded body now appearing as a grotesque joke—not the colleagues' joke on Lund, but the fact that the absurdity of a body that is both hanged and beheaded has, overshadowed by pacing effects, passed without notice. The opening scene of the series is an allegory of the internal incoherence that is licensed by the production of expected genre effects. It is also an antitheatrical gambit: having closed the curtain on the cop show, *Forbrydelsen* seeks to produce the fiction of leaving us on our

own in the streets of Copenhagen—the next scene places the camera outside a room looking in—about which it can now plausibly have something to say.

But this is no more than a rhetoric. More substantial than this opening gambit is the purposive mobilization of genre elements. Lund—like every other cop show protagonist—will prove incapable of (or, more accurately, uninterested in) maintaining a domestic life. Paradoxically, *Forbrydelsen* succeeds as a feminist work by not thematizing gender. Lund is bored with her son and bored with her mother, and not conspicuously interested in her boyfriend, either. Except for the gender of the protagonist, this is completely in line with the cop show cliché, and the fact that it is a little shocking in Lund demonstrates the double standard better than any explicit thematization could. But her singlemindedness is not so much psychologically motivated (the typical way out, taken to its logical limit as Asperger's syndrome in the Danish and American versions of *The Bridge*) as institutionally motivated, and with this Lund—that is, the genre element of the compulsively focused investigator—becomes the fulcrum around which the crime story is leveraged into a kind of force diagram of what Hegel called the "substantial powers": the principles at work in the day-to-day reproduction of society, as well as in its crises, which are represented in contemporary life by institutions such as the police, city government, parliamentary parties, the family, the real estate market, the news media, the school system. While it seems at first that the characters in *Forbrydelsen* are finely drawn, it is instead the types that are finely drawn. The substantial density and verisimilitude of the characters derive from their varying and manifold relationships to institutions rather from any psychological complexity or notable quirkiness. Whether their characters determine their positions or the positions determine their characters is not a question *Forbrydelsen* raises. The show is interested only in character as an index of individuals' relationships to institutions, whose interrelations can be mapped by means of these characters' interactions with one another. Lund identifies herself immediately with one of the substantial powers: she is a police detective the way Antigone is a sister.

And with that, something like Sophoclean tragedy becomes possible once again. Precisely by fulfilling the letter of the cop show contract, by motivating the contingent genre feature of the overly cathected police detective, *Forbrydelsen* raises the possibility of a realism that would not

simply be a rhetoric. Like Antigone, Lund's salient qualities are simply given. Their primary interest lies not in the character they compose but in the logic they challenge forth from the surrounding narrative material. In the course of her investigation, Lund causes far more damage—deaths, broken families, ruined reputations—than the murderer. By doing what she does not know how not to do, Lund causes every part of society she touches to unravel. It is not that Lund produces social contradictions; these are already present. Rather, by taking one set of obligations seriously—by not compromising with conflicting obligations or, in other words, by taking one set of obligations too seriously—Lund cannot help but set those contradictions in motion.

In *Forbrydelsen*, the principle of dissolution remains abstract. *The Wire*, as we shall see, solves the problem of genre and the problem of the "mapping effect" with the same stroke, producing a realism that is the opposite of the surface texture of "gritty realism," both a genre requirement and the analog of Lukácsian naturalism. But *The Wire* also presents us with an internal frame that, like the joinery of Ray's *Hinoki*, is constitutive of every moment in the series. The most insistent element in this regard is the aspect ratio, which is a boxy 4:3—the dimensions of an old cathode ray television set and classic network television—rather than the 16:9 ratio of high-definition screens and "quality television" on cable. *The Wire* looks like it is on television, but unlike a network cop show that simply is on television, the fact that it looks like it is on television is purposive.[15] The 4:3 aspect ratio does not so much mark *The Wire*'s difference from "quality television," though this is immediately felt, as insist on the free assumption of a form that from another standpoint is merely given. However, *The Wire* does not allow itself to be understood as a pastiche. *Grindhouse*, Robert Rodriguez's double-feature genre collaboration with Quentin Tarantino, for example, also takes care to look like the genres it copies, down to abundant dust on the print, editing mistakes, and so on. But while these external contingencies are made intentional, their contingent character is preserved: there is no attempt to motivate them or make them purposive, only to copy them: a version of the naturalist boarding house in *Remainder*. *The Wire*, by contrast, resists the audiovisual surface of the cop show, such as extra-diagetic music or other cues, expositional or explanatory editing, obviously artful or even reliably comprehensible dialogue, visual metaphor, a camera that "knows" or signals where the

center of a scene is or what is coming next. All of these genre-standard techniques are refused. *The Wire*, that is, understands genre as a certain structure within which one can move, not as a certain kind of surface that can be simulated. To be sure, *The Wire* refuses two opposing forms of televisual theatricality: on one hand, the kitchen sink of cues that, by forestalling the necessity of interpretation, subordinates everything to the generic effects of the network cop show, and on the other, the considerable attractions, from obviously thoughtful cinematography to the participation of well-known film actors to, as we shall see, a fundamentally Shakespearean approach to plot, made feasible by cable television. But more fundamentally, the insistence on the 4:3 aspect ratio and the refusal of network televisual grammar work together to insist on the "ultimate network standard (cop show)" as a given that is freely assumed, and thereby "inverting the form," which no longer appears as determined from without by a welter of contingencies, but rather as determined from within by the logic of the material, which is presented in the mode of what Jeff Wall would call, with reference to his own practice, "near documentary."

As with every realism, the measure of its success is not finally in the effectiveness of its antitheatrical rhetoric, but in the credibility of its narrative logic. This is not the place to produce a full-fledged theory of realism. But it is worth briefly rehearsing part of a key essay by Antônio Cândido, the major Brazilian critic of the pre-1964 generation who is woefully under-translated into English. In "Dialectic of Malandroism," Cândido observes that Manuel Antônio de Almeida's novel *Memoirs of a Militia Sergeant* (1854) achieves the standpoint of totality by means of a radical constriction of viewpoint.[16] The book presents an "impression of reality" (89) that strikes us with the "force of conviction" (88) despite the near absence of both slaves and landholders in early nineteenth-century Brazil—that is, the near absence of both the labor force and the ruling class (87). Despite this, the novel "suggests the lively presence of a society that seems to us quite coherent and existent" (86). Almeida's novel allows us "to intuit, beyond the fragments described, certain principles constitutive of society—a hidden element that acts as a totalizer of all these partial aspects" (89). This hidden element or logic (in this case, a certain, ultimately economically determined distance from European bourgeois norms) gives the novel its coherence and, as it plays out across social strata and situations, its "feeling of reality" (96). The novel's

constriction of viewpoint, far from being a liability, turns a narrow band of Brazilian society under Jōao VI into the vibrating string that resonates with the movement of an entire society.

As we have seen, Cândido's categories of judgment are subjective: the "sense" (*senso*) or "feeling" (*sentimento*) or "impression" of reality, which carries a greater or lesser "force of conviction." Plausibility is a subjective determination, but one whose mode is nonetheless universal. If we disagree about the "feeling of reality" produced by a work of fiction, we do indeed disagree rather than merely having different opinions about it. That is the force of Cândido's language of conviction. But while the hidden logic made perspicuous by the work pertains to the real, it is not to be found in the real as something to which literary form would correspond. Rather, the work asserts the immanence of its logic to the real through the form given to fictional phenomena that belong only to the work. This is a cognitive process of a special kind. We should not be shocked or disappointed that the modality of judgment it invokes ultimately rests on nothing more solid than argument and consensus. (So does politics.) As this book has argued before, in art plausibility is a higher criterion than correspondence to the real, which, after all, is not rare, even in cop shows of little merit.

As with *Forbrydelsen*, *The Wire* dramatizes, through interactions among individuals, the relationships among institutions—largely the same ones as *Forbrydelsen*, with less attention to the family and to national politics, and with the signal addition of the union and the working class, which in *Forbrydelsen* was represented only culturally by the murdered girl's (economically petty bourgeois) father. In fact, it is the trajectory of this working class that will be the essential content of the second season of *The Wire*.

The mapping of the postindustrial city in *The Wire* takes place by following the ways the drug trade navigates its institutions, mores, and cultural pathways. Early in the second season, a mid-level drug dealer named White Mike appears, largely to prepare a much later interaction between one of his crew and a central character, an interaction we will turn to shortly. Somehow this preparation itself must be motivated, and the surface verisimilitude of White Mike and his crew, peripheral figures in the drug trade, is endowed by the other characters, who understand White Mike's phenotypical whiteness and affective blackness, as we do, as positivities, which is why they can be hybridized in the

first place. One black police officer remarks to another about White Mike's affected swagger, "[These] thieving motherfuckers take everything, don't they?" From one perspective, such a figure helps to fill out a variegated and conflictual, "intersectional" tapestry of race, class, gender, and sexuality that constitutes the lived experience of social life in contemporary America. But this immediate plausibility is no more than the motivation of the device of White Mike and his crew. In the key seventh episode of the series, titled "Backwash," one of this crew, a white street-level dealer named Frog, is interesting not for himself but for the logic that his presence in the plot unleashes, beginning with the contempt heaped on him by Nick Sobotka, a young dockworker.

Initially, Nick's diatribe centers on their shared, presumably Polish American whiteness. "Your mama used to drag you down to St. Casimir's just like all the other pisspants on the block." (In keeping with the televisual near-documentary mode, the camera does not always know where to look, and we view Nick as he delivers his contumely through a long lens; our view is obscured by pedestrians and by Frog's oversize sweatshirt [figure 4.1].) But in the next sentence, the genus "white" immediately bifurcates into two different species: "hang on the corner don't give a fuck white" versus "Locust Point IBS Local 47 white." The distinction is a class distinction (lumpens versus working class) but the logic is racial (a difference in essential character rather than a different relationship to the economy). A moment later, when Nick refers to Frog and his like as "whiggers," the content of the epithet is not only Frog's affected "down, streetwise" attitude but, more essentially, his lack of attachment to the labor force understood as an identity. But Nick's understanding is mediated by a narrative logic that subsumes it. What brings the two characters together is a drug deal, which Nick has undertaken because there is not enough work for him on the docks. That is, what brings the characters together is unemployment. While Nick understands the difference between them as being one of identity, it is in fact, as we have seen, one of class. But since Nick, despite his identity as a laborer, is chronically underemployed himself, nothing separates them—other than a purely ideological and obscurant play of identities.

But this is not yet quite right. Nick's identity is not entirely an identity in the contemporary sense, a mode of social insertion whose operative feature is that it bypasses institutions, though, as we have just seen, it does also function that way for him. Rather, it is an older and

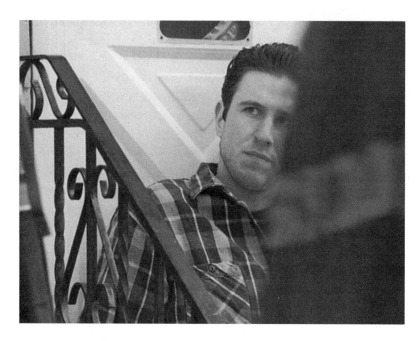

4.1 Still from *The Wire*.

endangered form of identity, one that has its place and real social basis in an institution—namely, IBS Local 47—whose fate the season centrally concerns. In this same scene, we see very clearly the strength of this collective identity, at whose core is the fact that, as Nick fiercely insists, "I don't work without no fuckin' contract." In other words, the strength of the union resides in class solidarity, in the union's collective struggle to wrest for its members a portion of the value that labor creates for capital. The core of that strength is the collective cohesion—the identity—of the union, which can stand together against individual self-interest to secure a favorable contract. But while the strength of the union lies in the collective identity of its members, a historical weakness lies there, too.

Marx made it one of his central points in the first volume of *Capital* that the working class consists not only of laborers but also of the "surplus population" (*K* 657/*C* 781) whose labor is for the moment not required for the valorization of capital. The "industrial reserve army" and the "active army of workers" (*K* 668/*C* 792) are analytically separate moments of the valorization process, but they are not, in Marx's

account, different class fractions. Employment and unemployment are not just logical moments of a single process but, in Marx's account, from the standpoint of labor they are also temporal moments. The life story of an individual worker will include both moments, not in a narrativizable progression from one to the other, but in a form whose logic, from an individual perspective, is chaotic and unpredictable: "The relative surplus population exists in all possible shades, and every worker belongs to it during the time when he or she is partially employed or wholly unemployed" (K 670/C 794). This is why Marx conceives of unionization as "systematic cooperation between the employed and the unemployed" (K 669/C 793). Unionization, in Marx's account, seeks to relieve the mutual pressure of the unemployed and the employed upon each other by countering the "'sacred' law of supply and demand" in the labor market (K 670/C 793).

But the world of *The Wire* is a world where these temporal moments have become spatialized. In our world, whose logic that other one claims to formalize (rather than whose facts and texture it claims to copy), labor turnover has dramatically decreased since Marx's time. More precisely, over the twentieth century the relative size of the decasualized portion of the labor force increased dramatically in relation to the casualized portion—a trend that is both clear and uneven, and that is reinforced but not singlehandedly caused by the gains won by the labor movement in the middle third of the century. The relative stabilization of the employed part of the working class implies the relative stabilization of the unemployed part as well, and this spatialization of unemployment both gives rise to a concept like the precariat and supports the identitarian fissuring of the working class.

This spatialization marks a structural limit and has nothing to do with good or bad intentions; indeed, it need not even present a limit as long as unionization represents a strategy rather than an identity. But as we have seen, part of the strength of the strategy lies in its condensation into an identity. This is powerfully expressed in one of the final scenes of the season, when Ott Motley, a black candidate for the position of union treasurer, which we understand is to alternate between Polish and black workers, withdraws his candidacy in a show of unity in favor of the doomed Frank Sobotka. If your racial phenotype being the same as someone else's does not count for much outside the union, your racial phenotype being different from someone else's does not count for

much inside the union, and this is the utopian moment, the negation of social life as we know it, within *The Wire*'s portrayal of union life. But the logic of identity, as we have seen, continues to cut both ways. The sublimation of racial difference within the union comes at the expense of a racialized difference (and not just racialized: there are no women in Local 47) within the working class. This relational logic remains "racial"—that is, an exclusion based on ascriptive social being—even if, in this instance, it cuts across race in its commonsense acceptation.

The same logic that produces Nick's contempt for Frog—an identity founded on the power of labor to valorize capital, under conditions that render a mass of labor idle—dooms the union itself. Many factors imperil this particular port—bad location, outdated infrastructure, shriveling manufacturing in Baltimore—but only one factor is bound up with the movement of history itself. In the same chapter of *Capital* cited earlier, Marx demonstrates that the fundamental movement of capital is the shedding of labor. Once the working day has been exploited to its natural or legal limit, capital increases the efficiency of labor through automation: "The accumulation of capital, which originally appeared only as its qualitative extension, completes itself . . . through a continual qualitative change in its composition: a constant increase of its constant component [or 'mass of the means of production'] at the expense of its variable component [or 'living labor power']" (*K* 657/*C* 781). This labor can be reabsorbed only through capital's expansion into and creation of new markets—an expansion that even bourgeois economists such as Paul Krugman and Larry Summers, to say nothing of the German *Wertkritik* school who make it their principal doctrinal point, warn may be approaching its end. It is precisely this process that Nick's uncle Frank Sobotka recognizes moments after the scene between Nick and Frog. Together with assembled politicians and city officials, Frank, the union's treasurer, attends a presentation on "the future of cargo management," which he later calls a "horror movie." The burden of the presentation is that "modern robotics do much of the work." And this is no futurist's imagining but a description of the existing state of affairs at the port of Rotterdam, which moves "more freight with fewer man-hours than any port in the world." As Frank is well aware, through the mediation of competition, Rotterdam's present is Baltimore's future. A few scenes later, Frank concludes, "It breaks my heart that there's no future for the Sobotkas on the waterfront." And

this dynamic inscribes itself directly into the daily life of Nick Sobotka. The next time we see him, an off-camera voice asks, "Nicky boy, you get days this week?" The answer is a curt, "Nah." The figure of Frog does not represent anything; rather, he elicits a logic. The confrontation between Frog and Nick is the vibrating string that resonates across the whole season, and across our entire society.

Frank meanwhile has dedicated himself to fighting this future. But the immediate cause of the union's downfall will be Frank's efforts to save it: the money he uses to influence politicians comes from what looks plainly enough to federal investigators like "union corruption." This kind of reversal lies at the core of the historical novel, from Walter Scott to Chinua Achebe, and the only reason the protagonist is a tragic rather than a satirical figure is that the logic opposed by the protagonist is part of the logic of the material on which he acts. Any punctual successes of the protagonist only activate the logic his actions presuppose. It is another ruse, but this time the ruse of history.

This is what Simon means when he claims that "*The Wire* is a Greek tragedy" rather than a Shakespearean one.[17] The distinction can be traced back at least to Hegel:

> But in modern tragedy individuals generally do not act for the sake of what is substantial in their purpose, nor does what is substantial prove to be the driving force behind their passion. Rather, the subjectivity of their heart and feelings or the peculiarity of their character presses for satisfaction. . . . The actual collision [in *Hamlet*] turns therefore not on the fact that the son in pursuing his ethical revenge must himself violate the ethical order, but in Hamlet's subjective character.[18]

The only Shakespearean characters in *The Wire*—characters whose actions are determined by inner conflict rather than characters who embody in themselves the conflict between substantial powers—are the junkies, particularly Bubbles and his friend Johnny Weeks, the one a "recovering addict" doomed to relapse, and the other an unrepentant addict doomed to overdose. Not only does Bubbles have, as the Twelve Step mantra has it, to "make a decision," we are made painfully aware that he has to make the same decision every day and indeed every minute—and, of course, Johnny is perpetually making the opposite one. While Bubbles and Johnny are sympathetic characters, they

are also the reductio of Hamlet and of his present-day avatars on quality television such as Walter White, Don Draper, Al Swearengen, Tony Soprano, and Boyd Crowder.

For a Shakespearean hero in Hegel's and Simon's account, an action that, in Aristotle's well-known formulation, is "serious, complete, and of a certain magnitude" would be ruled out from the beginning. But Frank Sobotka's predicament, no matter how naturalistically written and acted, owes nothing to psychological complexity, to a "subjectivity . . . that presses for satisfaction." On the contrary: the logic of his actions is simple. He acts directly for what is substantial, which is to say that Frank is a union treasurer the way Antigone is a sister. What would look in another kind of show like a "bad choice" emerges here necessarily from the material itself: the use of illicit cash to influence politicians is a direct consequence of the fact that the union no longer has the numbers to influence them with votes. The dice have already been rolled, all decisions follow from decisions that were made long before, and characters are both agents and playthings of larger forces. That Simon can rediscover Sophoclean form depends on the discovery that the procedural genre can, as it is in *Forbrydelsen*, be turned toward a mapping of the interrelations among the substantial powers. These powers are not, for a particular subject, given as his or her ethical substance as they are for Antigone and Creon but, rather, appear as if given in individuals' cathection to institutions. The focal characters in *The Wire* take their institutions seriously (i.e., too seriously). The principle that justifies the institution overrides practical compromises on which the institution's functioning also depends.

The excessiveness of the genre figure of the driven police detective is a condition of possibility for this mode of figuration. In the ordinary run of things, Greek tragedy makes no sense for contemporary narratives because, for us, social being is not given. Antigone is caught not only objectively, but also subjectively, between human law and the law of the gods. In our world, a cop can become a middle-school teacher or a writer instead. Institutions still bear their own imperatives, and these imperatives come in conflict. But individuals move in and out of institutions, and other institutions exist to mediate their conflicts. The overly cathected detective, meanwhile, as we have seen, is a purely contingent fact of the cop show genre. The genius of *The Wire*—glimpsed also in *Forbrydelsen*—is to see that these two problems solve each other.

The figure of the obsessive cop naturalizes the otherwise implausible or merely "psychological" tragic hero; the Sophoclean hero motivates the otherwise external and contingent figure of the obsessive cop. *The Wire* finally suspends the external determination of both of Simon's imperatives—cop show and cognitive map—by producing its own, internal purposiveness, a criterion internal to itself. By necessarily enlisting the "substantial powers," the Sophoclean hero opens up the possibility of realism in Cândido's sense—a realism that has to do with a logic that resonates with social life, and not with the imitation of social facts. If *The Wire* is compelling, it is not because of the verisimilitude of its surface, and much less because it provides the pleasures of the network genre or those of its elevated sibling on cable, but because its organizing logic—in this case, the logic of civil society in its failure to confront the effects of the shedding of labor—produces a surface that resonates down to its minutest particulars with the world we inhabit.

Far from endorsing a radical politics—whatever value that might have—*The Wire* never even thematizes one. Simon presents himself as something like a market socialist, calling for a reconsideration of socialism but remaining "utterly committed to the idea that capitalism has to be the way we generate mass wealth in this country."[19] Nonetheless, in the logic of its form, *The Wire* demands a radical politics. The substantial powers—the union, city government, the newspaper—are rendered increasingly powerless against the competition dynamic. As in Marx, the capitalist efficiency cycle is inexorable: without a massive and "systematic cooperation between the employed and the unemployed," there is no politics and no policy that would bring the "maybe 10 or 15% of my country [who are] no longer necessary to the operation of the economy" back into the capitalist valorization process.[20] In *The Wire*, as in Marx, nothing can change unless everything can.

Taking Sides

Kafka's "Worries of a Family Man" captures our attention less for the family man, who turns out to be the unnamed narrator of the piece, than it does for the figure of Odradek, a strange object that looks like a spool but is not, since its spool-like form, covered indeed in random pieces of string, is supplemented by two crossed bars that enable it to "stand upright as though on two legs."[1] We soon find out that Odradek not only stands upright but speaks.

In a powerful reading of this story, Roberto Schwarz notes the shifts in tone that reveal the family man's attitude toward Odradek: initially amused, then condescending, dismissive, anxious, and ultimately (though this is expressed indirectly) murderous.[2] Why should little Odradek provoke any reaction at all, much less this peculiar sequence? The only thing we know about the narrator other than what he tells us we know from the title: that he is head of household (*Hausvater*). The prose confirms that he sees himself as the bearer of bourgeois responsibility and propriety. Odradek, however, is, in Schwarz's reading, "the precise and logical construction of the negation of bourgeois life."[3] We are told twice that Odradek has no purpose. But he does have pur-

posive form, so manifestly that the family man can, to his frustration, withhold it from him for only a sentence before it reasserts itself. "One is tempted to believe," writes the family man, "that this entity previously had some purposive form and is now simply broken. Despite appearances, this is not the case. At least, no evidence can be seen for it; one cannot find a mark of incompletion or rupture that would suggest anything like that. The whole thing looks totally useless, but in its own way complete."[4] To say that Odradek is useless but in his own way complete is to say that Odradek's form is immanently determined. In societies like ours, no entity is permitted an exemption from the obligation to serve a heteronomous purpose. We are told, for example, that a university exists to train a workforce, or that novels exist to teach us respect for the other. Since Odradek's being, his purposive form, cannot be connected to any heteronomous activity—instead appearing complete in himself (i.e., self-determining)—on Schwarz's reading "he is the extreme image of liberty amidst the effort required by propriety; a perfection neglected but perfectly safe, since it is made up of parts that nobody wants"; climactically, Odradek represents "a lumpenproletariat without hunger and without fear of the police."[5]

But as powerful as Schwarz's reading is—and this brief summary does not do it justice—there is something excessive in it, extravagantly pushing aside as it does an interpretation that is closer to hand. Not only does the description of Odradek's form—"totally useless but in its own way complete"—paraphrase the Kantian formulation of "purposiveness without purpose" that characterizes the object of aesthetic judgment, but Kafka's very language (*zweckmäßige Form*) hews close to Kant's (*Zweckmäßigkeit ohne Zweck*).[6] In the collection published by Kafka in 1919, the story immediately precedes "Eleven Sons," of which Kafka famously told Max Brod that "the eleven sons are quite simply eleven stories that I am working on." Does "Worries of a Family Man" then not follow a procedure familiar to readers of Kafka—namely, to play the game of fiction (after Aristotle, the game of plausibility) with the most implausible premises? A learned ape, a giant bug in the family . . . or the work of art—not a particular work of art, but the Kantian schema for the object of aesthetic judgment—brought to life and lurking "in the attic, on the stairway, in the hallways, in the entryway by turns"?[7]

As we have seen, Kafka does not literalize "purposiveness without purpose" arbitrarily: it is the foundation for the theorization of the

modern concept of art in the late eighteenth century and early nineteenth century. Purposiveness with purpose is just purpose, and if something has a purpose, it can be judged by how well it suits that purpose. Lack of both purposiveness and purpose characterizes the "pathological" (*pathologisch*) judgment of the agreeable, by which Kant means not a diseased judgment, but one whose origins are idiopathic, particular to an individual body. "Hunger," Kant reminds us, "is the best sauce."[8] However, aesthetic judgment is, in Kant's terms, disinterested (*uninteressiert*), but interested here just means bound up with some external end, which can be determined either objectively (the judgment of the good) or subjectively (the judgment of the pleasant or agreeable, which includes the disturbing or painful or whatever else you happen to have an appetite for). The province of the first is the state; the province of the second, the market. On one side is "rational law," and on the other, the "object of desire."[9] On one side, the police; on the other, hunger.

Schwarz's interpretation and the more workaday one it supplants are therefore one and the same. It is Kant, not Kafka, who provides the formula for "the precise and logical construction of the negation of bourgeois life." In societies like ours, judgment unconstrained by the state (the concept) or the market (inclination) exists only in the unemphatic form of the work of art. But the proletariat is also produced and delimited by the police on one side and hunger on the other. Marx lets a self-described "well-wisher of mankind"—the Reverend Joseph Townsend, himself a family man—do the talking: "Legal constraint [to work] is attended with too much trouble, violence, and noise; whereas hunger is not only a peaceable, silent, unremitted pressure, but . . . the most natural motive to industry and labor" (*K* 676/*C* 800). Schwarz's formulation therefore asks us to imagine the "impossible of the bourgeois order"[10]—an emphatic form of the unemphatic alterity presented by the work of art.

As with all of Kafka's experiments in plausibility, the charge of "Worries of a Family Man" lies not so much in its allegorical content, the reduction to which would make the story banal, as in something specific to the medium of fiction. The interpretive problem is not "What does Odradek represent?" but "Why does the family man react the way he does?" What is the source of the terrible plausibility of the family man's progression from condescension to violence when confronted with a figure that he acknowledges to be harmless? The work of art is only a

work of art; its self-determination only holds within its own boundaries. It has no emphatic form. But when Kafka brings purposiveness without purpose, the Kantian schema for the work of art, into emphatic, nonartistic existence—as can happen only in a work of art—it begins to look like something that threatens the entire edifice on which the family man stands. Odradek threatens not through violence, but through his mere existence: a lumpenproletariat without hunger and without fear of the police.

Not for nothing is Odradek the figure of an impossibility. In a world without hunger and without fear of the police, without the twin compulsion of the market and of the state, there might be freedom and creativity; more and better music, more and better poetry; also—why not?—more and better sport, more and better science. But because value would not be everywhere subordinated to utility and appetite, the institution of art would have lost its necessity. For the magnificent ape Rotpeter in Kafka's "A Report to an Academy" (published in the same volume as "Worries of a Family Man"), to remain imprisoned in his cage would mean death. But he does not seek abstract freedom, which would also mean death soon enough. Rather, he fashions for himself a "way out" through the arduous discipline of mastering the norms of an alien society—ours. "Freedom," "creativity," "emancipation": these things are not, in their empty, abstract forms, promised by the work of art or entailed in the claim to autonomy. The work of art does not promise emancipation. Rather, it requires a taking of sides.

The burden of this book has been to demonstrate that under contemporary conditions, conditions under which the market prevails as a totalizing ideology, the plausible assertion of aesthetic autonomy has its own politics—a politics that differs from the politics the same assertion would have had in the modernist or romantic periods. In Kant, the categories of the agreeable and the good properly pertain to market-like activities, on one hand, and state-like activities, on the other. The faculty of aesthetic judgment, as "purposiveness without purpose" makes clear, owes its specificity to neither: the agreeable has no purposiveness, and the good involves a purpose. In the modernist period, the assertion of aesthetic autonomy was as much directed against institutions—academies, organs of official culture, the education apparatus, state and religious instruments of control, political parties and movements—as against the market. In our moment, these same institutions justify themselves, as

best they can, with reference to the market, which means that they are subordinate to the market even when they in principle regulate it.

A work's assertion of autonomy is the claim that its form is self-legislating. Nothing more. This book has tried to show that that claim, even when it is not directed against or even interested in the commodity form, involves an internal suspension of the commodity form, which nonetheless does not cease to operate, and a rejection of the market as the horizon of history—a rejection that is, constitutively, without force. Art that wishes to confront capitalism directly, as an opposing force, turns instead into a consumable sign of opposition. Art opposes capitalism, but it is powerless. Meanings compel through freedom: there is no line that leads from *this* to *that*. The power of an argument is of an entirely different order from the power of a union. But you can't have a union without an argument.

Notes

Introduction

1 György Lukács, *Werke, Volume 16: Heidelberger Philosophie der Kunst (1912–14)* (Darmstadt: Luchterhand, 1974), 9.

2 Terry Eagleton, "Structurally Unsound," *Times Literary Supplement*, June 8, 2016.

3 Tyler Cowen, *In Praise of Commercial Culture* (Cambridge, MA: Harvard University Press, 1998) 1; Dave Beech, *Art and Value: Art's Economic Exceptionalism in Classical, Neoclassical and Marxist Economics* (Leiden: Brill, 2015), 1.

4 Karl Marx, *Das Kapital: Kritik der politischen Ökonomie, Erster Band*, in Karl Marx and Friedrich Engels, *Marx/Engels: Werke*, vol. 23 (Berlin: Dietz, 2008) 189. The translations are mine, but see Karl Marx, *Capital: A Critique of Political Economy*, vol. 1, trans. Ben Fowkes (London: New Left Review, 1976), 279–80. Hereafter, and throughout the volume, these works are cited in parentheses in the text as *K* and *C*, respectively, followed by page numbers.

5 The logic here is enough to differentiate the Hegelian-Marxian concept of standpoint from the contemporary notion of viewpoint. The denotations of the words in English are more or less indistinguishable, but "standpoint"

in the Hegelian-Marxian tradition means virtually the opposite of what we usually mean by viewpoint. "Standpoint" refers to a logical position within a system of logical positions, where the system of relations is not posited as unknowable a priori. Since standpoints are logical positions, they can be adopted at will, even if they are empirically native to this or that social position. In the master-slave dialectic, the relation between the two standpoints becomes clear only in the shuttling back and forth between them. But one can also adopt the standpoint of nonpeople: the state in Hegel, and the proletariat in Lukács. Viewpoint, however, can apply only to people. Marx's distinction between m-c-m and c-m-c, which will have a role to play in what follows, is also one of standpoint, since both are merely segments in the unsegmented process of exchange. The "small master" may experience exchange as c-m-c, and the capitalist proper may experience exchange as m-c-m, but the distinction is not reducible to their subject positions or viewpoints. The point here is that the commodity has a standpoint as much as the capitalist. The capitalist can, of course, also have a viewpoint. But Marx's point in "personifying" the capitalist is that the viewpoint, to the extent that it diverges from the standpoint, is irrelevant.

6 G. W. F. Hegel, *Phänomenologie des Geistes* (Frankfurt: Suhrkamp, 1970), 265; G. W. F. Hegel, *Phenomenology of Spirit*, trans. A. V. Miller (Oxford: Oxford University Press, 1977); §351. Hereafter, the page and paragraph numbers are cited in parentheses in the text. The translations are mine.

7 György Lukács, "'Entäusserung' ('Externalization') as the Central Philosophical Concept of *The Phenomenology of Mind*," in *The Young Hegel: Studies in the Relations between Dialectics and Economics*," trans. Rodney Livingstone (Cambridge, MA: MIT Press, 1976). See also Fredric Jameson, *Representing Capital* (London: Verso, 2011), 81.

8 The phrase occurs throughout the *Phenomenology* and elsewhere: see G. W. F. Hegel, *Jenaer Systementwürfe III* (Hamburg: Felix Meiner, 1987), 189.

9 The reference is to Michael Fried, "Art and Objecthood," in *Art and Objecthood* (Chicago: University of Chicago Press, 1998), 148–72.

10 "Consumer sovereignty" is defined by William Harold Hutt as "the controlling power exercised by free individuals, in choosing [among] ends, over the custodians of the community's resources": William Harold Hutt, "The Concept of Consumers' Sovereignty," *Economic Journal* 50, no. 197 (March 1940): 66.

11 Immanuel Kant, *Kritik der Urteilskraft* (Frankfurt am Main: Suhrkamp, 1974), 143.

12 Richard Rushfield, "James Cameron Reveals His Quest to Build More Perfect CGI Boobs," *Gawker*, November 12, 2009, accessed July 22, 2018, http://gawker.com/5403302/james-cameron-reveals-his-quest-to-build -more-perfect-cgi-boobs.

13 James Lipton, "Why the Na'vi Have Breasts! Interview with James Cameron," *U Interview*, February 24, 2010, accessed July 22, 2018, http://uinterview.com/news/james-cameron-why-the-navi-have-breasts-985.

14 Max Horkheimer and Theodor W. Adorno, "The Culture Industry: Enlightenment as Mass Deception," in Max Horkheimer and Theodor W. Adorno, *Dialectic of Enlightenment*, trans. John Cumming (New York: Continuum, 1996), 120–67. Hereafter, *Dialectic of Enlightenment* is cited in the text as *DE*, followed by page numbers. As elsewhere, the translations are mine and diverge substantially from the cited text. Max Horkheimer and Theodor W. Adorno, *Dialektik der Aufklärung: Philosophische Fragmente* (Frankfurt am Main: Fischer, 1969). Hereafter, *Dialektik der Aufklärung* is cited in the text as *DA*, followed by page numbers.

15 The question "Why do slasher films have boyish female protagonists?" is interesting, but despite appearances, it is not an interpretive question: it is not to be answered by a close reading of *The Texas Chainsaw Massacre*, whose "meaning" is entirely subordinate to an audience's demand for a certain set of narrative conventions. Rather, it is answered by, in essence, querying the audience rather than the film, and when we have answered the question, we have learned something about audience rather than about the film: see Carol J. Clover, "Her Body, Himself," in Carol J. Clover, *Men, Women, and Chain Saws: Gender in the Modern Horror Film* (Princeton, NJ: Princeton University Press, 1992) 21–64. Even as Clover is valuably clear about the irrelevance of individual films to her object, except at the most distanced, folkloric level, the tools by which one would read audience desire remain ad hoc: a combination of interviews, audience observation, psychoanalytic theory, and speculation.

16 The identity of intention and meaning is forcefully announced by Walter Benn Michaels and Steven Knapp in their crucial essay "Against Theory," *Critical Inquiry* 8, no. 4 (Summer 1982): 723–42, and widely anthologized. I did not see the force of their account of "theory" when I first encountered it, because I thought one could remain agnostic about intention without sacrificing any of the insights of what I thought of as "theory," which was not Paul de Man and Stanley Fish but, rather, Lukács, the Frankfurt School, and their descendants, principally Roberto Schwarz and Fredric Jameson. That turned out not to be the case, for reasons that should become clear in this chapter and throughout this book. However, the fundamental compatibility of Knapp and Michaels's account of meaning with the post-Kantian development of aesthetics only holds when it is specified that "intention" does not designate an event in the mind of the artist but is, instead, something realized in the work itself: intention thus specified names immanent purposiveness. This specification has become more strongly thematized in Michaels's recent work, but in fact it was essential from the beginning (that

was, in fact, the point of identifying meaning and intention). The relationship to Jamesonian allegory is similarly complex, and for similar reasons. As long as allegory designates an external intention it is going to pose a problem, because the criteria by which one would judge such an intention are bound to be arbitrary. (I understand "strong rewriting" in Jameson's description of allegorical interpretation to designate compelling ascription; otherwise, this, too, poses a problem.) If allegory can, on the contrary, be described as emerging from a disposition of the material itself, as taking up social material in a way that then constitutes a kind of claim about that social material that can be judged on the basis of its plausibility—that is, on the basis of the coherence of its real entailments rather than on the basis of correspondence to facts—then we are once more on the territory of immanent purposiveness. This is discussed in chapter 1 and throughout this book. Antônio Cândido and Roberto Schwarz mark the most significant developments in the theorization of realism in this expanded, post-Lukácsian sense. Schwarz's influence will be felt throughout this book; Cândido's contribution is discussed in chapter 4.

17 It may be that in Jameson's work, the Freudian positivity of the unconscious is relatively inconsequential and can be rewritten in terms of the negative, Hegelian-Marxian unconscious, but it would take some work to ascertain. When Jameson writes about class-consciousness in Wyndham Lewis, for example, the point is that petty bourgeois class consciousness logically presupposes working-class consciousness and is unnecessary and unthinkable without it, and that Lewis is not aware of that entailment and presumably would have disavowed it. It does not mean that some secret part of Lewis's brain is aware of that entailment. Any Freudian "return of the repressed" would then have to be understood instead as the Hegelian "ruse of reason"—that is, as an example of the fact that logical entailments are real entailments. The claim here is not that Jameson never relies on a positive unconscious but that work that follows his lead would be better off working with a negative one.

18 Kant, *Kritik der Urteilskraft*, 155. For the shorthand version, see Kant, *Kritik der Urteilskraft*, 143 and 235.

19 G. W. F. Hegel, *Vorlesungen über die Ästhetik I* (Frankfurt am Main: Suhrkamp, 1970), 87. The entire paragraph under discussion is on this page. As is well known, this volume is compiled from Hegel's own lecture notes and transcriptions of students' notes, so there is no point in attending closely to Hegel's precise wording.

20 Fredric Jameson, *Postmodernism: Or, the Cultural Logic of Late Capitalism* (Durham, NC: Duke University Press, 1991), 4.

21 The English text is in Marx, *Capital*, 948–1084. Hereafter, Karl Marx, *Das Kapital 1.1: Resultate des unmittelbaren Produktionsprozesses* (Berlin:

Karl Dietz, 2009), is cited in parentheses in the text as *R*, followed by page numbers. The distinction occurs elsewhere in *Capital*, notably in *K* 533/*C* 645.

22 Karl Marx and Friedrich Engels, *Marx/Engels: Werke*, vol. 42 (Berlin: Dietz, 2008), 321.

23 Marx's notes on formal and real subsumption were not available to Adorno when he and Horkheimer were writing *Dialectic of Enlightenment*, but the logic, operative here and there in the published text of *Capital* (see esp. the section titled "Absolute and Relative Surplus Value" [*K* 531–42/*C* 644–54], two terms that map roughly onto "formal and real subsumption," which also make a brief appearance there) is clearly operative in Adorno's work.

24 Jameson, *Postmodernism*, 48

25 Jameson, *Postmodernism*, 48. It is by no means self-evident that the subsumption of aesthetic labor under capitalism is an effect of capitalism's triumphant march rather than a consequence of its ever more desperate search for profits once the rate of profit native to industrial capital has begun a secular decline: see "The Trajectory of the Profit Rate," in Robert Brenner, *The Economics of Global Turbulence* (London: Verso, 2006), 11–40.

26 Pierre Bourdieu, "Le marché des biens symboliques," *L'Anée Sociologique* 22 (1971): 52–53.

27 Bourdieu, "Le marché des biens symboliques," 54, 58.

28 Bourdieu, "Le marché des biens symboliques," 66.

29 Bourdieu, "Le marché des biens symboliques," 126.

30 "The essence of Modernism lies, as I see it, in the use of characteristic methods of a discipline in order to criticize the discipline itself. . . . [What quickly emerges is] that the unique and proper area of competence of each art coincide[s] with all that [is] unique in the nature of its medium. The task of self-criticism [becomes] to eliminate from the specific effects of each art any and every effect that might conceivably be borrowed from or by the medium of any other art": Clement Greenberg, "Modernist Painting," in *The Collected Essays and Criticism, Volume 4: Modernism with a Vengeance, 1957–1969* (Chicago: University of Chicago Press, 1993), 85–86.

31 Jameson, *Postmodernism*, 31.

32 Even the most laissez-faire theories of the market require at least one nonmarket institution—for example, money. Foucault's lectures on neoliberalism have become the locus classicus for the understanding of neoliberalism as the recognition that nonintervention in the mechanisms of the market requires strong intervention on the conditions of the market. Foucault's lecture of February 14, 1979 paraphrases Walter Euken, quoted in the footnotes: "Die Wirtschaftpolitische Tätigkeit des Staates sollte auf die Gestaltung der Ordnungsformen der Wirtschaft gerichtet sein, nicht

auf die Lenkung des Wirtschaftprozesses" (Michel Foucault, *The Birth of Biopolitics: Lectures at the Collège de France, 1978–1979*, trans. Graham Burchell [New York: Palgrave, 2008], 138, 154n37). The neoliberal utopia is in fact an upgrade of Hegel's more naïve one in *Philosophy of Right*, which essentially lets capitalists accumulate as much as they like—for Hegel understands that, under capitalism, the wealth of capital is the wealth of nations—as long as they are not allowed to usurp the job of intellectuals, which is to make decisions about the whole. What neither Hegel nor the neoliberal utopians allow for is that wealth is itself a power that can be arrayed against the regulatory apparatus. Some degree of what the economists call "regulatory capture" is implied by the concept of regulation itself.

33 See "Les relations entre champ de production restreinte et champ de grande production," in Bourdieu, "Le marché des biens symboliques" 81–100, esp. 90.

34 See Alexis Petridis, "Prince: 'Transcendence. That's What You Want. When That Happens—Oh, Boy,'" *The Guardian*, November 12, 2015, accessed July 22, 2018, https://www.theguardian.com/music/2015/nov/12/prince-interview-paisley-park-studios-minneapolis.

35 "As I look over the reasons I have cited to explain why the sculptor of the Laocoön is so measured in the expression of bodily pain, I find that they derive without exception from art-specific conditions, from the necessary limits and exigencies imposed by sculpture. I can scarcely imagine applying any of these to poetry": Gotthold Ephraim Lessing, *Laokoon: Oder, Über die Grenzen der Malerei und Poesie* (Stuttgart: Reclam, 2012), 28. Winkelmann is cited in Lessing, *Laokoon*, 10.

36 See Chapter 3, note 78.

37 David Simon, "The Death of Boom Culture? Walter Benn Michaels with David Simon, Susan Straight, and Dale Peck," New York Public Library, April 14, 2009, https://www.nypl.org/audiovideo/death-boom-culture-walter-benn-michaels-david-simon-susan-straight-dale-peck. As I consider in a later chapter, in another interview Simon repeatedly says, in various ways, "Fuck the average reader": Nick Hornby, "Interview with David Simon," *The Believer*, August 2007, accessed July 22, 2018, http://www.believermag.com/issues/200708/?read=interview_simon. Compare that statement with one plausibly attributed to Steve Jobs that "consumers aren't in the business of knowing what they want." There is a certain similarity of attitude, but what they mean is completely different. Jobs's claim is that consumers are not in the business of knowing what they want but that he is precisely in the business of knowing what consumers want or will want. "Fuck the reader" does not say, "Readers don't know what they want, but I do." Instead, it says, "What the reader wants is irrelevant to what I do."

38 See esp. György Lukács, *The Young Hegel*, trans. Rodney Livingstone (Cambridge, MA: MIT Press, 1976); György Lukács, *Goethe and His Age*, trans. Robert Anchor (London: Merlin, 1968).

39 See György Lukács, "Zur Ästhetik Schillers," in *Probleme der Ästhetik* (Neuwied: Luchterhand, 1969), 17–106. A translation is forthcoming in *Mediations* 32, no. 2 (Spring 2019).

40 Peter Bürger, *Theorie der Avantgarde* (Frankfurt am Main: Suhrkamp, 1974), 117.

41 Bürger, *Theorie der Avantgarde*, 134.

42 But see Daniel Zamora, ed., *Critiquer Foucault: Les années 1980 et la tentation néolibérale* (Brussels: Aden, 2014).

43 Although we know from his letters that James Joyce was hostile to the publishing market, he imagines himself from the beginning as superior to it, which is what makes his hostility so entertaining. Graver threats to autonomy are church and nation, although it is really the latter that threatens aesthetic, as opposed to personal autonomy. Astonishingly, the same logic holds with the South African writer Es'kia Mphahlele. Mphahlele is disgusted with the South African publishing industry and his position within it, and, in a country where until 1953 all education for black students had been run through mission schools, is frustrated with ever present "South African 'churchianity'": Ezekiel Mphahlele, *Down Second Avenue* (New York: Anchor, [1959] 1971), 210. Apartheid South Africa was nothing like a neoliberal state, since it required a massive bureaucracy to administer apartheid and to keep white unemployment low; under apartheid, the market is far from the most obvious threat. The astonishing thing is that, despite the almost unimaginable humiliation of living under apartheid, Mphahlele exiles himself from South Africa not only because of apartheid ("I can't teach [having been banned], and I want to teach"), but because of the threat to aesthetic autonomy represented by a resistance with which he is in full sympathy ("I can't write here and I want to write"). He cannot write not because he has been banned, but because the situation itself, a political urgency that is as much internal as external to Mphahlele himself, represents "a paralyzing spur": Mphahlele, *Down Second Avenue*, 199. This is not to endorse Mphahlele's decision over other possible ones but to point out that the Adornian option between engagement and autonomy—the strong version of the heteronomy/autonomy problem, a version in which both sides have a plausible attraction for the left but that presupposes, as this example underscores, something plausibly left to be heteronomous to—is far from a parochial concern and cannot be overcome at will.

44 Lisa Siraganian, *Modernism's Other Work: The Art Object's Political Life* (Oxford: Oxford University Press, 2012).

45 Something like this is asserted by, among others, the *Wertkritik* tendency in Germany: see Neil Larsen, Mathias Nilges, Josh Robinson, and Nicholas Brown, eds., *Marxism and the Critique of Value* (Chicago: MCM', 2014). Ernst Lohoff's chapter, "Off Limits, Out of Control," is particularly relevant: Ernst Lohoff, "Off Limits, Out of Control," in Larsen et al., *Marxism and the Critique of Value*, 151–86.

46 Karl Marx, *Die deutsche Ideologie*, in Karl Marx and Friedrich Engels, *Marx/Engels: Werke*, vol. 3 (Berlin: Dietz, 1978), 39. The translation is mine, but see Karl Marx, *The German Ideology*, in Karl Marx and Friedrich Engels, *Marx/Engels Collected Works*, vol. 5 (New York: International Publishers, 1976), 55.

47 Marx, *Die deutsche Ideologie*, 26; Marx, *The German Ideology*, 36. The better-known formulation of this dialectic comes from the opening passages of *The Eighteenth Brumaire*.

48 Karl Marx, "Thesen über Feuerbach," in Karl Marx and Friedrich Engels, *Marx/Engels: Werke*, vol. 3 (Berlin: Dietz, 1978), 5. See Karl Marx, "Theses on Feuerbach," in Karl Marx and Friedrich Engels, *Marx/Engels Collected Works*, vol. 5 (New York: International Publishers, 1976), 3.

49 Karl Marx, *Briefe an Kugelmann* (Berlin: Dietz, 1952), 111.

50 See Friedrich Schiller, *Letters on the Aesthetic Education of Man*, trans. Matt McLellan (Chicago: MCM', forthcoming).

51 See Ferreira Gullar, *Cultura posta em questão* e *Vanguarda e subdesenvolvimento* (Rio de Janeiro: José Olympio, 2002).

52 Gullar, *Cultura posta em questão*, 23.

1. Photography as Film and Film as Photography

1 Jeff Wall, "'Marks of Indifference': Aspects of Photography in, or as, Conceptual Art" in *Reconsidering the Object of Art, 1965–1975*, ed. Ann Goldstein and Anne Rorimer (Cambridge, MA: MIT Press, 1995), 266; J. M. Coetzee, *Dusklands* (Johannesburg: Ravan, 1974). Hereafter, page numbers from *Dusklands* are cited in parentheses in the text.

2 J. M. Coetzee, *Doubling the Point: Essays and Interviews* (Cambridge, MA: Harvard University Press, 1992), 204.

3 This, despite the ironic epigraph from *Bouvard and Pécuchet*: "What is important is the philosophy of history" (Coetzee, *Dusklands*, 58). We will briefly revisit the relation between Brecht and Schiller in chapter 3. The dialectic of the heroism and brutality of the figure who is a law unto himself is, after all, a historical one—this was Lukács's understanding of Schiller's treatment of the figure of the criminal—but Coetzee does not make that conspicuous.

4　See Coetzee's apposite notes on Kafka on the relationship between the "time of the narrative" and the "time of the narration" in "Time, Tense, and Aspect in Kafka's 'The Burrow'," in *Doubling the Point*, 210–32.

5　See Alain Badiou, "The Autonomy of the Aesthetic Process" (1965), trans. Bruno Bosteels, *Radical Philosophy* 178 (March–April 2013): 32–39.

6　Needless to say, structures like this precede Coetzee, hardly the first postmodern metafictionalist; indeed, under the term "Romantic irony," they precede modernism and even Romanticism itself. The point is that, after the modernist canon of immanence, they are meant to register as a shock, but the shock is in fact a new way to solve an old problem.

7　Cindy Sherman, *The Complete Untitled Film Stills* (New York: Museum of Modern Art, 2003), 16. All of the images cited in the text are in this volume.

8　Michael Fried, "Art and Objecthood," in *Art and Objecthood* (Chicago: University of Chicago Press, 1998), 164.

9　Hegel, *Phänomenologie des Geistes*, 36/§32.

10　Theodor Adorno, *Minima Moralia* (Frankfurt am Main: Suhrkamp, 1951), 107.

11　Adorno, *Minima Moralia*, 108.

12　Adorno, *Minima Moralia*, 107.

13　Arielle Bier, "Viktoria Binschtok: 'Cluster,'" accessed July 22, 2018, https://viktoriabinschtok.wordpress.com/work-3/cluster-series.

14　Jeff Wall, *Catalogue Raisonné, 1978–2004* (Göttingen, Germany: Steidl, 2005), 275.

15　Julian Stallabrass, "Museum Photography and Museum Prose," *New Left Review* 65 (September–October 2010): 93–105.

16　There are obviously many other workable definitions of allegory available. For the relation between Jamesonian allegory and the figure as it is defined here, see note 16 of the introduction.

17　In fact, Osborne understands the opposition between constructed and documentary images as a continuum, with his *Underground* series falling on the constructed side, and *Aufzug* falling on the documentary side within the series, without, for all that, being a documentary photograph. He writes:

> I was working there for a few weeks with permission of the DB rail authority, which stipulated that I work late in the evening (post-rush hour) since my camera (4 × 5″ view camera) and the low lighting made a tripod necessary. (A very different set up from Walker Evans and his hidden camera [as in his subway series *Many Are Called*].) As a consequence of this bulky/cumbersome setup, nearly all of the pictures were made with the cooperation of the subject. They're not "staged" in the sense of being cast or lit—I generally just asked the subjects to do whatever they were doing before I interrupted them, and to be still for the ½ or ¼ second exposure. These exchanges were usually extremely

brief because within a minute or two a train would show up and the person would take off. The *Aufzug* picture is different from the others in a couple of ways. Its structure is much more perspectival than the others, and related to this, it didn't require the cooperation of the subject. (As a subject's distance from the camera increases, the problem of motion blur diminishes.) Since the guy was fairly far from the camera and confined in a little glass box, I didn't need to ask him to be still. So in terms of a spectrum of constructed/documentary photography, that one is closer to the "documentary" end of things. (Mike Osborne, personal communication with the author, July 25, 2016)

18 The brand name is blurred in a way that looks accidental but, given the compositional process, must be deliberate. This blunts the pointed insistence of the allegory; it would be distractingly obvious if a Samsung television in the apartment corresponded to the Hanjin container ship in the port. However, it would not be a mistake on the beholder's part to assume that by 2004 essentially no television sets were manufactured in North America. Those very few sets that were assembled in North America, much more specialized than the mid-range consumer model pictured in *A View from an Apartment*, relied heavily on parts that, like the Hanjin container ship, would have originated in South Korea.

19 This is not to say, obviously, that paintings are inevitably allegorical and photographs inevitably are not, but only that this particular picture would be allegorical if it were a painting. In Whistler's *Wapping*, the boundary between pictorial interior and exterior space is hard to place precisely. But while the relation between interior and exterior is clearly part of the meaning of the painting, which represents working-class life on the Thames as continuous with working-class life in the inn, nothing strikes the eye as allegorical.

20 This is not the only flagrantly manipulated element of the picture. See, for example, the less thematically weighted reflection of the dining room light fixtures, which does not correspond in shape or number to the fixtures we see; or the reflected light in the coffee cup, which corresponds neither to the lights we see nor to the reflected light in the coffee pot. These pseudo-indices of artifice may be understood as attempts to deflect the allegory of the television as a compositional problem by absorbing it into the broader technical problem of reflected light. The oblique reference, directly invoked by Wall's early *Picture for Women* (1979) is Manet's *A Bar at the Folies-Bergère*. On this reading, what would be "just there" would be not the room and its view but the labor of the artist in composing the picture. However, this does not seem to me to solve the problem of the allegory of the television. The powerfully antitheatrical rhetoric of the two-worlds strategy is not knocked off its axis à la Coetzee by the thematization of reflection, and in relation to that strategy the television continues to pose a problem.

21 Michael Fried, *Why Photography Matters as Art as Never Before* (New Haven, CT: Yale University Press, 2008), 47–62.

22 Martin Heidegger, "Der Ursprung des Kunstwerks," in *Holzwege* (Frankfurt am Main: Vittorio Klostermann, 1980), 34: "Die Welt ist die sich öffnende Offenheit der weiten Bahnen der einfachen und wesentlichen Entscheidungen im Geschick eines geschichtlichen Volkes."

23 Wall, "Marks of Indifference," 251.

24 See Stallabrass, "Museum Photography and Museum Prose."

25 The question involves a theory of action, as well as a theory of photography, and is by no means a settled matter. The debate, fruitful in this regard, between Walter Benn Michaels and Dominic McIver Lopes has not achieved final form on either side. However, the point is that, by emphasizing Mason's interest in film photography, Linklater mobilizes the standard account.

26 Henri Bergson, *L'évolution creatrice* (Paris: F. Alcan, 1909), 109.

27 The quote is the continuation of the previous one from Bergson, *L'évolution creatrice*.

28 Clement Greenberg, "Modernist Painting," in *Clement Greenberg: The Collected Essays and Criticism, Volume 4: Modernism with a Vengeance, 1957–1969*, ed. John O'Brian (Chicago: University of Chicago Press, 1993), 90. I thank Oren Izenberg for pointing out the rabbit hole lurking at the center of this argument and Walter Michaels for showing the (post-Greenbergian) way out.

29 Susanne Kippenberger, "Interview mit Marina Abramovic: Mit 70 muss man den Bullshit reduzieren." *Der Tagesspiegel*, July 25, 2016, accessed July 22, 2018, http://www.tagesspiegel.de/weltspiegel/sonntag/interview -mit-marina-abramovic-ich-kann-keine-gemaelde-schicken-darum-schicke -ich-mich-selbst/13913260-2.html.

2. The Novel and the Ruse of the Work

1 See Charles Ray, *Charles Ray: Sculpture 1997–2014* (Stuttgart: Hatje Cantz, n.d. [2014]), 107.

2 Ray, *Charles Ray*, 106.

3 Walter Benjamin, *Illuminationen* (Frankfurt am Main: Suhrkamp, 1977), 139; Walter Benjamin, *Illuminations* (New York: Schocken, 1968), 220. The implicit critique of Heidegger (*Dasein*) in the language of Hegel's critique of sense-certainty (*Hier und Jetzt*) is hard to discern in translation, but it is operative in the present argument.

4 The statement is from Wim Wenders, dir., *Salt of the Earth*, Decia Films, 2015. The image is in Sebastião Salgado, *Migrations* (New York: Aperture, 2000), 134–35. One could also mention in this context Warhol's *Death*

and Disaster series, in which car crashes figure prominently. For Warhol, the Benjaminian portability of the image would be part of the point. There is also a substantial history of crashed cars and car parts in sculpture, from César to John Chamberlain and Dirk Skreber. These sculptures tend to make the choice of whether to treat the car as raw material or as content, of whether the sculpture is essentially a form or essentially an experience, rather than thematizing the contradiction between them.

5 Ray, *Charles Ray*, 106.

6 Ray, *Charles Ray*, 106.

7 Benjamin, *Illuminationen*, 144; Benjamin, *Illuminations*, 224.

8 Benjamin, *Illuminationen*, 146; Benjamin, *Illuminations*, 225.

9 Benjamin, *Illuminationen*, 144; Benjamin, *Illuminations*, 224.

10 Ferreira Gullar, *Antologia crítica: Suplemento dominical do Jornal do Brasil* (Rio de Janeiro: Contra Capa, 2015), 170–71.

11 Ben Lerner, *10:04* (New York: Farrar, Straus and Giroux), 109. Hereafter, page numbers from this work are cited in parentheses in the text.

12 "Es gibt bei den Chassidim einen Spruch von der kommenden Welt, der besagt: es wird dort alles eingerichtet sein wie bei uns. Wie unsre Stube jetzt ist, so wird sie auch in der kommenden Welt sein; wo unser Kind jetzt schläft, da wird es auch in der kommenden Welt schlafen. Was wir in dieser Welt am Leibe tragen, das werden wir auch in der kommenden Welt anhaben. Alles wird sein wie hier—nur ein klein wenig anders." As Lerner may not know, since he claims in the acknowledgments to have gotten the quote through Agamben, Benjamin continues, "So hält es die Phantasie. Es ist nur ein Schleier, den sie über die Ferne zieht. Alles mag da stehen, wie es stand, aber der Schleier wallt, und unmerklich verschiebt sich's darunter. Es ist ein Wechseln und Vertauschen; nichts bleibt und nichts verschwindet": Walter Benjamin, *Gesammelte Schriften*, vol. 4 (Frankfurt am Main: Suhrkamp, 1972), 419–20.

13 See the nonfiction account of the Salvage Art Institute in Ben Lerner, "Damage Control," *Harper's Magazine*, December 2013, accessed July 22, 2018, https://harpers.org/archive/2013/12/damage-control, and the institute's own manifesto at http://salvageartinstitute.org.

14 See Nicholas Brown, *Utopian Generations: The Political Horizon of Twentieth-Century Literature* (Princeton, NJ: Princeton University Press, 2005), 41.

15 "The many-faceted, self-differentiating expansion, individuation, and complexity of life is the object on which desire and work act. Such manifold doing has now contracted into simple differentiation within the pure movement of thought": G. W. F. Hegel, *Phänomenologie des Geistes* (Frankfurt am Main: Suhrkamp, 1970), 157; G. W. F. Hegel, *Phenomenology of Spirit*, trans. A. V. Miller (Oxford: Oxford University Press, 1977), §199.

16 Recall the final words of *Molloy*: "Then I went back into the house and wrote, It is midnight. The rain is beating on the windows. It was not midnight. It was not raining" (Samuel Beckett, *Molloy, Mallone Dies,* and *The Unnameable* [New York: Grove, 1958], 176).

17 Jennifer Ashton, "Totaling the Damage: Revolutionary Ambition in Recent American Poetry," *nonsite* 18 (October 8, 2015), accessed July 22, 2018, http://nonsite.org/feature/totaling-the-damage.

18 Friedrich Hölderlin, *Hyperion* (Stuttgart: Reclam), 132.

19 Baruch Spinoza, *Ethics*, pt. 4, preface, in Baruch Spinoza, *Spinoza: Complete Works*, trans. Samuel Shirley (Indianapolis: Hackett, 2002), 321.

20 G. W. F. Hegel, *Jenaer Systementwürfe III* (Hamburg: Felix Meiner, 1987), 189.

21 Hegel, *Jenaer Systementwürfe III*, 190. The second sentence is a marginal gloss on the first.

22 Hegel, *Jenaer Systementwürfe III*, 190.

23 Hegel, *Jenaer Systementwürfe III*, 190–91, marginal note.

24 William Empson, *Some Versions of Pastoral* (London: Chatto and Windus, 1935).

25 Cormac McCarthy, *The Road* (New York: Vintage, 2006), 169.

26 Samuel Beckett, *Worstward Ho* (New York: Grove, 1983), 13.

27 Tom McCarthy, *Remainder* (New York: Vintage, 2007), 128. Hereafter, page numbers are cited in parentheses in the text.

28 Heinrich von Kleist, "Über das Marionettentheater," in *Sämtliche Werke und Briefe*, vol. 3 (Frankfurt am Main: Deutscher Klassiker, 1987), 560–61.

29 Anton Chekhov, quoted in Valentine T. Bill, *Chekhov: The Silent Voice of Freedom* (New York: Philosophical Library, 1987), 79.

30 György Lukács, *The Historical Novel* (Lincoln: University of Nebraska Press, 1983), 94.

31 Daniel Defoe, *Robinson Crusoe* (London: Penguin [1719] 1985), 66.

32 Benjamin Kunkel, *Indecision* (New York: Random House, 2005), 38.

33 Teju Cole, *Open City* (New York: Random House, 2011), 18. *Open City* is a particularly difficult instance of the ruse of the work. Is the book ultimately a condemnation of the idiocy and complacency of the major contemporary middlebrow intellectual commonplaces—Noravian *lieux de mémoire*, Barthesian *puncta*, super-complicated and yet totally aimless discussions of ethnic or racial identity, and so on—or just an example of them? The rigorous fictionality that the novel form requires guarantees that the former will remain a possibility no matter how closely the author's opinions resemble its protagonist's. But the novel, as closely as one might look, refuses, even in a dramatic revelation near the end, to tip its hand. All I can say for certain is that whichever position I take, my students will tend to take the other.

34 Virginia Woolf, *Mrs. Dalloway* (New York: Harcourt, 1981), 32.

35 Reinaldo Moraes, *Pornopopéia* (Rio de Janeiro: Objetiva, 2008), 138.

36 Jennifer Egan, *A Visit from the Goon Squad* (New York: Anchor, 2011), 3, 7–8. Hereafter, page numbers are cited in parentheses in the text.

37 As my student Sylvia Wolak pointed out to me, this chapter is literally manipulative: you have to turn the book sideways to read it.

3. Citation and Affect in Music

Epigraph: Arnold Schönberg, "Neue Musik, veraltete Musik, Stil und Gedanke," in *Stil und Gedanke: Aufsätze zur Musik* (Frankfurt am Main: Fischer, 1976), 34.

1 Roberto Schwarz, "Altos e baixos da atualidade de Brecht," in *Seqüências brasileiras: Ensaios* (São Paulo: Companhia das Letras, 1999), 113–48. References are to Roberto Schwarz, "The Relevance of Brecht: High Points and Low," trans. Emilio Sauri, *Mediations* 23, no. 1 (Fall 2007): 27–61.

2 Theodor W. Adorno, "Engagement," *Noten zur Literatur* (Frankfurt: Suhrkamp, 2003), 409–30. As the German title makes clear, the terminology is Sartre's, not Adorno's.

3 Bertolt Brecht, "Das moderne Theater ist das epische Theater," in Bertolt Brecht, *Schriften zum Theater* (Berlin: Suhrkamp, 1957), 16.

4 Brecht, "Das moderne Theater ist das epische Theater," 14, 16, 26.

5 Brecht, "Das moderne Theater ist das epische Theater," 18.

6 Bertolt Brecht, "Literarisierung des Theaters: Anmerkungen zur *Dreigroschenoper*," in Brecht, *Schriften zum Theater*, 29.

7 Brecht, "Das moderne Theater ist das epische Theater," 28.

8 Brecht, *Schriften zum Theater*, 60–73.

9 G. W. F. Hegel, *Vorlesungen über die Ästhetik I* (Frankfurt am Main: Suhrkamp, 1986), 82.

10 Hegel, *Vorlesungen über die Ästhetik I*, 82; G. W. F. Hegel, *Vorlesungen über die Ästhetik III* (Frankfurt am Main: Suhrkamp, 1986), 269.

11 Adorno, "Engagement," 416.

12 Adorno, "Engagement," 417.

13 Schwarz, "The Relevance of Brecht," 43.

14 Schwarz, "The Relevance of Brecht," 44.

15 Bertolt Brecht, *Die heilige Johanna der Schlachthöfe*, in *Werke: Große kommentierte Berliner und Frankfurter Ausgabe*, vol. 3 (Frankfurt am Main: Suhrkamp, 1988), 211. The observation is from Schwarz, "Altos e baixos da atualidade de Brecht," 59–61fn19, a spectacular close reading that traces "Hyperions Schicksalslied" through *Saint Joan*: see Friedrich Hölderlin, *Hyperion* (Stuttgart: Reclam, 1961), 160.

16 Schwarz, "The Relevance of Brecht," 49.

17 Schwarz, "The Relevance of Brecht," 56.

18 Karl Marx, *Der achtzehnte Brumaire des Louis Bonaparte*, in Karl Marx and Friedrich Engels, *Marx/Engels: Werke*, vol. 8 (Berlin: Dietz, 1960), 116.

19 Friedrich Schiller, *Die Räuber* (Stuttgart: Reclam, 1969), 105, 33.

20 Bertolt Brecht, *Die Dreigroschenoper*, in Brecht, *Werke*, 2:305. Hereafter, page numbers from this work are cited in parentheses in the text.

21 *Hermann and Dorothea* exemplifies Marx's observation, cited earlier, from the beginning of the *Eighteenth Brumaire*. Hermann's solid and plodding but handsome bourgeois is elevated (not without irony) over Dorothea's first love, a Jacobin and would-be citoyen whose revolutionary charisma is overcome by means of his death (described not without regret), prior to the action of the poem, in Paris.

22 Walter Benjamin, "Was ist das epische Theater?" (first version), in Walter Benjamin, *Versuche über Brecht* (Frankfurt am Main: Suhrkamp, 1966), 9.

23 Walter Benjamin, "Was ist das epische Theater?" (second version), in Benjamin, *Versuche über Brecht*, 26–27.

24 Walter Benjamin, "Studien zur Theorie des epischen Theaters," in Benjamin, *Versuche über Brecht*, 31.

25 Brecht, "Über gestische Musik," in Brecht, *Schriften zum Theater*, 253.

26 Kurt Weill, "Über den gestischen Charakter der Musik," in Kurt Weill, *Ausgewählte Schriften*, ed. David Drew (Frankfurt am Main: Suhrkamp, 1975), 41.

27 Weill, "Über den gestischen Charakter der Musik," 40.

28 See Brecht, *Schriften zum Theater*, 210–12.

29 There is a robust literature on "tempo entrainment": see, e.g., Sylvie Nozoradan, Isabelle Peretz, and André Mouraux, "Selective Neuronal Entrainment to the Beat and Meter Embedded in a Musical Rhythm," *Journal of Neuroscience* 32 (December 5, 2012): 17572–81. Neuroscientific study of the arts has, of course, not limited itself to the effects of music: see, e.g., Alvin Goldman, "Imagination and Simulation in Audience Response to Fiction," in *The Architecture of the Imagination*, ed. Shaun Nichols (Oxford: Oxford University Press, 2006), 41–56. But while the neurological effects of literary representation do not include the crucial act of interpretation, and therefore clearly do not account for a key feature of literature, the corporal effects of music, which brain science may eventually be equipped to understand, seem intuitively to constitute the very being of music. It is easy conceptually to subordinate, along with Brecht, "coerced empathy" (an effect whose production in literature it is part of Goldman's project to explain) to literary meaning (which is not part of Goldman's project to explain). With music, it is less obvious what the provoked effects would be subordinated to. Hegel's otherwise scandalous exclusion of instrumental music ("not yet strictly to be called an

art": Hegel, *Vorlesungen über die Ästhetik III*, 149]) from his system of the arts is, despite the absurdity of this judgment in historical perspective (Hegel and Beethoven are exact contemporaries), not capricious.

30 Plato, *Republic*, trans. G. M. A. Grube, rev. ed. (Indianpolis, IN: Hackett, 1992), book III.

31 Aristotle, *Politics*, trans. C. D. C. Reeve (Indianapolis, IN: Hackett, 1998), book 8.

32 Hegel, *Vorlesungen über die Ästhetik III*, 146.

33 See page 81 above. Ferreira Gullar, *Antologia crítica: Suplemento dominical do Jornal do Brasil* (Rio de Janeiro: Contra Capa, 2015), 171. To take just one example among a limitless supply, Mahler's *Das Lied von der Erde* is thoroughly invested in provoking an affective response: it would not be a purely personal reaction to experience a descending chomatic figure in the oboe in the final movement as heartbreaking. See, e.g., measure 42, which begins around 3:35 in Daniel Barenboim's interpretation (Chicago Symphony Orchestra, Daniel Barenboim, Waltraud Meier, and Siegfried Jerusalem, *Mahler: Das Lied von der Erde*, compact disc, Warner Classics, [1991] 2002). See also Gustav Mahler, *Das Lied von der Erde* (Vienna: Universal, 1912), 109. More than this, however, *Das Lied von der Erde* is also about affect as nothing more than earth responding to earth, and about the suspension of that relationship in reflection. This is true not just in its lyrical content, but also in the very composition. For example, in the fourth movement the alto is required to sing at a tempo that makes enunciation palpably difficult, such that she is unmistakably an animal making a sound—the howling ape from the first movement or the singing bird from the third, neither of which, however, is reflecting on its animal nature. *Das Lied von der Erde* is about the fact that one can experience a broken chromatic line as heartbreaking.

34 Kurt Weill, "Die Oper—wohin?" in Hinton and Schebera, *Kurt Weill*, 68.

35 Kurt Weill, "Verschiebungen in der musikalischen Produktion," in Stephen Hinton and Jürgen Schebera, eds., *Kurt Weill: Musik und Theater: Gesammelte Schriften, mit einer Auswahl von Gesprächen und Interviews* (Berlin: Henschelverlag, 1990), 45.

36 Not that points of social identification are themselves bad things, and not that social identification cannot be pursued by artistic means. But in that case, what are available for judgment are the desirability of the ends and the suitability of the means, not the music itself. If esprit de corps were the aim, there is no reason that the "return to absolute music" should be seen as a positive step since, in politics as well as in the market, what is worth doing is whatever works.

37 Rudyard Kipling, *Barrack-Room Ballads and Other Verses* (Leipzig: Heinemann and Balestier, 1892), 19.

38 Brecht, *Die Dreigroschenoper*, 251–52. The first couplet is borrowed from the translation by Mannheim and Willet (Brecht, *The Threepenny Opera*, trans. Ralph Mannheim and John Willet, in *The Threepenny Opera, Baal, and The Mother* [New York: Arcade, 1993], 85.)

39 Kurt Weill and Bertolt Brecht, *Die Dreigroschenoper*, score, Universal, Vienna, 2008, 44–55; Die Dreigroschenband [Lewis Ruth-Band], *Die Dreigroschenoper: The Original 1930 Recordings*, Teldec/Warner, 1990.

40 Bertolt Brecht, "Vergnügungstheater oder Lehrtheater?" in Brecht, *Schriften zum Theater*, 66.

41 Brecht, *Werke*, 2:442.

42 Lotte Lenya, "That Was a Time," *Theater Arts*, May 1956, 93.

43 See, e.g., Kurt Weill, "Bekenntnis zur Oper" [Commitment to Opera], in *Ausgewählte Schriften*, ed. David Drew (Berlin: Suhrkamp, 1975), 29–31.

44 Janet de Almeida and Haroldo Barbosa, *Pra que discutir com madame?* Continental, 1945:

> Madame diz que a raça não melhora
> Que a vida piora por causa do samba
> Madame diz que o samba tem pecado
> Que o samba coitado devia acabar
>
> Madame diz que o samba tem cachaça
> Mistura de raça, mistura de cor
> Madame diz que o samba democrata
> É música barata sem nenhum valor
>
> Vamos acabar com samba
> Madame não gosta que ninguém sambe
> Vive dizendo que o samba é vexame
> Pra que discutir com Madame
>
> Tchu ru ru
> Tchu ru ru ru
> Tchu ru ru ru
> Tchu ru ru
>
> No carnaval que vem também concorro
> Meu bloco de morro vai cantar ópera
> E na avenida entre mil apertos
> Vocês vão ver gente cantando concerto
>
> Madame tem um parafuso a menos
> Só fala veneno meu Deus que horror
> O samba brasileiro, democrata
> Brasileiro na batata é que tem valor.

The order of the lyrics as presented follows João Gilberto, *João Gilberto Live in Montreux*, Elektra/Musician, 1986. I owe many thanks to Walter Garcia and Marcelo Pretto for digging up the recording from 1945.

45 See the interview with Haroldo Barbosa from *O Pasquim*, vol. 249, 1974, in Jaguar and Sérgio Augusto, eds., *O Pasquim: Antologia 1973–1974*, vol. 3 (Rio de Janeiro: Desiderata, 2009), 336. See also Tania da Costa Garcia, "Madame Existe," *Revista da Faculdade de Comunicação da FAAP*, no. 9 (2001), accessed July 22, 2018, http://www.faap.br/revista_faap/revista _facom/artigos_madame1.htm.

46 Pyotr Ilyich Tchaikovsky, *Piano Concerto No. 1 in B-flat Minor, Opus 23*, in Pyotr Ilyich Tchaikovsky, *Complete Collected Works*, vol. 28, ed. Aleksandr Goldenweiser (Moscow: Muzgiz, 1955).

47 Kurt Weill, "Die Oper—wohin?" in Hinton and Schebera, *Kurt Weill*, 68.

48 Antonio Carlos Jobim, *Jobim*, MCA, 1973.

49 Caetano Veloso and Gal Costa, *Domingo*, Polygram, 1967.

50 For a much more detailed version of this argument, see "Postmodernism as Semiperipheral Symptom," chapter 8 in Nicholas Brown, *Utopian Generations: The Political Horizon of Twentieth Century Literature* (Princeton, NJ: Princeton University Press, 2005), 166–92. There, the ideological element of Trópicalia was seen to be its hypostasization of contradictions, while the utopian element lay in the desires that the songs of Tropicália manage, nonemphatically, to fulfill. I was not satisfied with the second half of that argument at the time; in the terms of the present argument, it cannot be right, since the latter desire is registered in the market simply as demand. Neither of these earlier arguments is, however, precisely wrong. Rather, the line dividing the ideological and utopian aspects of Tropicália runs not between the song and the desire it satisfies but, rather, through them both. Desire, of course, far exceeds the market, which can only channelize a few desires into demand. Meanwhile, the hypostasization of contradictions is indeed ideological. But, as we shall see, even Veloso's ideology, when produced through musical form, has an oppositional aspect that it is the burden of the present argument to bring forward.

51 Roberto Schwarz, "Cultura e política, 1964–1969," in *O pai da família e outros estudos* (Rio de Janeiro: Paz e Terra, 1978), 74.

52 Roberto Schwarz, "Verdade tropical: Um percurso de nosso tempo," in *Martinha versus Lucrécia* (São Paulo: Companhia das Letras, 2012), 99.

53 Caetano Veloso, *Verdade tropical* (São Paulo: Companhia das Letras, 1997), 117.

54 Weill, *Ausgewählte Schriften*, 54.

55 Augusto de Campos, "Conversa com Caetano Veloso," in *Balanço da bossa e outras bossas* (São Paulo: Perspectiva, 1974), 200.

56 Caetano Veloso, "Primeira feira de balanço," [1965] in Caetano Veloso, *O mundo não é chato* (São Paulo: Companhia das Letras, 2005), 143. The punning title involves the fact that "balanço" is both a musical term for something like "swing" and an account balance.

57 Veloso, "Primeira feira do balanço," 143.

58 Caetano Veloso, *Caetano Veloso*, Philips, 1969.

59 In order of reference: "Marinheiro só" (traditional); "Cambalache," by Enrique Santos Discépolo; "Chuvas de verão," by Fernando Lobo; "Carolina" by Chico Buarque; "Atrás do trio elétrico," "Os Argonautas," "Lost in the Paradise," and "The Empty Boat" by Caetano Veloso.

60 Brecht, "Das moderne Theater ist das epische Theater," 21.

61 Humberto Werneck, *Chico Buarque: Letra e música* (São Paulo: Companhia da Letras, 1989), 76.

62 Werneck, *Chico Buarque*, 80.

63 Veloso, *Verdade tropical*, 234.

64 Caetano Veloso and Gilberto Gil, *Tropicália 2*, Elektra, 1994. Caetano and Gil's return to their shared musical project of the late 1960s is, from the standpoint of the current argument, misnamed: it is, practically track for track (though none of the songs are repeated) a sequel not to the original *Tropicália* but rather to Veloso's "white album" of 1969.

65 I take Schwarz's "Verdade tropical" to be the definitive analysis of Veloso's public political positions. The article has been controversial. Some of the commentary has been in bad faith; some simply agrees with Veloso's politics and disagrees with Schwarz's; some feels the need, in defending Veloso's music, to defend his politics. For the present purposes, it is enough to note the gap between Veloso's public political positions and the politics entailed by his musical project.

66 White Stripes, *De Stijl*, Sympathy for the Record Industry, 2000.

67 It has been suggested that the lyrics were inspired by annoyance at the phone company, but that does not mean the lyrics have any meaning.

68 Stating the essential idea in a drum solo is itself a statement about what constitutes musical necessity, as one thing everyone can agree on is that, in most rock, drum solos are definitely not a musical necessity. One of the self-imposed rules governing *White Blood Cells* was not to use guitar solos.

69 The White Stripes' determination to use only analog recording technology, while not directly relevant to the argument at hand, might seem to suggest a primitivist or a nostalgic drive. But the preference for analog technology is purely technical. Analog technology is a victim of what Marx called "moralischer Verschleiss," something like normative wear and tear, what happens when equipment is rendered worthless not by physical wear and tear but by the appearance of equipment that is more efficient (i.e., costs

less per unit of value produced) but not necessarily better in any other way. "It's not trying to sound retro," says Jack White of the White Stripes. "It's just recognizing what was the pinnacle of recording technology": quoted in Chris Norris, "Digging for Fire: Detroit's Candy-Striped Wonder Twins Keep the Sound Stripped and the Tales Lively for *Elephant*," *Spin*, vol. 19, no. 5, May 2003, 78. Another word for "worthless" is, of course, "affordable." The famous department store guitars are also not an aesthetic decision in the immediate sense but, rather, part of the limiting conditions the White Stripes imposed on themselves to forestall the theatricality of live performance. The attraction of the cheap guitars is not the sound, which surely disappears into the pedal board, but that they do not stay in tune very well. The point is not to let them go out of tune but to impose an arbitrary constraint: one has to work constantly to keep them in tune.

70 Theo van Doesburg, *Grundbegriffe der neuen gestaltenden Kunst* (Mainz, Germany: Florian Kupferberg, [1925] 1966), 32.

71 Jennifer Egan, *A Visit from the Goon Squad* (New York: Anchor, 2011), 34.

72 White Stripes, *Hello Operator*, Sympathy for the Record Industry, 2000.

73 Blind Willie McTell, *Complete Recorded Works in Chronological Order*, vol. 1, Document, 1990. McTell's tempo is closer to Weill's foxtrot. Thinking in cut time, a quarter-note pulse is accented on offbeats rather than on backbeats, and the syncopation goes by twice as fast in relation to a quarter-note as in "Hello Operator."

74 "Blind Willie McTell Monologue on Accidents," audio clip, published February 8, 2009, accessed July 22, 2018, http://www.youtube.com/watch?v =5n8skkVSlzs.

75 White Stripes, *Hello Operator*; White Stripes, *Elephant*, V2, 2003; White Stripes, *Icky Thump*, Warner Brothers, 2007.

76 Robert Johnson, *Stop Breakin' Down Blues*, Vocalion, 1938; White Stripes, *The White Stripes*, Sympathy for the Record Industry, 1999; Rolling Stones, *Exile on Main Street*, Rolling Stones, 1972.

77 Blind Willie McTell, *Complete Recorded Works in Chronological Order*, vol. 2, Document, 1990; White Stripes, *Lord, Send Me an Angel*, Sympathy for the Record Industry, 2000.

78 Jazz, at least from the moment it ceases to be a genre and becomes a self-revolutionizing field, could not be brought within the White Stripes' project, in any case. An album like Oliver Nelson's *The Blues and the Abstract Truth*, which is a self-conscious attempt to explore the constraints of the blues form and rhythm changes (the chord progression underlying George Gershwin's "I Got Rhythm" and, subsequently, a great number of jazz standards), partakes in 1961 of something like the music-immanent component of the White Stripes' project. Of course, by that time a self-revolutionizing music-immanent development in jazz, supported by a paradigmatic Bour-

dieusian restricted field, had been long established. Cee-Lo Green's album *The Lady Killer* (2010) undertakes a version of the historical component of the White Stripes' project on the terrain not of rock but that of the relationship between black popular musical forms and the mass music market. "Bright Lights Bigger City," a pastiche built of elements from "Eye of the Tiger" and "Everybody's Working for the Weekend," with sonic references to Michael Jackson's "Beat It" and assembled on the bones of his "Billie Jean," which itself is built over a bass line lifted from Hall and Oates's "I Can't Go for That," which is in turn a pastiche—in the straightforward, culture industry sense—of 1960s rhythm and blues, packs about half of the pop music field circa 1982 into a single song. Incidentally, 1982 is the year the television show *Cheers*, referenced in the lyric "where everybody knows your name," debuted. The yuppie novel *Bright Lights, Big City* was published two years later. There is no musical reference that I can discern to Jimmy Reed's blues "Bright Lights, Big City," which is itself a statement about pop music circa 1982.

79 Quoted in Norris, "Digging for Fire," 78.

80 Norris, "Digging for Fire," 79.

81 The White Stripes' procedure is, however, different from euphemism. Picking arbitrarily among hundreds of possible examples: if the original lyrics to "Tutti Frutti" began "Tutti frutti, good booty," the bowdlerized recorded version we know both replaces a sexual signifier and suggests its meaning lyrically. "Ball and Biscuit" insists musically without a lyrical signifier.

82 Schumann's "Abends am Strand" (Opus 45, no. 3), a setting of Heine's "Wir saßen am Fischerhause" from *Die Heimkehr*, runs through six distinct moods in six stanzas and returns to the first with a difference in the seventh and last: Heinrich Heine, *Buch der Lieder* (Stuttgart: Reclam, 1990), 119–20; Dietrich Fischer-Dieskau and Christoph Eschenbach, *Robert Schumann: Lieder*, disc 3, Deutsche Grammophon, 1994.

83 Lead Belly, *The Titanic: The Library of Congress Recordings*, vol. 4, Rounder, 1994.

4. Modernism on TV

1 Jørgen Leth, *Stopforbud* (1963), in *The Jørgen Leth Collection 30–37: Experimental Films*, DVD, Danish Film Institute, Copenhagen, 2010. The title is an English-Danish pun on a common street sign.

2 Jørgen Leth, "Working Credo," *Film Special Issue: Leth* (2002): 3.

3 Jørgen Leth, *De fem benspænd* [The Five Obstructions] (2003), and *Det perfekte menneske* [The Perfect Human] (1968), both in *The Jørgen Leth Collection 01–05: The Anthropological Films*, DVD, Danish Film Institute, Copenhagen, 2007.

4 Of course, the frame is von Trier's, and we cannot discount the possibility that who concedes is not Lars von Trier but only "Lars von Trier." Certainly, von Trier edits himself—as when he shows his own hand shaky on the vodka bottle while Leth's is steady—in an excruciating light. For our purposes, this makes no difference. As far as his films are concerned, Leth is Leth.

5 "Monsieur Rukov" is no doubt also a reference to the Danish screenwriter Mogens Rukov, who worked with von Trier on *The Element of Crime*. The Brussels *Perfect Human* contains a number of references to von Trier's *Europa* trilogy—itself centrally concerned with genre—an insiders' joke that functions formally, not politically, like the inside joke in the song "Pra que discutir com madame?" in (see chapter 3).

6 Mette Hjort and Ig Bondebjerg, "Interview with Jørgen Leth, in *The Danish Directors: Dialogues on a Contemporary National Cinema*, ed. Mette Hjort and Ig Bondebjerg (Bristol, UK: Intellect, 2003).

7 Eugene Jolas, "Proclamation," *Transition* 16–17 (June 1929): 13.

8 Hjort and Bondebjerg, *The Danish Directors*, 64, 71.

9 See Parliament of Denmark, Danish Film Act of 1997, accessed July 22, 2018, http://www.wipo.int/wipolex/en/text.jsp?file_id=199849.

10 Nick Hornby, "Interview with David Simon," *The Believer*, August 2007, accessed July 22, 2018, https://believermag.com/an-interview-with-david-simon. "Fuck the average reader" is not, despite appearances, a statement of elitism like Schönberg's in the previous chapter. What is rejected here is the imperative to guess at desires to be satisfied in the anonymous market.

11 Hornby, "Interview with David Simon."

12 David Marc, *Demographic Vistas: Television in American Culture* (Philadelphia: University of Pennsylvania Press, 1996), 14.

13 Marc, *Demographic Vistas*, 37.

14 Raymond Williams, *Television* (New York: Schocken, 1975), 87.

15 *The Wire* has been since remastered by HBO in high definition, in a 16:9 ratio. This does not change the fact that the original shots were composed for 4:3 and usually work better in 4:3. Also, as a decision made by HBO rather than Simon, it has no bearing on the significance of the original decision to go with a 4:3 ratio.

16 Antônio Cândido, "Dialectic of Malandroism," in *On Literature and Society* (Princeton, NJ: Princeton University Press, 1995), 79–103. Hereafter, page numbers cited in parentheses in the text. However, the translation may be silently amended to match more closely Antônio Cândido, "Dialéctica da malandragem," *Revista do Instituto de Estudos Brasileiros* 8 (June 1970): 67–89.

17 Hornby, "Interview with David Simon."

18 Hegel, G.W.F. *Vorlesungen über die Ästhetik III* (Frankfurt am Main: Suhrkamp, 1986), 558–59.

19 David Simon, "David Simon: 'There are now two Americas. My country is a horror show.'" *The Guardian*, December 7, 2013, accessed July 22, 2018, https://www.theguardian.com/world/2013/dec/08/david-simon-capitalism-marx-two-americas-wire.

20 David Simon, "David Simon." Workforce participation declined dramatically after the crash of 2008, prompting mainstream concerns about "secular stagnation." But when the second season of *The Wire* aired in 2003, the unemployment rate was around 6 percent, and even under those relatively benign conditions the "reserve army"—the unemployed, the involuntarily part time, and the "marginally attached"—numbered some fifteen million souls, a figure that does not include people who are not considered part of the workforce because they are not presently looking for work.

Epilogue

1 Franz Kafka, "Die Sorge des Hausvaters," in *Erzählungen* (Berlin: S. Fischer, 1965), 171.

2 Roberto Schwarz, "Worries of a Family Man," trans. Nicholas Brown, *Mediations* 23, no. 1 (Fall 2007): 21–25.

3 Schwarz, "Worries of a Family Man," 23.

4 Kafka, "Die Sorge des Hausvaters," 171.

5 Schwarz, "Worries of a Family Man," 24.

6 Immanuel Kant, *Kritik der Urteilskraft* (Frankfurt am Main: Suhrkamp, 1974), 143.

7 Kafka, "Die Sorge des Hausvaters," 171.

8 Kant, *Kritik der Urteilskraft*, 122–23.

9 Kant, *Kritik der Urteilskraft*, 123.

10 Schwarz, "Worries of a Family Man," 23.

Bibliography

Adorno, Theodor. "Engagement." In *Noten zur Literatur*, 409–30. Frankfurt am Main: Suhrkamp, 2003.

Adorno, Theodor. *Minima Moralia*. Frankfurt am Main: Suhrkamp, 1951.

Almeida, Janet de, and Haroldo Barbosa. *Pra que discutir com Madame?* Continental, 1945.

Aristotle, *Politics*, trans. C. D. C. Reeve. Indianapolis, IN: Hackett, 1998.

Ashton, Jennifer. "Totaling the Damage: Revolutionary Ambition in Recent American Poetry." *nonsite* 18 (October 8, 2015). http://nonsite.org /feature/totaling-the-damage.

Augusto, Sérgio, and Jaguar [Sérgio Jaguaribe], eds. *O Pasquim, Antologia 1973–1974, Volume 3*. Rio de Janeiro: Desiderata, 2009.

Badiou, Alain. "The Autonomy of the Aesthetic Process" (1965), trans. Bruno Bosteels. *Radical Philosophy* 178 (March–April 2013): 32–39.

Beckett, Samuel. *Molloy, Mallone Dies*, and *The Unnameable*. New York: Grove, 1958.

Beckett, Samuel. *Worstward Ho*. New York: Grove, 1983.

Beech, Dave. *Art and Value: Art's Economic Exceptionalism in Classical, Neoclassical and Marxist Economics*. Leiden: Brill, 2015.

Benjamin, Walter. *Gesammelte Schriften*, vol. 4. Frankfurt am Main: Suhrkamp, 1972.

Benjamin, Walter. *Illuminationen*. Frankfurt am Main: Suhrkamp, 1977.

Benjamin, Walter. *Illuminations*. New York: Schocken, 1968.

Benjamin, Walter. *Versuche über Brecht*. Frankfurt am Main: Suhrkamp, 1966.

Bergson, Henri. *L'évolution creatrice*. Paris: F. Alcan, 1909.

Bill, Valentine T. *Chekhov: The Silent Voice of Freedom*. New York: Philosophical Library, 1987.

Bourdieu, Pierre. "Le marché des biens symboliques." *L'Anée Sociologique* 22 (1971): 49–126.

Brecht, Bertolt. *Die Dreigroschenoper*. In *Werke: Große kommentierte Berliner und Frankfurter Ausgabe*, vol. 2, 229–322. Frankfurt am Main: Suhrkamp, 1988.

Brecht, Bertolt. *Die heilige Johanna der Schlachthöfe*. In *Werke: Große kommentierte Berliner und Frankfurter Ausgabe*, vol. 3, 127–234. Frankfurt am Main: Suhrkamp, 1988.

Brecht, Bertolt. *Schriften zum Theater*. Berlin: Suhrkamp, 1957.

Brecht, Bertolt. *The Threepenny Opera*, trans. Ralph Mannheim and John Willet. In *The Threepenny Opera, Baal, and The Mother*, 62–141. New York: Arcade, 1993.

Brenner, Robert. *The Economics of Global Turbulence*. London: Verso, 2006.

Brown, Nicholas. *Utopian Generations: The Political Horizon of Twentieth-Century Literature*. Princeton, NJ: Princeton University Press, 2005.

Bürger, Peter. *Theorie der Avantgarde*. Frankfurt am Main: Suhrkamp, 1974.

Campos, Augusto de. "Conversa com Caetano Veloso." In *Balanço da bossa e outras bossas*, 199–207. São Paulo: Perspectiva, 1974.

Cândido, Antônio. "Dialectic of Malandroism." In *On Literature and Society*, 79–103. Princeton, NJ: Princeton University Press, 1995.

Cândido, Antônio. "Dialéctica da malandragem." *Revista do Instituto de Estudos Brasileiros* 8 (June 1970): 67–89.

Chicago Symphony Orchestra, Daniel Barenboim, Waltraud Meier, and Siegfried Jerusalem. *Mahler: Das Lied von der Erde*. Warner Classics, [1991] 2002.

Clover, Carol J. *Men, Women, and Chain Saws: Gender in the Modern Horror Film*. Princeton, NJ: Princeton University Press, 1992.

Coetzee, J. M. *Doubling the Point: Essays and Interviews*. Cambridge, MA: Harvard University Press, 1992.

Coetzee, J. M. *Dusklands*. Johannesburg: Ravan, 1974.

Cole, Teju. *Open City*. New York: Random House, 2011.

Cowen, Tyler. *In Praise of Commercial Culture*. Cambridge, MA: Harvard University Press, 1998.

Defoe, Daniel. *Robinson Crusoe*. London: Penguin, [1719] 1985.

Doesburg, Theo van. *Grundbegriffe der neuen gestaltenden Kunst*. Mainz, Germany: Florian Kupferberg, [1925] 1966.

Dreigroschenband [Lewis Ruth-Band]. *Die Dreigroschenoper: The Original 1930 Recordings.* Teldec/Warner, 1990.

Egan, Jennifer. *A Visit from the Goon Squad.* New York: Anchor, 2011.

Empson, William. *Some Versions of Pastoral.* London: Chatto and Windus, 1935.

Fischer-Dieskau, Dietrich, and Christoph Eschenbach. *Robert Schumann: Lieder*, disk 3. Deutsche Grammophon, 1994.

Foucault, Michel. *The Birth of Biopolitics: Lectures at the College de France, 1978–1979*, trans. Graham Burchell. New York: Palgrave, 2008.

Fried, Michael. "Art and Objecthood." In *Art and Objecthood*, 148–72. Chicago: University of Chicago Press, 1998.

Fried, Michael. *Why Photography Matters as Art as Never Before.* New Haven, CT: Yale University Press, 2008.

Gilberto, João. *João Gilberto Live in Montreux.* Elektra/Musician, 1986.

Goldman, Alvin. "Imagination and Simulation in Audience Response to Fiction." In *The Architecture of the Imagination*, ed. Shaun Nichols, 41–56. Oxford: Oxford University Press, 2006.

Greenberg, Clement. "Modernist Painting." In *The Collected Essays and Criticism, Volume 4: Modernism with a Vengeance, 1957–1969*, ed. John O'Brian, 85–100. Chicago: University of Chicago Press, 1993.

Gullar, Ferreira *Antologia crítica: Suplemento dominical do Jornal do Brasil.* Rio de Janeiro: Contra Capa, 2015.

Gullar, Ferreira. *Cultura posta em questão* e *Vanguarda e subdesenvolvimento.* Rio de Janeiro: José Olympio, 2002.

Hegel, G. W. F. *Jenaer Systementwürfe III.* Hamburg: Felix Meiner, 1987.

Hegel, G. W. F. *Phänomenologie des Geistes.* Frankfurt am Main: Suhrkamp, 1970.

Hegel, G. W. F. *Phenomenology of Spirit*, trans. A. V. Miller. Oxford: Oxford University Press, 1977.

Hegel, G. W. F. *Vorlesungen über die Ästhetik I.* Frankfurt am Main: Suhrkamp, 1970.

Hegel, G. W. F. *Vorlesungen über die Ästhetik III.* Frankfurt am Main: Suhrkamp, 1986.

Heidegger, Martin. "Der Ursprung des Kunstwerks." In *Holzwege*, 1–72. Frankfurt am Main: Vittorio Klostermann, 1980.

Heine, Heinrich. *Buch der Lieder.* Stuttgart: Reclam, 1990.

Hinton, Stephen, and Jürgen Schebera, eds. *Kurt Weill: Musik und Theater: Gesammelte Schriften, mit einer Auswahl von Gesprächen und Interviews.* Berlin: Henschelverlag, 1990.

Hjort, Mette, and Ig Bondebjerg. "Interview with Jørgen Leth." In *The Danish Directors: Dialogues on a Contemporary National Cinema*, ed. Mette Hjort and Ig Bondebjerg, 58–74. Bristol, UK: Intellect, 2003.

Hölderlin, Friedrich. *Hyperion.* Stuttgart: Reclam, 1961.

Horkheimer, Max, and Theodor Adorno. *Dialectic of Enlightenment,* trans. John Cumming. New York: Continuum, 1996.

Horkheimer, Max, and Theodor Adorno. *Dialektik der Aufklärung: Philosophische Fragmente.* Frankfurt am Main: Fischer, 1969.

Hutt, William Harold. "The Concept of Consumers' Sovereignty." *Economic Journal* 50, no. 197 (March 1940): 66–77.

Jameson, Fredric. *Postmodernism: Or, the Cultural Logic of Late Capitalism.* Durham, NC: Duke University Press, 1991.

Jameson, Fredric. *Representing Capital.* London: Verso, 2011.

Jobim, Antonio Carlos. *Jobim.* MCA, 1973.

Johnson, Robert. *Stop Breakin' Down Blues.* Vocalion, 1938

Jolas, Eugene. "Proclamation." *Transition* 16–17 (June 1929): 13.

Kafka, Franz. "Die Sorge des Hausvaters." In *Erzählungen,* 170–72. Berlin: S. Fischer, 1965.

Kant, Immanuel. *Kritik der Urteilskraft.* Frankfurt am Main: Suhrkamp, 1974.

Kipling, Rudyard. *Barrack-Room Ballads and Other Verses.* Leipzig: Heinemann and Balestier, 1892.

Kleist, Heinrich von. "Über das Marionettentheater." In *Sämtliche Werke und Briefe,* vol. 3, 560–61. Frankfurt am Main: Deutscher Klassiker, 1987.

Kunkel, Benjamin. *Indecision.* New York: Random House, 2005.

Larsen, Neil, Mathias Nilges, Josh Robinson, and Nicholas Brown, eds. *Marxism and the Critique of Value.* Chicago: MCM′, 2014.

Lead Belly. *The Titanic: The Library of Congress Recordings,* vol. 4. Rounder, 1994.

Lerner, Ben. *10:04.* New York: Farrar, Straus and Giroux.

Lessing, Gotthold Ephraim. *Laokoon: Oder, Über die Grenzen der Malerei und Poesie* Stuttgart: Reclam, 2012.

Leth, Jørgen. *De fem benspaend* [The Five Obstructions] (2003). In *The Jørgen Leth Collection 01–05: The Anthropological Films.* DVD. Danish Film Institute, Copenhagen, 2007.

Leth, Jørgen. *Det perfekte menneske"* [The Perfect Human] (1968). In *The Jørgen Leth Collection 01–05: The Anthropological Films.* DVD. Danish Film Institute, 2007.

Leth, Jørgen. *Stopforbud* (1963). In *The Jørgen Leth Collection 30–37: Experimental Films.* DVD. Danish Film Institute, Copenhagen, 2010.

Leth, Jørgen. "Working Credo." *Film Special Issue: Leth* (2002): 3.

Lukács, György. "'Entäusserung' ('Externalization') as the Central Philosophical Concept of *The Phenomenology of Mind.*" In *The Young Hegel: Studies in the Relations between Dialectics and Economics,* trans. Rodney Livingstone, 537–68. Cambridge, MA: MIT Press, 1976.

Lukács, György. *Goethe and His Age*, trans. Robert Anchor. London: Merlin, 1968.

Lukács, György. *The Historical Novel*. Lincoln: University of Nebraska Press, 1983.

Lukács, György. *Werke, Volume 16: Heidelberger Philosophie der Kunst (1912–14)*. Darmstadt: Luchterhand, 1974.

Lukács, György. *The Young Hegel*, trans. Rodney Livingstone. Cambridge, MA: MIT Press, 1976.

Lukács, György. "Zur Ästhetik Schillers." In *Probleme der Ästhetik*, 17–106. Neuwied, Germany: Luchterhand, 1969.

Mahler, Gustav. *Das Lied von der Erde*. Vienna: Universal, 1912.

Marc, David. *Demographic Vistas: Television in American Culture*. Philadelphia: University of Pennsylvania Press, 1996.

Marx, Karl. *Der achtzehnte Brumaire des Louis Bonaparte*. In Karl Marx and Friedrich Engels, *Marx/Engels: Werke*, vol. 8, 111–207. Berlin: Dietz, 1960.

Marx, Karl. *Briefe an Kugelmann*. Berlin: Dietz, 1952.

Marx, Karl. *Capital: A Critique of Political Economy*, vol. 1, trans. Ben Fowkes. London: New Left Review, 1976.

Marx, Karl. *Die deutsche Ideologie*. In Karl Marx and Friedrich Engels, *Marx/Engels: Werke*, vol. 3, 9–530. Berlin: Dietz, 1978.

Marx, Karl. *The German Ideology*. In Karl Marx and Friedrich Engels, *Marx/Engels Collected Works*, vol. 5, 19–539. New York: International Publishers, 1976.

Marx, Karl. *Grundrisse der Kritik der politischen Ökonomie*. In Karl Marx and Friedrich Engels, *Marx/Engels: Werke*, vol. 42, 47–768. Berlin: Dietz, 2008.

Marx, Karl. *Das Kapital: Kritik der politischen Ökonomie, Erster Band*. In Karl Marx and Friedrich Engels, *Marx/Engels: Werke*, vol. 23. Berlin: Dietz, 2008.

Marx, Karl. *Das Kapital 1.1: Resultate des unmittelbaren Produktionsprozesses*. Berlin: Dietz, 2009.

Marx, Karl. "Thesen über Feuerbach." In Karl Marx and Friedrich Engels, *Marx/Engels: Werke*, vol. 3, 5–7. Berlin: Dietz, 1978.

Marx, Karl. "Theses on Feuerbach. In Karl Marx and Friedrich Engels, *Marx/Engels Collected Works*, vol. 5, 3–5. New York: International Publishers, 1976.

McCarthy, Cormac. *The Road*. New York: Vintage, 2006.

McCarthy, Tom. *Remainder*. New York: Vintage, 2007.

McTell, Blind Willie. *Complete Recorded Works in Chronological Order*, vol. 1. Document, 1990.

McTell, Blind Willie. *Complete Recorded Works in Chronological Order*, vol. 2. Document, 1990.

Michaels, Walter Benn, and Steven Knapp. "Against Theory." *Critical Inquiry* 8, no. 4 (Summer 1982): 723–42.

Moraes, Reinaldo. *Pornopopéia*. Rio de Janeiro: Objetiva, 2008.

Mphahlele, Ezekiel. *Down Second Avenue*. New York: Anchor, 1971.

Nozoradan, Sylvie, Isabelle Peretz, and André Mouraux. "Selective Neuronal Entrainment to the Beat and Meter Embedded in a Musical Rhythm." *Journal of Neuroscience* 32 (December 5, 2012): 17572–81.

Plato. *Republic*, trans. G. M. A. Grube, rev. ed. Indianapolis: Hackett, 1992.

Ray, Charles. *Charles Ray: Sculpture 1997–2014*. Stuttgart: Hatje Cantz, n.d. [2014].

Rolling Stones. *Exile on Main Street*. Rolling Stones, 1972.

Salgado, Sebastião. *Migrations*. New York: Aperture, 2000.

Schiller, Friedrich. *Die Räuber*. Stuttgart: Reclam, 1969.

Schiller, Friedrich. *Letters on the Aesthetic Education of Man*, trans. Matt McLellan. Chicago: MCM', forthcoming.

Schönberg, Arnold. "Neue Musik, veraltete Musik, Stil und Gedanke." In *Stil und Gedanke: Aufsätze zur Musik*, 25–34. Frankfurt am Main: Fischer, 1976.

Schwarz, Roberto. "Altos e baixos da atualidade de Brecht." In *Seqüências brasileiras: Ensaios*, 113–48. São Paulo: Companhia das Letras, 1999.

Schwarz, Roberto. "Cultura e política, 1964–1969." In *O pai da família e outros estudos*, 61–92. Rio de Janeiro: Paz e Terra, 1978.

Schwarz, Roberto. "The Relevance of Brecht: High Points and Low," trans. Emilio Sauri. *Mediations* 23, no. 1 (Fall 2007): 27–61.

Schwarz, Roberto. "Verdade tropical: Um percurso de nosso tempo." In *Martinha versus Lucrécia*, 52–110. São Paulo: Companhia das Letras, 2012.

Schwarz, Roberto. "Worries of a Family Man," trans. Nicholas Brown. *Mediations* 23, no. 1 (Fall 2007): 21–25.

Sherman, Cindy. *The Complete Untitled Film Stills*. New York: Museum of Modern Art, 2003.

Siraganian, Lisa. *Modernism's Other Work: The Art Object's Political Life*. Oxford: Oxford University Press, 2012.

Spinoza, Baruch. *Ethics. Spinoza: Complete Works*, trans. Samuel Shirley. Indianapolis: Hackett, 2002.

Stallabrass, Julian. "Museum Photography and Museum Prose." *New Left Review* 65 (September–October 2010): 93–105.

Tchaikovsky, Pyotr Ilyich. *Piano Concerto No. 1 in B-flat Minor, Opus 23*. In Pyotr Ilyich Tchaikovsky, *Complete Collected Works*, vol. 28, ed. Aleksandr Goldenweiser. Moscow: Muzgiz, 1955.

Veloso, Caetano. *Caetano Veloso*. Philips, 1969.

Veloso, Caetano, and Gal Costa. *Domingo* Polygram, 1967.

Veloso, Caetano, and Gilberto Gil. *Tropicália 2*. 1994, Elektra.

Veloso, Caetano. "Primeira feira de balanço" [1965]. In *O mundo não é chato*, 143–53. São Paulo: Companhia das Letras, 2005.

Veloso, Caetano. *Verdade tropical*. São Paulo: Companhia das Letras, 1997.

Wall, Jeff. "'Marks of Indifference': Aspects of Photography in, or as, Conceptual Art." In *Reconsidering the Object of Art, 1965–1975*, ed. Ann Goldstein and Anne Rorimer, 247–67. Cambridge, MA: MIT Press, 1995.

Wall, Jeff. *Catalogue Raisonné, 1978–2004*. Göttingen, Germany: Steidl, 2005.

Weill, Kurt, and Bertolt Brecht. *Die Dreigroschenoper*. Score. Vienna: Universal Edition, 2008.

Weill, Kurt. *Ausgewählte Schriften*, ed. David Drew. Frankfurt am Main: Suhrkamp, 1975.

Wenders, Wim, dir. *Salt of the Earth*. Decia Films, 2015.

Werneck, Humberto. *Chico Buarque: Letra e música*. São Paulo: Companhia da Letras, 1989.

White Stripes. *De Stijl*. Sympathy for the Record Industry, 2000.

White Stripes. *Elephant*. V2, 2003.

White Stripes. *Hello Operator*. Sympathy for the Record Industry, 2000.

White Stripes. *Icky Thump*. Warner Brothers, 2007.

White Stripes. *Lord, Send Me an Angel*. Sympathy for the Record Industry, 2000.

White Stripes. *The White Stripes*. Sympathy for the Record Industry, 1999.

Williams, Raymond. *Television*. New York: Schocken, 1975.

Woolf, Virginia. *Mrs. Dalloway*. New York: Harcourt, 1981.

Zamora, Daniel, ed. *Critiquer Foucault: Les années 1980 et la tentation néolibérale*. Brussels: Aden, 2014.

Index

10:04 (Lerner) 36, 46, 82–91, 93

Salgado, Sebastião, 80
Schiller, Friedrich, 28, 37, 43, 88, 117
sculpture, 79–82, 106–7, 165–66; as a
 medium, 81–82
Schönberg, Arnold, 115, 151
Schumann, Robert: "Abends am
 Strand," 149, 203n82
Schwarz, Roberto, 115, 117–19, 121,
 132, 178–80
Sherman, Cindy, 45–55, 58, 68, 74
short story, 82, 89–90, 107, 108;
 versus the novel, 89, 104–5
Simon, David, 160, 163
Spinoza, Baruch, 91–92
Stallabrass, Julian, 57–58
standpoint, 3–4, 15, 22, 35, 36, 39,
 42, 43, 60, 66–67; versus viewpoint,
 183n5
Stella, Frank, 69
stoicism, 8; postmodern, 36, 87,
 90, 91. See also Hegel, G. W. F.:
 stoicism in
subjectivity, 5, 52–54, 74, 160,
 175–76. See also consciousness
sublime, 8, 103; modernist, 86

Tatum, Art, 153
television, 23–24, 69–70, 112,
 160–77; as a medium, 162–65
theater, 115–22; as a medium, 76, 77,
 116, 123, 127
theatricality, 7, 45, 48–49, 50, 59, 60,
 71, 76, 89, 165, 169; nontheatri-
 cality, 49, 50–51, 69–71, 74, 76;
 antitheatricality, 51, 77–78, 166,
 169, 192n20, 202n6
Thiong'o, Ngũgĩ wa, 70
totality, 27, 60, 66, 86, 99, 113
Tropicália, 131–40

tragedy, 167, 175–77
True Detective (Fukunaga), 69–71

unconscious, 5, 11–12, 186n17
Untitled Film Stills (Sherman), 45–55,
 58, 68, 74

value, 172; aesthetic, 49, 68, 69,
 83–84, 114, 115–16, 151, 160, 181;
 form, 33; use and exchange, 3–4, 8,
 38, 49, 68, 123, 134. See also Marx,
 Karl: value form in
Van der Rohe, Mies, 64
Veloso, Caetano, 131–40, 146, 150,
 201n65
violence, 33, 58–59, 60, 67, 180–81
Visit from the Goon Squad, A (Egan),
 82, 103–14, 143
Volpi, Alfredo, 26–27, 165
von Trier, Lars, 154–59, 204n4

Wall, Jeff, 41, 45, 56–69, 71; just-
 thereness in, 58–59, 61–62, 64, 67,
 71, 192n20
Weill, Kurt, 122–24, 131, 133, 139,
 150; "Cannon Song" (from Three-
 penny Opera), 124–27
Wertkritik, 174
White Stripes, The: "Ball and Biscuit,"
 148–49; De Stijl, 142; "Hello
 Operator," 140–43, 144; "There's
 No Home for You Here," 147–48;
 "Your Southern Can Is Mine,"
 143–45, 146. See also Blind Willie
 McTell
Williams, Raymond, 162–63
Wire, The (Simon), 159, 160, 168–77
Woolf, Virginia, 103
work of art. See artwork